CALIFORNIA'S
DEADLIEST
EARTHQUAKES

CALIFORNIA'S DEADLIEST EARTHQUAKES

A HISTORY

ABRAHAM HOFFMAN

THE
History
PRESS

Published by The History Press
Charleston, SC
www.historypress.net

First published 2017

Manufactured in the United States

ISBN 9781467136020

Library of Congress Control Number: 2017931823

CONTENTS

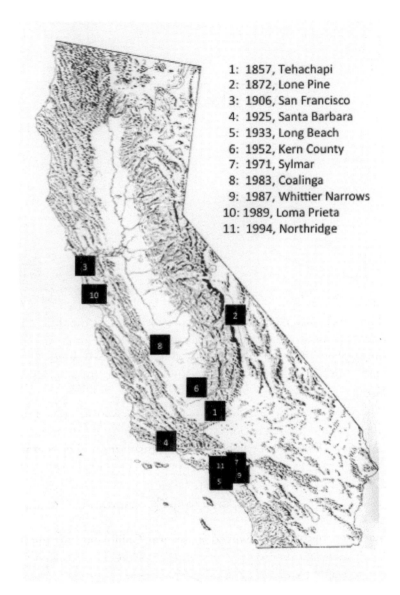

1: 1857, Tehachapi
2: 1872, Lone Pine
3: 1906, San Francisco
4: 1925, Santa Barbara
5: 1933, Long Beach
6: 1952, Kern County
7: 1971, Sylmar
8: 1983, Coalinga
9: 1987, Whittier Narrows
10: 1989, Loma Prieta
11: 1994, Northridge

Map showing location of California's major earthquakes. *Courtesy of Brian Dillon.*

INTRODUCTION

On August 23, 2011, my son Joshua was at his new job in an office building in New York City. At 1:50 p.m., the person sitting at the desk next to his said to him, "Would you please not kick my desk with your foot?"

Joshua replied, "I'm not kicking your desk. It's an earthquake."

As the room shook, his co-workers cried, "We don't have earthquakes in New York!"

On the Richter scale, the quake measured 5.9, and its epicenter was in Virginia. It rattled the nerves of New Yorkers but didn't do much damage there. Although East Coast earthquakes are uncommon, they're not all that rare, though most are in the 2.1 to 3.0 range. As a native-born Californian, Joshua was familiar with earthquakes, so the one on August 23 didn't faze him. It was minor league compared to the 6.6 Northridge earthquake on January 17, 1994.

I have been personally involved in several California earthquakes and include my own observations in the narrative. I have done this in the spirit of knowing that when natural disasters occur, everyone has a story to tell, and so I include my own.

The first chapter of this book examines why California has more earthquakes than any other state in the nation. The final chapter offers suggestions on how to prepare for a major earthquake, and be assured, there's one coming. Not sure when, but it's out there.

1

THE PACIFIC RIM AND THE RING OF FIRE

Country singer Johnny Cash famously defined passionate love as a "ring of fire." There's a broader definition of the Ring of Fire, and it more than matches the perils of Cash's song.

Take a map of the world and, starting with the southern tip of Chile, draw a sort of wobbly horseshoe up the Pacific coast of South America, Central America and North America. Then head west across the Aleutian Islands to Japan and China and south to the Philippines, Indonesia, New Zealand and Antarctica. Add a stirrup for the horseshoe by going west across Southeast Asia through India and on to the Middle East, and finally, head west across the Mediterranean region to the Atlantic Ocean. It doesn't look much like a ring, but the squiggly line carries an important message: it goes through the most seismically active regions in the world.

One of the most catastrophic explosions in recorded history occurred on the island of Krakatoa (also spelled Krakatau) in the south Pacific when a volcano erupted in 1883. The explosion was so tremendous that volcanic ash altered the world's climate for several years. Volcanoes, earthquakes and tsunamis (gigantic waves) were partners in wreaking major destruction, death and injury. On the coast of South America, Chile has the dubious distinction of being where the largest earthquake ever was recorded. In 1960, the Villarica volcano erupted, creating an earthquake with a magnitude 9.6 that went on for *ten minutes*. (The 1906 San Francisco quake lasted around 47 seconds.) The quake generated a tsunami that sent thirty-five-foot waves across the Pacific Ocean to devastate the city of Hilo, Hawaii, killing sixty-one

people. Other tsunamis reached as far as China, and Chile itself sustained damage from the destructive trio of volcano, quake and tsunami. The volcanic eruption also caused landslides in the Andes Range—fortunately in uninhabited areas. An estimated six thousand people in Chile died in the quake, and property damage ran between $600 to $800 million—some $6.4 billion in present-day dollars.

More recently, Chile suffered from an 8.8 quake on February 27, 2010, and an 8.2 on April 1, 2014.

Peru, Ecuador, Costa Rica, Nicaragua, Guatemala and Mexico have experienced major quakes, resulting in large loss of life and property. On September 19, 1985, a magnitude 7.0 quake killed five thousand people in Mexico City and caused between $3 to $4 billion in damages. Four hundred buildings were destroyed, and three thousand more were severely damaged. The Mexican government established an alert system—the Sistema de Alerta Sismica—using electronic messages from sensors, but the system isn't perfect. As of 2016, there were still some eighty families living in camps, survivors of the 1985 quake, still awaiting relocation. Mexico holds evacuation drills every September 19.

Similar statistics apply to other Latin American countries. Ecuador suffered a severe quake on April 16, 2013, with 661 dead and more than 27,000 people injured. On December 23, 1972, Managua, the capital city of Nicaragua, had a 6.2 quake that killed 6,000, injured 20,000 and left 250,000 people homeless. Although a 6.2 magnitude would be considered moderate to severe in California, Managua had many houses and buildings that were more than forty years old and structurally incapable of withstanding the quake. An offshore quake by Nicaragua killed 116 people in 1992; it was followed by a tsunami. Costa Rica experienced a 7.6 quake on September 5, 2012, followed by more than 1,600 aftershocks. El Salvador and Panama also felt this quake. Costa Rica's high standards of building construction spared the country much damage, and few casualties were reported. Guatemala experienced an offshore quake on November 7, 2012, just two months after the Costa Rica quake. At magnitude 7.4, the quake killed 39 people. It was felt in Chiapas, Mexico, north of Guatemala.

Such quakes ruin the economy of the regions, as agriculture and industry are severely affected. But the Ring of Fire doesn't stop in Latin America. New Zealand, where *The Lord of the Rings* trilogy was filmed, has numerous active volcanoes. One area in particular, the Auckland volcanic field, has at least forty active volcanoes. In recent years China, Japan, Indonesia, Nepal and the Philippines (where somewhere in its islands there are almost

constant quakes) have experienced major earthquakes, along with Iran. A 6.6 quake struck Bam, Iran, around 2:00 a.m. on December 26, 2003, killing more than thirty thousand people when their homes collapsed on them. Ten years later, on April 16, 2013, a 7.7 hit Saravan, Iran.

On April 25, 2015, a 7.8 quake struck Nepal, killing almost 9,000 people, injuring at least 18,000 and leaving more than 2 million people homeless. The quake caused avalanches that killed 20 mountain climbers, injured 120 and wiped out entire villages. Severe aftershocks caused more destruction. Much of the disaster was caught on camera and can be seen on the PBS program *Himalayan Megaquake.*

Japan's 9.0 quake on March 11, 2011, killed more than 16,000 people, injured more than 6,100 and had 2,600 missing. The quake attracted international attention due to the horrific tsunami that followed the quake and caused major problems with the country's nuclear reactors. On Thursday, April 14, 2016, a 7.0 quake hit around six hundred miles southwest of Tokyo, injuring 761 people and killing 9. No problems occurred at the Sendai nuclear plant, which had reopened the previous August. In China, there have been a dozen major quakes since 2008, the worst of which occurred May 12, 2008, a 7.9 that killed more than 68,000 with another 18,000 missing. Indonesia lost 130,000 killed in the Sumatra-Andaman earthquake of December 26, 2004, and the subsequent tsunami. More than half a million people were left homeless. This quake also affected Sri Lanka, where 35,000 people died; it was also felt in India, Thailand and Somalia.

Haiti, though not on the Pacific Ring of Fire, is nonetheless in a region vulnerable to earthquakes. On January 22, 2010, a 7.0 quake rocked the island it shares with the Dominican Republic in the Caribbean. The exact figure of those killed is not known; estimates run from 100,000 to 250,000. Over 1.5 million were made homeless, and years after the quake, 280,000 still lived in wretched tent camps. Following the quake, a cholera epidemic claimed more than 8,000 lives.

When a disaster of catastrophic proportions hits a nation, other countries are quick to offer financial aid for food, shelter, clean water, counseling, low-interest loans and new building construction. Haiti is one of the poorest countries in the world, and construction of new homes has been delayed in favor of building schools. Houses get a lower priority because few Haitians owned their homes, and owners of apartment houses charged more than most Haitians could afford—so years would follow with hundreds of thousands of people living in poverty in the tent camps.

There are some people with vested interests who have insisted that earthquakes are isolated incidents—that like lightning, once it hits an area it won't hit there again. Don't believe any of this. The fact is that the planet, the ground beneath everyone's feet, is in constant motion. The motion varies from movements detected only by seismographs to catastrophic earthquakes. The volcanic eruptions, earthquakes and tsunamis cited earlier are only recent examples of major seismic events. These and many other countries have long records of earthquakes and volcanoes, not only on the Ring of Fire but across the globe: Italy (think of Vesuvius), Turkey, Saudi Arabia and Tanzania. The list goes on.

This book deals with California, but it should be noted that other states have had earthquake experiences. In 2015, Oklahoma attracted national attention when its earthquake count jumped from practically none to almost nine hundred that measured 3.0 or more. The year before, the state had twice as many magnitude 3.0 as California. The oil and gas industry has been accused of making deep deposits of wastewater from its oil fracking, causing stress in strata far below the surface; investigations are ongoing. Since 2001, eleven states have had earthquakes measuring 3.8 or more: Alaska with seven, California with six, Virginia with two (the one in 2011 felt by my son in New York as mentioned in the introduction to this book), Illinois with two and one each for Alabama, Colorado, Florida, Hawaii, Indiana, Oklahoma and Washington. Nine of these states had quakes measuring 5.0 or above.

Modern detection of earth movement dates only to the end of the nineteenth century when an Italian geologist, Giuseppe Mercalli, developed the Mercalli scale, in 1902. Mercalli devised a scale that measured the intensity of an earthquake from I to XII (later X), with I being a "Did you feel it? I didn't" to X, an enormous catastrophe in which everything is destroyed. Mercalli's scale was qualitative in that it was based on anecdotal information supplied by earthquake survivors. There were problems with this scale, as people sending in reports might not have been in the same locations or were at different distances from the epicenter. It also didn't work for epicenters in remote locations where few people lived. Nevertheless, the Modified Mercalli scale, as it is now called and referred to as the MM or MMI scale, continues to be useful for structural engineers and the observations by eyewitnesses.

Seismographs, a way of recording quakes familiar to anyone watching a report on a quake in the news media, record the intensity of the quake without measuring it. Small vertical lines suddenly jump to a dark mass of clustered lines in the period of the temblor that could be anywhere from

two or three seconds to two minutes (and as noted earlier, on occasion to a frightening eight to ten minutes). But seismographs, though centuries old, merely recorded the lines and didn't measure the intensity.

In 1935, Charles Richter, a seismologist at the California Institute of Technology in Pasadena, was working with his mentor Beno Gutenberg and developed a quantitative scale that is now known throughout the world. The Richter scale, as it became known (Gutenberg wasn't recognized for his contribution until many years later), utilizes a logarithmic system of whole numbers and decimal fractions. Each whole number is ten times greater than the previous number: a magnitude 7 is ten times greater than magnitude 6 and one hundred times greater than magnitude 5. The Richter scale is recognized as the standard for measuring quakes, though other measurements have also been developed.

California has accepted its status as earthquake country and has taken important measures since the early twentieth century in establishing building codes that are continually upgraded and revised as seismologists and geologists acquire new information on earthquake faults. Changes in architectural styles have eliminated decorations on arcades, doors and windows such as ornate ornaments and cornices (a molding on top of a building wall) that served no purpose other than ornament. Cornices had a nasty habit of breaking off and falling on people during an earthquake.

Although most states do not recognize problems with the earthquakes that rarely occur within their borders, the fact that they do occur takes those states by surprise; homes and buildings are not built to the same standards as California structures and are therefore vulnerable to damage by quakes of lesser magnitude.

California's most famous earthquake fault is the San Andreas Fault, the name accorded to it by University of California–Berkeley geologist Andrew Lawson in 1895. The name is so familiar that moviegoers immediately knew what the motion picture *San Andreas*, released in 2015, would be about. However, California has hundreds of faults; in fact, the state is honeycombed with them. They have names: Imperial, San Jacinto, Elsinore, Whittier, Chino, Laguna Salada, Newport-Inglewood, Garlock, San Miguel, Palos Verdes, San Clemente, San Diego Trough—and this is just a part of a much longer list.

While this book was being written, a 5.2 quake occurred on the San Jacinto Fault on June 10, 2016. It struck in a desert area southeast of Los Angeles and south of Palm Springs. For anyone not familiar with this fault, the fault isn't just in the desert. It runs through the cities and towns of San Bernardino,

Redlands, Colton, Moreno Valley, Hemet (home of the Ramona Pageant), Rialto and Fontana. The quake's epicenter was in Anza-Borrego State Park, south of Indio and west of the Salton Sea. Once again, California dodged a bullet, as this earthquake's epicenter was in a remote area. But bear in mind that San Bernardino is a city with a population of 215,000. Anyone planning to write a doomsday scenario could imagine the San Jacinto *and* San Andreas Faults rupturing together, creating a 7.5 earthquake that would bring death and destruction throughout that part of California known as the Inland Empire.

One final note: this book consists of twelve chapters describing major California earthquakes, covering the period 1769 to 2016, plus this chapter and a concluding chapter on how to prepare for a major quake. No attempt is made to describe every measurable quake in California during that time frame. Such a project would result in a series of volumes similar to a set of encyclopedias, with more volumes added as time went on. To stress the point again: earthquakes do not occur in isolation. Tectonic plates create strains on the earth's crust, which breaks and causes earthquakes. Volcanoes erupt and cause earthquakes. Tsunamis result from earthquakes. California experiences thousands of earthquakes every year, almost all of them of such low intensity that people don't notice them, but there are a few that will cause people to take notice, given the shaking of their homes or offices, everything falling off shelves and cracking walls.

This book is not a technical study of earthquakes. Instead, it tells the story of how people in California have endured and survived earthquakes and how state and local governments have strived to protect those people from death, injury and damage to their homes and businesses. While there are no heroes or villains in this history, there are opposing groups of people: seismologists, geologists and elected officials who work to make the state a safer place to live and those who act like ostriches and stubbornly believe that earthquakes are an occasional nuisance and argue that retrofitting old buildings is too costly or that it's not necessary to advise prospective buyers about how close a new track home development is to a fault zone (thereby violating a state law).

2
EARTHQUAKES IN EARLY CALIFORNIA

By the summer of 1769, Spain's Sacred Expedition had moved north from Baja (lower) to Alta (upper) California. The expedition had two goals: constructing missions to convert the native people to the Catholic faith and creating a military presence to counter any plans from the British or Russians to take control of the Pacific coast of North America. Spain had lodged a claim to the Pacific coast in 1603 but had done little since that time to secure the region. British and French ships were sailing in the Pacific Ocean, ostensibly for scientific exploration. Russians were moving south from Alaska, hunting sea otters for their valuable fur.

Two men led the expedition. Captain Gaspar de Portolá headed a military contingent with instructions to build *presidios* (forts) to let other nations know that the Spanish claim would be defended. Franciscan Father Junipero Serra brought several priests with him to convert the native peoples they would meet. Serra established the first of Alta California's missions, San Diego, and Portola's soldiers started the San Diego Presidio.

In July, Portolá and some of the soldiers proceeded north, intending to construct a presidio in the vicinity of Monterey Harbor, a location first described by Sebastián Vizcaíno more than 160 years earlier. Father Juan Crespí accompanied this group, distributing gifts and making friends with the native people and telling them of the Christian God.

On July 28, the Portolá Expedition was encamped by a river some thirty miles southeast of where the pueblo of Los Angeles would be founded a dozen years later. Crespí kept a diary in which he recorded his observations

of the plants and animals he saw, the hospitality extended by the natives and the possibilities of water and arable land for future colonists. But on that date, he had something special to write about: earthquakes.

"We called this place El Dulcisimo Nombra de Jesus [Sweet Name of Jesus of the Earthquakes], because four times during the day we had been roughly shaken up by earthquakes," Crespí wrote. "The first and heaviest trembling took place at about one o'clock and the last near four o'clock in the afternoon." Several Indians were visiting the encampment when the first earthquake struck. "One of the heathen who were in the camp, who doubtless exercised among them the office of priest, alarmed at the occurrence no less than we, began with frightful cries and great demonstrations of fear to entreat heaven, turning to all the winds," wrote Crespí. Three other members of the expedition who kept diaries also mentioned the earthquake and its aftershocks.

Several days later, the expedition reached the Los Angeles basin and proceeded into the San Fernando Valley. They named a river flowing through the area the Río de Porciuncula, as August 1 celebrated "the jubilee of Our Lady of Los Angeles de Porciuncula." During the day, they experienced an earthquake at ten o'clock in the morning, followed by an aftershock at one o'clock in the afternoon and another an hour later. In the days that followed, the expedition felt five more quakes or aftershocks.

So were recorded the first experiences of Europeans with California earthquakes. In the decades that followed, earthquakes of varying severity would affect the lives of the missionaries, soldiers, *pobladores* (civilian settlers) and Indians.

Between 1769 and 1823, the Franciscan padres established twenty-one missions in Alta California. By offering simple gifts to the Indians, such as tools, clothing and other items, and demonstrating how agriculture could provide new food products such as wheat, beef and pork, the padres induced Indians to accept baptism. From the Franciscan viewpoint, acceptance of baptism made the Indians *neophytes*, mission Indians who nominally were Christian and subject to the discipline and direction of the padres. The Franciscans never intended to convert all the Indians in California to the Catholic faith; the Indian population was far too large. Modern estimates number the native population of what became California at between 250,000 to 300,000. The missionaries lacked the personnel and resources to make large-scale conversions possible. The padres focused their attention on tribes living in areas—mainly near the coast—where land was fertile and water abundant.

By the time Father Serra died in 1784, he had set up nine missions; his successors added the other twelve. It should be noted that these missions did not at first resemble the missions that today continue to serve Catholics and non-Catholics as places of historic interest. The first mission buildings were built of wood—the adobe structures were the result of using Indian labor, and the furnishings of paintings, statues and other items came later.

Occasionally, the padres realized that a mission was not well located, the land lacking fertile soil or water or the mission buildings too temporary or vulnerable to wind or rain. They were also defenseless against earthquakes.

Mission San Juan Capistrano was the seventh mission established by the Franciscans. Interestingly, the mission was founded not once but twice. Father Fermín de Lasuén founded the mission on October 30, 1775, but a native uprising in San Diego prompted Lasuén to bury the heavy church bells and return to the presidio at San Diego. A year later, Serra came back to the site and, on November 1, 1776, he dug up the bells and founded the mission a second time.

In 1779, a small church made of adobe bricks was completed, and it became known as the Serra Chapel. As the mission grew, the padres decided to build a more substantial church, one made of stone rather than adobe brick. They engaged the services of Isidor Aguilar, a master stonemason and imaginative architect. Aguilar planned a structure with a large central dome and six smaller vaulted domes, all made of stone. This contrasted with other missions that were made with flat wood roofs.

Construction began on the new building in 1797. Just three years later, on November 22, 1800, a major earthquake struck the San Diego area, cracking walls in the uncompleted building. Aguilar made the necessary repairs. Neophytes dragged boulders from creek beds and gullies and gathered the limestone that was used in making a mortar to cement the stones.

Unfortunately, in 1803, Aguilar died, and with the church still under construction, the padres and neophytes continued to finish the task. However, without Aguilar's skill, the quality of the mortar was inconsistent, and the stones were not cut to the sizes necessary for a secure fit. The church was finally completed in 1806.

On Sunday, December 8, 1812, while mass was being held in the mission church, a massive earthquake struck Southern California. The large central dome collapsed into the church, killing forty neophytes and injuring many others. The padres gave up on any idea of rebuilding the church, instead returning to the Serra Chapel. The ruins of the church remain visible to the present day.

Seismologists estimate the magnitude of the earthquake as between 6.9 and 7.5. The epicenter may have been in the San Gabriel Mountains near Cajon Pass, along the notorious San Andreas Fault, and the quake has been named the Wrightwood quake, after the town that was founded in that area in the 1920s. Although Wrightwood is some ninety miles from San Juan Capistrano, the number of lives lost and the destruction of the church has given the quake the alternate name of San Juan Capistrano earthquake.

Jose Arguello, military commander at the Santa Barbara Presidio, reported, "Almost daily shocks this month. Several buildings ruined and damaged at presidio and mission. Earth opened in several places, with sulfur volcanoes."

Less than two weeks after the destruction of the church, another powerful quake hit Southern California, on December 21, causing widespread damage. Its epicenter may have been in the Santa Barbara Channel. This later quake might have caused some damage at Mission San Gabriel, about seventy miles from the Wrightwood epicenter, but records are poor. San Diego even felt the Wrightwood quake.

Writing about the earthquake and its many aftershocks, Father José Francisco de Paula Senan, padre at the San Buenaventura Mission, said, "The already severe conditions have been rendered even more severe by the horrible temblors and earthquakes that have been experienced in this province and which will constitute a special epoch in it because of the great resulting damages." He considered the violence of the quakes "extraordinary."

The padre summarized the effect of the quakes, noting that the missions of San Fernando and Santa Barbara would have to be rebuilt and San Gabriel Mission required repairs. "At Missions Santa Inez and San Buenaventura quite some time will be required to repair the damage which I consider annoying to describe in detail. Concerning the last named mission, I will say only that the tower partially fell and that the wall of the sanctuary was cracked from top to bottom." La Purisima Mission, he reported, "was reduced to rubble and ruin presenting the picture of a destroyed Jerusalem."

In their annual report to the College of San Fernando on December 31, 1812, Franciscan padres Mariano Payeras and Antonio Ripoli described the destruction of the San Juan Capistrano Mission in graphic terms. "The extraordinary and horrifying earthquake which this mission suffered on the memorable day of the glorious Apostle Saint Thomas completely ruined the church," they wrote. The church's nave, a number of statues and paintings and many decorations were destroyed, and some of the buildings, including

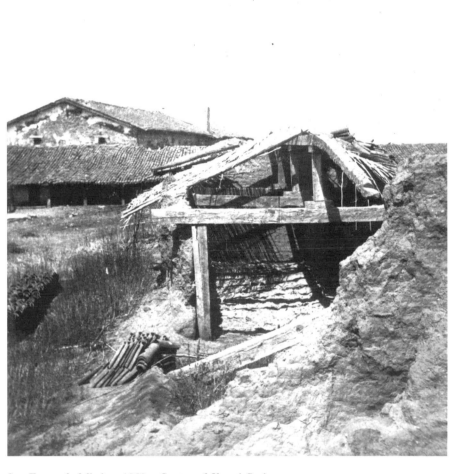

San Fernando Mission, 1860s. *Courtesy of Kenneth Pauley.*

housing for the neophytes, were a total loss. They said that "even the adobe wall of the garden, covered with tile, has either fallen down or is out of line to such an extent that the damaged parts will provide scarcely any material which may be used for later construction."

Seismologists estimate the December 21 quake at 7.1 magnitude. It destroyed the Santa Barbara Mission church and almost destroyed Mission La Purisima Concepcion, and did serious damage to Missions Santa Inez and

San Fernando. Fortunately, no deaths were reported from this earthquake. Aftershocks were felt for several months, some of them quite strong.

In the following decades of the Spanish-Mexican era in California there would be other earthquakes, the small pueblo of Los Angeles experiencing a 5.50 on September 24, 1827; in Hayward Valley on the east side of San Francisco Bay (6.25) on June 10, 1836; and on the San Francisco side on June 7, 1838 (7.00). Earthquakes were also reported in the Santa Cruz area in 1840 and San Jose in 1847, their exact dates and estimated magnitudes unknown.

Mexico achieved its independence from Spain in 1821, and in 1834, the Mexican government effectively secularized the Alta California missions. This policy removed the Franciscan padres from the missions and in theory turned the lands over to the neophytes. In reality, Californios—powerful owners of extensive land grants and ranchos who dealt in the hide and tallow trade and raised huge herds of cattle—coveted the former mission lands. The Indians were helpless against rancho owners. Many former neophytes found work as ranch hands or laborers; many died from exposure to European diseases.

Ostensibly, the missions were to continue functioning as parish churches, but their relative isolation meant that few Californios would attend services there. For example, Californio rancho owners had homes located in the Plaza area of Los Angeles, walking distance from the parish church. They saw no need to travel a dozen miles to the San Gabriel Mission or over Cahuenga Pass into the San Fernando Valley to the San Fernando Mission. The new landowners used the mission buildings as storehouses or stables. For the rest of the nineteenth century, the California missions didn't need earthquakes to damage them. The walls were allowed to crumble until the buildings were little more than ruins.

Near the end of the nineteenth century, Charles F. Lummis, an eccentric transplant from Ohio to Los Angeles and a devotee of the Spanish (not necessarily Mexican) culture, launched a crusade to rescue and restore the California missions. Over time, the missions were repaired, repainted, rebuilt and reconstructed until they became architectural reminders of the Spanish Mexican era. But as will be seen in later chapters, their restoration would not make them immune to earthquakes.

3
THE 1857 TEHACHAPI EARTHQUAKE

In October 1853, a young man completed a lengthy journey from Saxony in central Europe, stopping in New York to meet relatives, then taking a ship to Nicaragua and crossing to the Pacific, finally arriving in Los Angeles, California. Harris Newmark had come to join his brother in the grocery and dry goods business. He spoke German and Swedish; on the final leg of his roundabout voyage, he picked up some Spanish and eventually learned English. His linguistic skills would prove invaluable in conducting business in polyglot Los Angeles.

In the early 1850s, the town that Newmark would call home was a backwater place filled to a great extent with would-be gold seekers headed for the gold fields, losers returning from unsuccessful efforts at prospecting, vagrants, Californios, Indians, Anglos and a rough crowd of troublemakers. Inadequate courts and law enforcement prompted vigilante actions in which murderers met their ends with nooses around their necks and the rope thrown over a corral gate.

Despite the violence of gunplay, drunken brawls, Indian uprisings and outlaw criminality, Newmark saw potential in the scruffy town. He soon left clerking in his brother's store and began investing in real estate and other enterprises, eventually winning recognition as one of the town's most prominent and influential citizens. Near the end of his long life, he wrote his memoirs, *Sixty Years in Southern California, 1853–1913*, in which he recorded the transformation of Los Angeles from frontier town to major metropolis.

Newmark's memory was remarkable. His book told in great detail of people and events across the decades. And when the Tehachapi earthquake struck Southern California, he was an eyewitness to the fright and destruction it caused.

About sixty miles north of Los Angeles, on a road that is now Interstate Highway 5, and a bit north of the Tejon Pass summit, Fort Tejon served as a base for the U.S. Army. The fort was staffed by the First Dragoons (later the First Cavalry), and during this frontier period, it served as headquarters for expeditions in pursuit of outlaws and hostile Indians. Among the more unusual activities at the fort was the use of camels to transport supplies across the desert area between Southern California and New Mexico Territory.

At about 8:20 a.m. on the morning of January 9, 1857, an earthquake with an estimated magnitude of 7.9 ruptured the San Andreas Fault as much as 225 miles. It was felt as far north as the gold rush town of Marysville and south to Mexico. There had been some foreshocks, and after the initial temblor, there were numerous aftershocks. Unlike most earthquakes that are announced with a major upheaval, there were reports of foreshocks taking place up to nine hours before the big one.

This was not the first earthquake felt by Newmark as a Los Angeles resident, nor would it be the last. "The first earthquake felt throughout California, of which I have any recollection, occurred on July 11th, 1855, somewhat after eight o'clock in the evening, and was a most serious local disturbance," he recalled. "Almost every structure in Los Angeles was badly damaged, and some of the walls were left with large cracks." The adobe home that had been owned by pioneer resident Hugo Reid, and in which his widow still lived, was "wrecked, notwithstanding that it had walls four feet thick, with great beams of lumber drawn from the mountains of San Bernardino." The quake made ground rise and fall, chimneys crumble and items on store shelves hit the floor. He remembered that "water in barrels, and also in several of the *zanjas* [irrigation ditches], bubbled and splashed and overflowed." Additional earthquakes occurred in 1856—on April 14, May 2 and September 20—and on these occasions, "we were alarmed by receiving more or less continuous shocks which, however, did little or no damage."

Seismologists estimate the July 11, 1855 earthquake at magnitude 6. The earthquake also damaged the bell tower at the San Gabriel Mission. People reported a tidal wave, indicating the epicenter may have been off the coast.

Now, two years later, came the much stronger earthquake. Harris Newmark felt its impact and recalled the event vividly in his book:

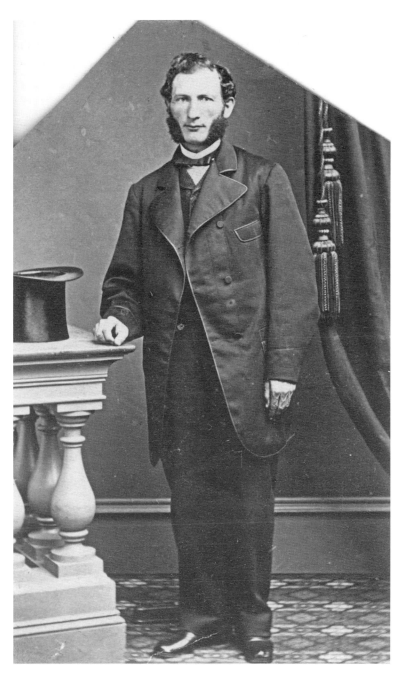

Harris Newmark, eyewitness to the 1857 Fort Tejon earthquake. *Courtesy of Western States Jewish History.*

At half past eight o'clock on the morning of January 9th, a tremor shook the earth from North to South; the first shocks being light, the quake grew in power until houses were deserted, men, women, and children sought refuge in the streets, and horses and cattle broke loose in wild alarm....For perhaps two, or two and a half minutes, the temblor *continued and much damage was done. Los Angeles felt the disturbance far more than many other places, although five to six shocks were noted and twenty times during the week people were frightened from their homes; at Temple's rancho and at Fort Tejon, great rents were opened in the earth and then closed again, piling up a heap or dune of finely powdered stone and dirt.*

Newmark noted that the earthquake uprooted trees, and cattle on the hills lost their footing. As for the soldiers at Fort Tejon, Newmark recalled, "Many officers, including Colonel B.L. Beall—well known in Los Angeles social circles—barely escaped from the barracks with their lives; and until the cracked adobes could be repaired, officers and soldiers lived in tents."

Newmark recalled his experience after more than half a century; however, contemporary accounts also describe the quake. Ellen McGary, a resident of San Bernardino, some eighty miles east of Los Angeles, wrote to a friend in Salt Lake City, Utah: "The trees shook as if in a strong wind, the water in the well splashed against the sides, the walls of the houses creaked, and folks stagger as if they were a 'little bit tight,' but there was no material damage done." Caroline Barnes Crosby, Ellen's aunt, described a sound "resembling distant cannon or like the waves of the sea dashing against a rocky shore." Another San Bernardino resident, D.B. Thomas, said he had experienced earlier earthquakes, "but this was different and caused a sensation unlike any I have ever experienced."

In Los Angeles, the quake jolted late sleepers awake, prompting people— still in their nightclothes—to run out of their homes. Historian Ward McAfee described one man who

was taking his bath at the time the quake began. As the shaking began gently at first, he resolved to ride it out in the tub. After a few moments, the rocking motion increased somewhat in force, and he chose to run for his life. A group of ladies praying in the courtyard for consolation received a greater shock with the appearance of the naked bather in their midst.

Newspapers north of the quake area reported accounts of its violence. One man told the *Sacramento American* "that it was severely felt in that region

and seemed to shake the hills for miles around." The *Stockton Republican* stated, "The commotion was very visible, lasting some minute or two. We have heard two or three gentlemen describe the sensation as being so violent as to cause a kind of seasickness." San Francisco's *California Chronicle* told a somewhat humorous story of a man who determined the direction of the quakes while eating his breakfast: "A place of beefsteak, swimming in gravy to its very edge, was the instrument. After the motion ceased, it was found that the gravy has been ejected from the dish on two sides for about two inches each way, in a line east and west by the compass."

Francisco Ramirez, a young Mexican American in Los Angeles who founded a Spanish-language newspaper, *El Clamor Publico*, wrote about the quake with an implicit criticism of the town's lawlessness. "It appeared that the earth, tired of resisting our wickedness, shook us as the birds shake her troublesome feathers." He observed that in the initial moments of the quake, people were in the town's streets, some loudly praying while others threw up their breakfasts.

Despite the magnitude of the earthquake, only two people died—a woman was killed in her home near Fort Tejon when the building collapsed, and an elderly man in Los Angeles dropped dead, apparently from a heart attack. Although some buildings in Los Angeles collapsed, most adobe structures survived surprisingly well. Location may have played a part in the buildings' survival. Southern California was going through a period of drought at the time, resulting in dry, solid ground on which the houses were built. By contrast, buildings in places with a high water table, even hundreds of miles farther north, might have been more susceptible to damage. Ward McAfee noted, "While the negative aspects of drought are common knowledge in Southern California, it should also be realized that drought lowers the possibility of earthquake damage in the area. The Great Quake of 1857 serves as a testimonial to this fact."

The 1857 quake may have had a high magnitude, but its relatively low intensity lessened the likelihood of destruction. People described the earthquake as slow-moving rather than a severe jolt. Pioneer Los Angeles resident H.D. Barrow, writing in his memoir almost a half century later, said, "The movement seemed to be comparatively slow, giving things time to recover after moving in one direction. If the motion had been short and sudden, the damage would have been appalling."

Historians William Secrest Jr. and William Secrest Sr., in their book *California Disasters*, observe that the Tehachapi earthquake was "as perhaps

as large or larger than the San Francisco earthquake of 1906. It was only due to the sparse population, and lack of high population densities throughout California, that much greater damage and loss of life did not occur."

In researching the 1857 earthquake, McAfee expressed surprise that the event so quickly became yesterday's news to Southern California residents. Of greater concern at the time was the furor caused by the depredations of Juan Flores and his outlaw band. Two weeks after the earthquake, the Flores gang ambushed and killed Los Angeles County sheriff James R. Barton and three posse members. Following his capture, Flores was removed from jail and lynched by a mob too impatient for the wheels of justice to turn. Everyone breathed easier with the earthquake and the cessation of Flores's depredations.

The earthquake caused the Kern River to reverse its course temporarily, and fish from Tulare Lake were found miles from the lakebed. Evidence of the power of this earthquake could be found throughout Southern California. Cracks in the ground appeared in the San Gabriel Valley. Water springs surfaced in the San Fernando Valley and near Santa Barbara. To the north, the church tower at San Buenaventura Mission partially collapsed.

Aftershocks continued for almost four years, starting with two large ones in the week after January 9, estimated at 6.25 and 6.70 magnitude. An earthquake hit San Bernardino on December 16, 1858, magnitude 6.00, considered by seismologists to be an aftershock of the January 9 Fort Tejon quake. Of the 1857 earthquake, McAfee surmised that it "stands out as an anomaly for its lack of impact among the people that it affected....That a quake of this size left adobe structures undamaged as close to the fault as San Bernardino deserves to be recorded as one of history's miracles."

In the dozen years following the Tehachapi quake, at least seven quakes of various estimated magnitudes occurred in California. Some of these were in mountain areas, others near small towns. But these would pale in comparison to the quake that hit the eastern Sierra Nevada Range on March 26, 1872.

4

THE 1872 LONE PINE/OWENS VALLEY EARTHQUAKE

By 1872, John Muir had lived in the Yosemite Valley area for four years. During that time, his reputation as a naturalist had grown, his articles on nature, geology and the earth sciences appearing in newspapers and magazines. Luminaries such as Ralph Waldo Emerson and Joseph LeConte paid visits to his mountain cabin. Born in Scotland in 1838, Muir immigrated to the United States with his family as a young boy. A freak accident occurred in which Muir lost the use of one eye and went temporarily blind. While recuperating, he began to appreciate the wonders of nature, as opposed to the problems of civilization.

After several adventures, traveling across the United States on foot and living briefly in Cuba, Muir came to California and set out immediately for the Sierra Nevada Range. His love affair with Yosemite Valley continued for the rest of his life. In his book (one of many) *The Yosemite*, Muir recalled his experience with one of the largest earthquakes in California's recorded history—the Lone Pine earthquake of Tuesday, March 26, 1872:

> At half past two o'clock of a moonlit morning in March, I was awakened by a tremendous earthquake, and though I had never before enjoyed a storm of this sort, the strange thrilling motion could not be mistaken, and I ran out of my cabin, both glad and frightened, shouting "A noble earthquake! A noble earthquake!" feeling sure I was going to learn something
>
> The shocks were so violent and varied, and succeeded one another so closely, that I had to balance myself carefully in walking as if on the deck

of a ship among waves, and it seemed impossible that the high cliffs of the Valley could escape being shattered. In particular, I feared that the sheer-fronted Sentinel Rock, towering above my cabin, would be shaken down, and I took shelter back of a large yellow pine, hoping that it might protect me from at least the smaller outbounding boulders.

Muir might have considered the quake "noble" and "thrilling," but the same might not be said in the small town of Lone Pine in the heart of Owens Valley, immediately east of the Sierra Nevada Range. The shock, estimated between 7.9 and 8.3, hit between 2:00 and 3:00 a.m., the epicenter not far from the town. About 250 people lived in Lone Pine, and 27 died; almost everyone lost a friend or relative. Only seven of fifty-nine buildings escaped damage. The land itself was altered; a new lake was formed (Diaz Lake), crevasses opened and there were miles of scarps—scars on the hillsides showing displacement caused by the quake—running from the small villages of Olancha to Big Pine.

Severe damage and destruction to Lone Pine buildings and homes as a result of the Owens Valley/Lone Pine earthquake. *Courtesy of Eastern California Museum.*

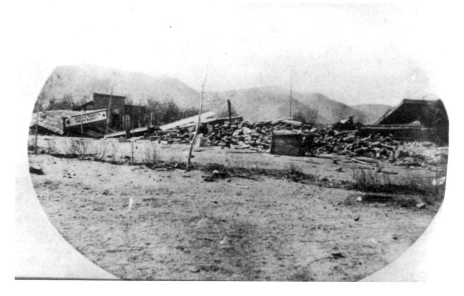

The 1872 earthquake flattened the small town of Lone Pine. *Courtesy of Eastern California Museum.*

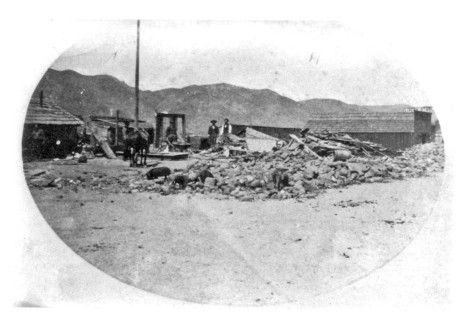

Men standing in the rubble after the 1872 earthquake wrecked the town of Lone Pine. *Courtesy of Eastern California Museum.*

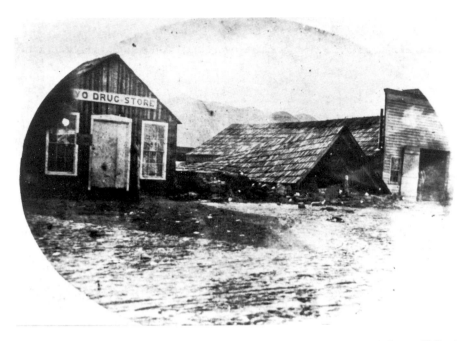

All that remains of the Inyo Drug Store and another building after the 1872 Owens Valley/ Lone Pine earthquake. *Courtesy of Eastern California Museum.*

Almost every town in Inyo County had buildings that suffered heavy damages, with property losses estimated at $250,000 (1872 values). Bishop, the valley's biggest town, experienced cracks in the ground. Horizontal visible scarps were seven feet wide. Buildings made of adobe or stone suffered more damage than did wooden ones. Camp Independence, a military encampment near the county seat of Independence, was closed because of the damages to its buildings.

Emma Duva lived on a farm about twenty miles from Lone Pine. When the quake hit, "The dog was howling and the poultry squawking as if something was trying to choke, and they were so badly frightened they didn't seem to know what to do but squawk, and no wonder—it was enough to frighten anyone," she recalled.

Eva Shepherd, eight years old at the time, remembered her fear when the quake struck. "No words can express the terror I went through in the next few minutes. Under our feet the rubble was rolling and shaking, while those sod walls were still crumbling and crashing around us. I thought the end of the world had come," she recalled. Somehow Eva succeeded in crawling out of the debris. "The ground was heaving and shaking so we could hardly

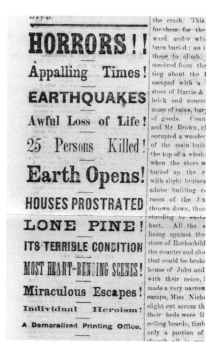

On March 30, 1872, the *Inyo Independent* headlined the tragedy of the Owens Valley/Lone Pine earthquake. *Courtesy of Eastern California Museum.*

stand. Only one of us was injured. Mrs. Rogers had been caught by a section of wall before she could get out of bed, and two of her ribs were broken."

Indians in the region, with an oral tradition of a major earthquake centuries before, left in anticipation of a much worse one to come. People came up with various theories as to the causes of the earthquake, including shooting stars (meteors) and electricity, the latter a new innovation not clearly understood but as reasonable an explanation as could be given by those who experienced and survived earthquakes.

More than two hundred miles to the south, residents of Los Angeles felt the earthquake. It was "of sufficient force to throw people out of bed, many men, women and children seeking safety by running out in their night-clothes," recalled Harris Newmark. "A day or two afterward excited riders came in from the Owens River Valley bringing reports which showed the quake to have been the worst, so far as loss of life was concerned, that had afflicted California since the memorable catastrophe of 1812." Newmark made this assertion because the 1857 Tehachapi earthquake had claimed only two lives.

Lone Pine's victims were buried in a common grave marked by a plaque identifying the site as California Historical Landmark No. 507. It is about a mile north of Lone Pine and enclosed by a fence. A second marker, erected on March 26, 1988, states that sixteen people are buried there. (Other sources say fourteen.) The names of several of the victims are listed; "The rest of French, Irish, Chilean, Mexican & Native American ancestry are known but to God." The Secrests noted, "Only the absence of any large population east of the Sierra and in central California kept both fatalities and property loss low."

U.S. Geological Survey geophysicist Susan Hough visited the cemetery and observed in her book *Finding Fault in California*:

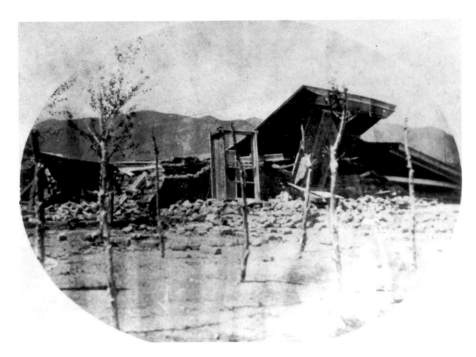

Destruction caused by 1872 Owens Valley/Lone Pine earthquake. *Courtesy of Eastern California Museum.*

[W]*e arrived at one of the most poignant stops on an earthquake tour of the state, a weathered wooden picket fence enclosing the mass grave of sixteen of the earthquake's victims. Sixteen men, women, and children, each accorded perhaps three or four feet of lateral space. Standing at one end, with gentle breezes swirling overhead, one cannot help being moved by the expanse of ground within the fence perimeter. Appropriately enough, during the spring wildflower season the earth summons forth blazing yellow desert dandelions to grace this otherwise most Spartan gravesite.*

The earthquake brought out the creative juices of Bret Harte, editor of the *Overland Monthly* and a noted author of stories about the California gold rush. In 1873, he wrote a short story, "The Ruins of San Francisco," a sort of science fiction tale that takes place one thousand years in the future. "Towards the close of the nineteenth century," the story begins, "the city of San Francisco was totally engulfed by an earthquake." The story appeared in *Overland Monthly.*

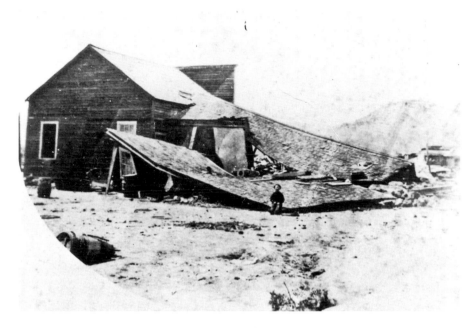

Collapsed house or business with child sitting in front after 1872 Owens Valley/Lone Pine earthquake. *Courtesy of Eastern California Museum.*

With tongue-in-cheek humor, Harte utilized the immediate memory of the Lone Pine earthquake to visit a future calamity for the City by the Bay. His story describes the discovery of the ruins of the city and the events leading up to the quake and San Francisco's destruction. "Historians disagree in the exact date of the calamity," he wrote, citing one "authority" who fixed the date as in 1880. Some of the sentences in the story eerily predict what would actually happen in 1906. "For many years California has been subject to slight earthquakes, more or less generally felt, but not of sufficient importance to warrant anxiety or fear....Everything tends to show that the calamity was totally unlooked for."

Harte got his "prediction" wrong in one important respect. He believed the city would sink under the waters of San Francisco Bay. Instead of destruction by earthquake and water, the catastrophe would be by fire.

Harte's story was not entirely forgotten, as it was included in the publication of his collected works. The San Francisco earthquake and fire, to be discussed in the next chapter, attracted worldwide attention. An article in the Hobart, Tasmania *Mercury* of May 18, 1906—only a month after the disaster—remarked on Harte's story: "It is a remarkable

example of literary prophecy—although not quite the way that the author foreshadowed."

Harte's article, of course, was serendipitous; he had no crystal ball, no oracle to predict a disaster that lay more than thirty years in the future. But, like many Californians, he knew about earthquakes and the damage they could cause, and he had the immediate experience of knowing about the Lone Pine earthquake. As will be seen in the next chapter, however, what destroyed San Francisco would be quite different from Harte's prediction of the sea swallowing up the city.

5
THE 1906 SAN FRANCISCO EARTHQUAKE (AND FIRE)

By April 1906, San Francisco had grown from a tiny village to the preeminent city on the Pacific coast, with a population of 400,000. The City by the Bay was a center of finance, manufacturing and publishing, including newspapers and magazines. Its elite class lived in mansions on Nob Hill. City residents considered themselves cosmopolitan, enjoying opera and theatrical performances and a tolerance for diversity that even allowed for a section of the city where Chinese people lived. As a major seaport, San Francisco led in international commerce, insurance companies and the Pacific Coast Stock Exchange.

There was also a seedier side of brothels and political corruption. Abraham Ruef, a lawyer turned saloon boss, dominated local politics. He collected what he called "lawyer's fees" from anyone needing a business license or franchise, including trolley cars, warehouses and French restaurants, the last of these being fronts for brothels. Ruef's chief stooge, Mayor Eugene Schmitz, did Ruef's bidding, as did San Francisco's board of supervisors.

Local reformers, among them Fremont Older, editor of the *San Francisco Call*, pressed for investigations and indictments against Ruef and his cronies. It was while the investigations were under way that the earthquake struck on April 18.

San Francisco was not immune to earthquake or fire, and it was no stranger to both. In its early years, fire had destroyed much of the city some half a dozen times, and each time, like the phoenix, the city rose again from the ashes. As for earthquakes, there had been a fairly minor one in 1865

and a more serious one on October 21, 1868, with a magnitude estimated at between 6.8 and 7.1. The 1868 quake actually occurred on the Hayward Fault, some twenty miles east of the San Andreas Fault, and it pretty much demolished the East Bay town of Hayward, with serious damage and loss of life throughout Alameda County. The earthquake also caused destruction in the North Bay Area, in Santa Rosa, Petaluma and east to Vallejo. Sacramento and Stockton felt it, as did people living in the Sierra Nevada foothill communities from Downieville to Sonora. Even Carson City, Nevada, felt the shock, two hundred miles east of the Bay Area.

San Francisco, the largest city in the state, also suffered severe damage. The quake knocked down commercial buildings, the gas plant and the city hall. The *Daily Californian* reported:

> *One of the most alarming and destructive shocks of earthquake ever felt here since its settlement by whites occurred this morning at about ten minutes before eight o'clock. The direction of the shock seemed to be from the southwest to northeast, and so severe was it that in a number of places the ground opened from six inches to two feet, through which water and quicksand, in considerable quantities, was forced to a height of from one to three feet. The amount of damage sustained here at present cannot be estimated.*

Whatever lessons this earthquake taught in regards to reinforcing buildings and creating construction standards were largely forgotten by 1906. In the early twentieth century, the city boasted modern skyscrapers built of reinforced concrete in the business district. But much of the city still consisted of vulnerable brick and wooden buildings, including apartment houses, residences and office buildings. City leaders had also forgotten or ignored the fact that "water lots" created in the gold rush years were essentially plots of underwater land turned into landfills on which buildings had been constructed. When the 1868 earthquake hit, the ground on the water lots liquefied, and down came the buildings. In 1906, there were many buildings on this "made ground" that would be, and were, vulnerable to destruction, particularly if an earthquake was to strike.

On Wednesday, April 18, at 5:12 a.m., most people in San Francisco were asleep in bed, and few were out on the street at that time. The first shock, estimated by seismologists as between 7.7 and 8.3 magnitude, hit about two miles offshore from the city. The shaking lasted for forty-seven seconds (some accounts claimed it went for two minutes), and it was felt as far south as Los

Angeles, north in Oregon and east in Nevada. A foreshock lasting about twenty-five seconds gave people no time to prepare for the main tremor.

Buildings constructed on bedrock held up fairly well. Those on made ground suffered liquefaction and collapsed. Fires broke out soon after the main shock. (There would be many aftershocks as well.) The most famous of the fires was dubbed the "Ham and Eggs" fire, allegedly started by someone cooking breakfast when the earthquake hit. Wooden buildings were quickly consumed in flames. When the alarms went off at the fire stations, firemen immediately went into action, their horse-drawn wagons taking them to burning buildings. But when they attached the hoses to the fire hydrants, only a trickle came out, then nothing. The earthquake had broken the water mains, rendering the firemen's efforts useless. Even if the water mains had somehow survived, firemen would have found many of the hydrants under piles of bricks and other debris. Much of the city burned, and flames grew into unstoppable firestorms.

The earthquake and its aftershocks immediately separated San Francisco from the outside world, as telephone and telegraph wires went down. Survivors describing the quake were stunned by its ferocity. Mark Cohn, a merchant from Little Rock, Arkansas, was on vacation with his wife. While his wife was already in San Francisco, Cohn was staying at a hotel with an

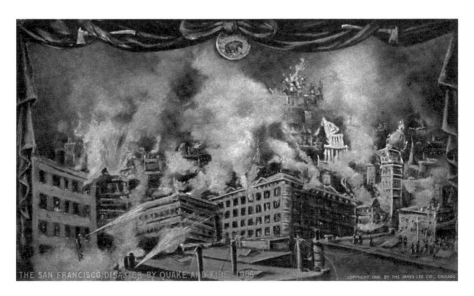

Postcard illustrating the 1906 San Francisco earthquake and fire disaster. *Author's collection.*

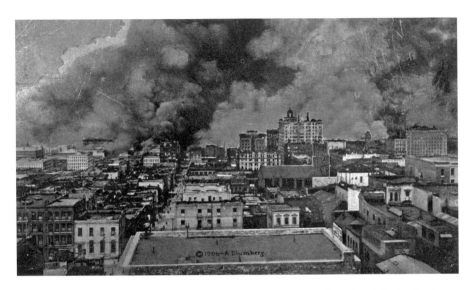

Postcard showing San Francisco on fire following the 1906 earthquake. *Author's collection.*

old friend in nearby San Jose. In a letter written around April 23 to his son Albert, Cohn said:

> *Nothing like it or similar was ever known to have happened by the oldest settlers here. The room that I and my friend Levinson occupied was filled with broken glass, furniture, etc. The amount of plaster that fell in and about our beds is enough to have killed twenty persons, and that we both escaped uninjured is certainly a most gracious gift from God, that we should be thankful for, for the balance of our lives.*

Cohn left immediately for San Francisco, but it took him until 4:30 p.m. to get there.

> *Just arrived after changing vehicles five times on the way getting here. First a train then a farm wagon, then an electric car, then a spring wagon, and finally a carriage, altogether costing me six dollars, when it should have cost but one dollar and a quarter, and instead of it taking one hour and twenty minutes, it took us six hours but I was happy to find mama safe and well, although very nervous and apprehensive about me.*

Sixteen-year-old Sol Lesser was sharing a big bed with his elder brother Monroe on the night of April 17. "We slept soundly with no foreboding

38

of the terrible calamity that was to occur at dawn the next morning," he recalled. "I was awakened as my bed was jerked suddenly sideways. I was tossed out of bed and landed on the floor. Doors came unhinged and pictures and ornaments jangled throughout the house." Through an open window, he heard the sound of breaking glass and chimneys coming down.

Sol and Monroe quickly dressed and went outside. They saw men and women in their nightclothes, fearful to go back into their homes. "To me, as a sixteen-year-old, it didn't seem like reality." Sol worked at the firm of Holbrook, Merrill and Stetson, a major supplier of plumbing and hardware. Not fully realizing the extent of the disaster, he walked five miles to the store. By the time he arrived, the building was on fire. "With nothing better to do, I wandered back to my own neighborhood." Learning that relief committees were being organized, he borrowed a horse-drawn milk wagon and went to the Southern Pacific Railway Depot, where he joined a relief committee. He was given a white bandage with a red cross on it and the letters RELIEF COMMITTEE. Sol loaded the wagon with bread, milk and canned goods and went to Lafayette Park, where thousands of men, women and children were congregated. "There was no discipline of any kind," he said. "The minute the wagon entered the park with supplies the people surged onto it and helped themselves until it was empty."

As an adult, Lesser moved to Hollywood and became a movie producer, best known for the long series of Tarzan movies. "Though I was young at the time, the courage of the people and the foresight of San Franciscans stand out in my memory like it was yesterday," he recalled. Sol Lesser died in 1980 at the age of ninety.

At the time of the earthquake, San Francisco's most famous visiting celebrity, tenor Enrico Caruso, completed his cross-country tour with the Metropolitan Opera Company, arriving in the city to open the opera season there with *Queen of Sheba* at the Grand Opera House on April 16. Caruso and company stayed at the Palace Hotel, its staff putting up with his imperious demands. The next night, he sang the role of Don José in *Carmen* to an enthusiastic audience.

When the first shock of the earthquake struck at 5:12 a.m., Caruso went to the window of his spacious apartment. "And what I see makes me tremble in fear," he recalled. "I see the buildings toppling over, big pieces of masonry falling, and from the street below I hear the cries and screams of men and women and children." Caruso and other members of the opera company left the hotel, only to return inside and exit again when there was an aftershock. The company members went to the St. Francis Hotel, Caruso

still in his pajamas and a fur coat. "Ell of a place," he complained. "I never come back here!"

On the morning of April 20, Caruso and company left for Oakland, and from there, they took the train to New York City, abandoning most of their luggage and losing the props, costumes and scenery for nineteen operas, lost in the firestorm that destroyed the hotels. Caruso kept his promise. He never returned to San Francisco.

A month to the day after the earthquake, Pauline Reinhart wrote a letter to her nieces and nephews in Winnemucca, Nevada, from a temporary home across the bay in Alameda. "The earthquake was bad enough, but the terror of terrors was that simultaneously with the quake the water mains broke. Not a drop of water to drink, to wash with, or to quench the fire, which started almost simultaneously with the earthquake," she wrote. "They had nothing to fight the fire with except dynamite, until later in the day they succeeded in getting salt water from the bay."

On April 28, Margaret Wright wrote to her sister-in-law, Ethel Pape Wright, recounting her experiences during the earthquake. Her husband, Captain Henry Wright, was a U.S. Navy officer stationed in San Francisco. Concerned that the fires were approaching their home, the Wrights first went to Buena Vista Park, accompanied by their Japanese maid, her husband,

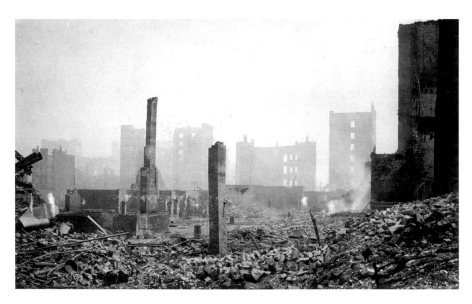

View from Jones Street and Golden Gate Avenue after the San Francisco earthquake and fire of 1906. *Courtesy U.S. Geological Survey.*

the Wrights' four-year-old son Joseph and the family physician, Dr. O'Neill. Finding the fire spreading close to the park, the group decided to return to the house, but on the suggestion of Dr. O'Neill, they hiked to the panhandle area of Golden Gate Park.

The next day, they went home, but Margaret was fearful that another temblor could bring down the house, so they went back to the panhandle— only to learn that the fires were getting nearer. One of Dr. O'Neill's cousins invited them to stay at her Ocean Beach cottage. They returned to the house on Saturday and ended their odyssey by taking a ferry to Berkeley, where they were able to rent a house.

In her letter, Margaret summarized what had happened to the city:

> *The business portion of the city is a mass of ruins. Market Street was swept [sic] its entire length to within one block of the ferries. Everything South of Market west, nearly all the mission district, and north of Market to Van Ness. There is not a trace left of Chinatown. I suppose every San Franciscan has suffered greatly from the fire. Many are destitute and numbers are homeless. The earthquake of course did great damage to all brick buildings, and many frame [houses] are not fit for habitation. Some frame ones slid off the foundations.*

Writing ten days after the earthquake and fire, Margaret concluded her letter, "I think my nerves are not quite steady yet."

The accounts given by Enrico Caruso, Mark Cohn, Sol Lesser, Pauline Reinhart and Margaret Wright exemplified the stories that would be told by thousands of other survivors. Their letters and recollections constitute a valuable narrative of ordinary citizens coping with extraordinary circumstances.

Jack London and his wife, Charmian, lived in Glen Ellen, some fifty miles north of San Francisco. The earthquake woke them up; they went to the site where they were having a home built, Beauty Ranch, where the barn, still under construction, had suffered some damage. They could see smoke rising off in the distance as fires grew in the city.

According to Charmian, Jack did not initially want to write about the catastrophe. "I'll never write a word about it. What use trying?" But then a telegram arrived, sent by *Collier's* magazine. The magazine wanted him to go to the beleaguered city and write what he saw there, 2,500 words at twenty-five cents a word. As a bestselling author, he was supposed to be very wealthy, but money was always a problem—and the rate was quite

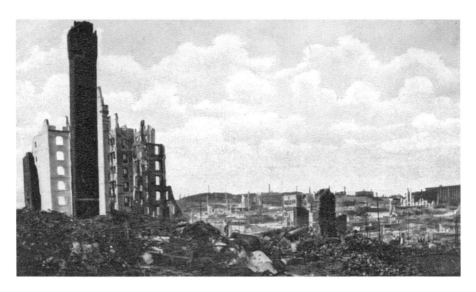

Postcard view of the burnt area of San Francisco as seen from Van Ness Street after the earthquake and fire. *Author's collection.*

lucrative. Jack and Charmian soon boarded a train and headed south to San Francisco. The train carried few passengers; trains going north were packed with people anxious to get away from the disaster. Jack lost no time in writing the article, and *Collier's* published it in its May 5 issue:

> *At nine o'clock Wednesday evening I walked down through the very heart of the City. I walked through miles and miles of magnificent buildings and towering skyscrapers. All was in perfect order. The police patrolled the streets. Every building had its watchman at the door. And yet it was doomed, all of it. There was no water. The dynamite was giving out. And at right angles two different conflagrations were sweeping down upon it.*

London didn't just observe the destructiveness of the fires. He described an episode when he saw a man at Union Square who had a truck loaded with trunks taken from a hotel for safekeeping, but now the fires surrounded the square on three sides. London urged the man to get away. "He was all but hemmed in by several conflagrations," he wrote. "He was an old man and he was on crutches....I convinced him of his danger and started him limping on his way. An hour later, from a distance, I saw the truck-load of trunks burning merrily in the middle of the street."

The courage of San Francisco's residents impressed London:

> *Before the flames, throughout the night, fled tens of thousands of homeless ones. Some were wrapped in blankets. Others carried bundles of bedding and dear household treasures. Sometimes a whole family was harnessed to a carriage or delivery wagon that was weighted down with their possessions. Baby buggies, toy wagons, and go-carts were used as trucks, while every other person was dragging a trunk. Yet everybody was gracious. The most perfect courtesy obtained. Never in all San Francisco's history, were her people so kind and courteous as on this night of terror.*

But London also saw some luggage, clothing and personal belongings dumped onto streets as people tried to escape the fires. However, San Francisco is a city of steep hills, and men and women dragging trunks became exhausted. London noted that soldiers were under orders to keep everyone moving, even those people too tired to drag their trunks. "The exhausted creatures, stirred on by the menace of bayonets, would arise and struggle up the steep pavement, pausing from weakness every five or ten

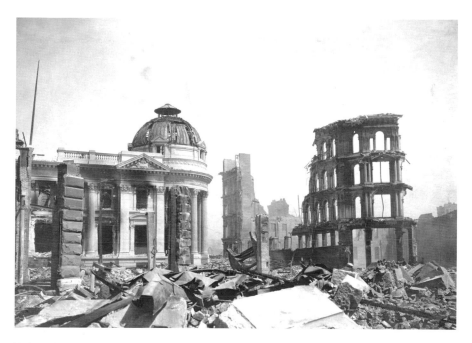

Ruins of the Hibernia Bank building as a result of the San Francisco earthquake and fire. *Courtesy U.S. Geological Survey.*

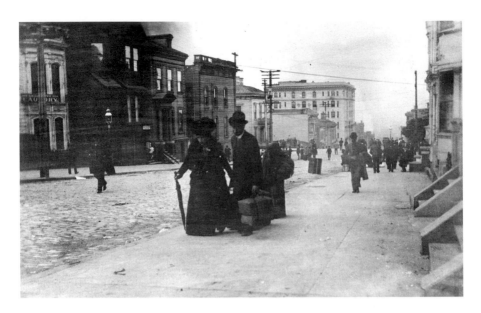

People pulling trunks along a San Francisco street following the 1906 earthquake and fire. *Courtesy U.S. Geological Survey.*

feet." Getting to the top of the hill, they found yet more flames heading toward them, necessitating more effort. "In the end, completely played out, after toiling for a dozen hours like giants, thousands of them were compelled to abandon their trunks," wrote London. He also noted that working-class men buried their trunks in vacant lots and backyards rather than undertaking the futile task of dragging them up and down hills.

On the second day, London walked past what was left of the city hall, which had been greatly damaged by the quake. "Market Street was piled high with the wreckage, and across the wreckage lay the overthrown pillars of the City Hall shattered into short crosswise sections." A later investigation would reveal that the pillars had been constructed with inferior materials at a greatly inflated cost, an egregious example of municipal corruption.

Mission Street revealed a dozen dead steers killed in the earthquake and roasted by the fire. "At another place on Mission Street I saw a milk wagon. A steel telegraph pole had smacked down sheer through the driver's seat and crushed the front wheels. The milk cans lay scattered around." The fires raged on through Thursday and into Friday, the flames sweeping through Russian Hill, Telegraph Hill and a large part of the city's wharves and docks.

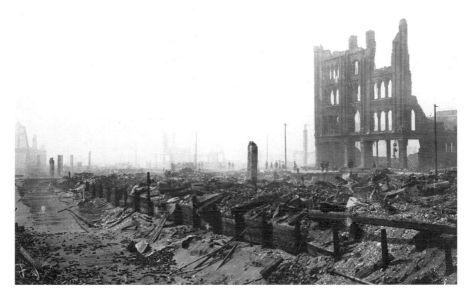

View south from Fourth and Market Streets, showing results of the fire following the San Francisco earthquake. *Courtesy U.S. Geological Survey.*

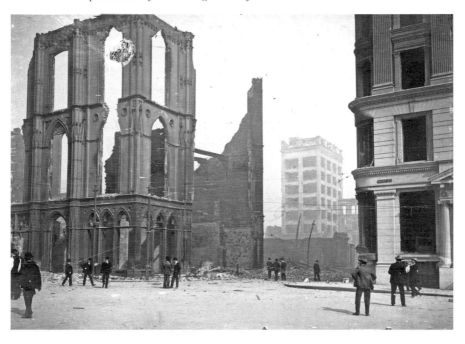

Looking down Montgomery Street from the corner of Market Street at earthquake and fire-wrecked buildings in 1906. *Courtesy U.S. Geological Survey.*

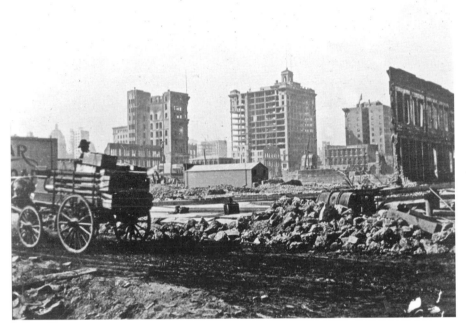

View showing massive damage to San Francisco as a result of the 1906 earthquake and fire. *Courtesy U.S. Geological Survey.*

London concluded his article by assessing the situation and offering some cautious optimism for recovery. "San Francisco, at the present time, is like the crater of a volcano, around which are camped tens of thousands of refugees," he wrote. "All the surrounding cities and towns are jammed with the homeless ones, where they are being cared for by the relief committees." London noted that the railroads were taking refugees wherever they wanted to go, free of charge, and he estimated that more than 100,000 people had left San Francisco. London believed that "the Government," by which he likely meant San Francisco's officials, as well as relief efforts coming from all over the United States, were providing food for the refugees. He ended his report with an interesting observation about the city's future: "The bankers and businessmen have already set about making preparations to rebuild San Francisco."

London's *Collier's* article is important in that he wrote about what he had seen for himself, with no need to exaggerate the dimensions of the

catastrophe that had struck the Bay Area. A similar report was written by Trumbull White, an author and journalist who contributed a section of the book *Complete Story of the San Francisco Horror, 1906, by the Survivors and Rescuers*, edited by Richard Linthicum and published shortly after the San Francisco earthquake (available online in numerous editions). White's chapter, "Complete Story of the San Francisco Horror Scenes of Death and Destruction," described the author's journey into the darkness of the earthquake and fire. As with Jack London's work, White interviewed numerous survivors, and his chapter included many photographs showing the extent of the catastrophe. One of the refugee accounts, cited by White, came from W.W. Overton, who described the destruction of the city's Chinatown: "The fire swept the Mongolian section clean. It left no shred of the painted wooden fabric. It ate down to the bare ground and this lies stark, for the breezes have taken away the light ashes. Joss houses and mission schools, grocery stores and opium dens, gambling halls and theaters—all of that went."

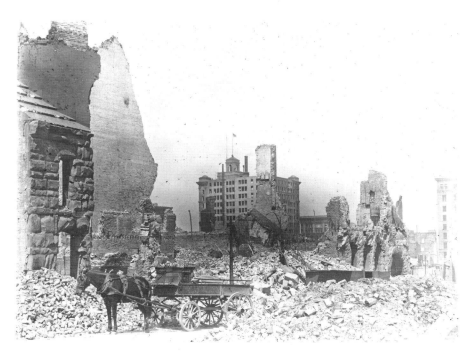

View of California Hotel (*center*) along with nearby buildings damaged and destroyed in the 1906 San Francisco earthquake and fire. *Courtesy U.S. Geological Survey.*

White's prose was more purple than London's eyewitness comments:

> *Where on the morning of April 18, 1906, stood a city of magnificent splendor, wealthier and more prosperous than Tyre and Sidon of antiquity, enriched by the mines of Ophir, there lay but a scene of desolation. The proud and beautiful city had been shorn of its manifest glories, its palaces and vast commercial emporiums leveled to the earth and its wide area of homes, where dwelt a happy and a prosperous people, lay prostrate in thin ashes.*

Flowery language notwithstanding, Wright's chapter consists mainly of survivors telling their stories in some length and detail, making it a valuable compendium that, like London's article, informs and shocks readers a century later.

Refugees fled the city by whatever means possible, thousands boarding ferries and boats that took them across San Francisco Bay to seek shelter in the East Bay cities. Others headed south, climbing nearby hills to witness the destructiveness of the fires. Panicked by the quake and the impending firestorms, many told tales that were often exaggerated and inaccurate, making it difficult for newspaper reporters and editors to distinguish fact from fiction. Rumors spread of large-scale looting, rape and huge cracks in the earth into which people fell into a bottomless abyss.

If anything, some newspapers underestimated the extent of the disaster. The *Los Angeles Times* on Thursday, April 19, reported fifty thousand homeless; that number would greatly increase. The *Times* admitted, "It will be impossible to send full details for several days," and that as of 10:00 p.m. on Wednesday night, "the newspapers ceased all effort to collect news, and the Associated Press force is compelled to act independently." In contradiction to the famous axiom, no news would *not* necessarily be good news. Reporters covering the story were on their own in getting to a place where they could get their stories to the newspapers.

Charles Morris (not to be confused with Artillery Corps colonel Charles R. Morris, who fought the fires) was a newspaperman who wrote an account of the earthquake and fire and published it within a few weeks after the disaster. *The San Francisco Calamity by Earthquake and Fire* has been reprinted numerous times by different publishers under varying titles. An eccentric volume that includes his own observations, accounts by eyewitnesses, stories (accurate or not), exaggerations and false tales of death and destruction, it continues to attract uncritical readers.

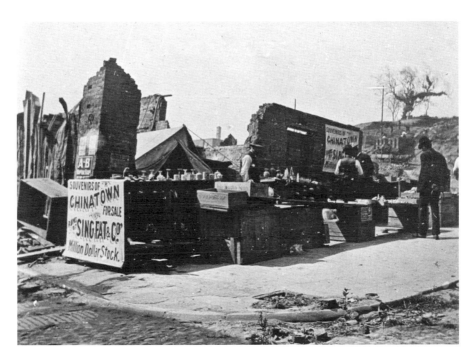

Remains of Chinatown after the 1906 San Francisco earthquake and fire. *Courtesy U.S. Geological Survey.*

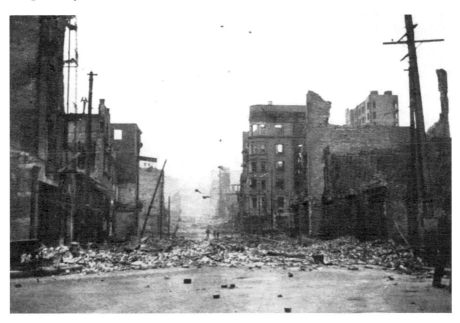

San Francisco in ruins. *Courtesy U.S. Geological Survey.*

Typical tales in Morris's book include a man chewing off the ears of a dead woman to steal her earrings, a woman pushing an upright piano, inches at a time, and three men atop a burning building who were shot by troopers to spare them the painful death of being burned alive, an act witnessed by five thousand people. None of these incidents occurred.

Simon Winchester, in his book *A Crack in the Edge of the World: America and the Great California Earthquake of 1906*, writes of Morris's book, "Is there any truth to these stories—to the tale of the earrings, or of the sad lady with her pianoforte, or the assassinated men plunging from the top of a burning hotel? Almost certainly not, say today's more clinically attached historians." Winchester warns readers to stay away from books about the earthquake and fire that focus on sensational and improbable stories, asserting they would "be well advised to choose rather carefully, and to bear in mind that, in the light of the peculiarly flexible and liberal flamboyance that has long been associated with literary San Francisco and its most notable tragedy, one piece of advice rules: *caveat lector.*"

In San Francisco itself, the *Daily News* succeeded in putting out an issue, hours after the earthquake struck. The headline trumpeted, "HUNDREDS DEAD! Fire Follows Earthquake, Laying Downtown Section in Ruins— City Seems Doomed for Lack of Water." The paper included a list of known dead and injured, but its production was a makeshift effort, only a single sheet. The earthquake knocked out the paper's electricity and power at the paper's printing plant at 1308 Mission Street. Printers used a hand-cranked press to print the single-sheet newspaper, running new editions until everyone at the plant was ordered to leave the building. Soldiers were about to dynamite it in what turned out to be a futile effort to fight the flames.

Why were the fires so intense that winds blew them up into firestorms that destroyed so much of the city? The answer may be found in the city's history of repeated fire incidents and the failure of officials to implement building standards and develop a modern system of fire prevention. The great majority of the city's buildings, such as boardinghouses, residences and commercial buildings, were of wood construction, and narrow streets impeded efforts of firefighters. Fires broke out almost immediately after the initial shock, and as noted above, water mains were broken, rendering the fire department helpless to fight the fires.

The solution for fighting the fires became the most controversial action in the disaster. Major General Adolphus Greely, commander of the U.S. Army's Pacific Division, stationed at the Presidio, had left on leave a few

days before the earthquake. Brigadier General Frederick Funston became the acting commander of the division. A man of action, Funston lost no time in calling out all available army soldiers. "I marched the troops into the city," he later stated, "to aid the municipal authorities and not to supersede them."

The unintended consequence of this decision would be the widespread belief that martial law had been declared. Soldiers carrying rifles patrolled the city, dissuading (and occasionally shooting) suspected looters and ordering civilians to clean up debris, their rifles their ultimate authority. In point of fact, no declaration of martial law was ever made, but city residents generally believed such law was in effect. The city newspapers *Call*, *Examiner* and *Chronicle* combined to put out a joint edition and, on April 19, printed on the front page a statement that President Theodore Roosevelt had issued a message putting the city under martial law. Another story in the paper claimed that Mayor Eugene Schmitz and police chief Jeremiah Dinan had made a similar declaration.

Historian Philip Fradkin declared in his book *The Great Earthquake and Firestorms of 1906* that "Roosevelt sent no such message, the mayor and the police chief made no such proclamation, and Governor George C. Pardee did not request that martial law be declared." The governor did have the authority to order the National Guard to patrol the streets of San Francisco as well as Santa Rosa, Oakland and San Jose, where the quake had caused serious damage, and he did this. Pardee noted that while federal troops had no right to be there, he nonetheless approved of the fact that they were. Misinformation about the so-called martial law decision traveled as far as the *New York Times* and the Hearst papers.

Ironically, Mayor Schmitz, whom the district attorney would indict for corruption in office after the fires had burned down, took strong action against suspected looters:

PROCLAMATION BY THE MAYOR

> *The Federal Troops, the members of the Regular Police Force and all Special Police officers have been authorized by me to KILL any and all persons found engaged in Looting or in the Commission of Any Other Crime.*
>
> *I have directed all the Gas and Electric Lighting Co.'s not to turn on Gas or Electricity until I order them to do so. You may therefore expect the city to remain in darkness for an indefinite time.*

I request all citizens to remain at home from darkness until daylight every night until order is restored.

I WARN all Citizens of the danger of fire from Damaged or Destroyed Chimneys, Broken or Leaking Gas Pipes or Fixtures, or any like cause.

E.E. Schmitz, Mayor
Dated April 18, 1906

Many San Francisco residents resented the draconic message as unnecessary, if not downright threatening. To be sure, as historian Brian Dillon has shown, "[D]runks, toughs, and criminals had a field day, preying upon the innocent and looting abandoned houses and businesses, especially saloons, with virtual impunity." To deal with disorder, no less than six different government organizations worked more or less (often less) together: the San Francisco Police Department, regular U.S. Army troops under General Funston, U.S. Marines and U.S. Navy personnel (with Funston as their commander), the California National Guard (which was neither requested nor desired by Schmitz or Funston but mobilized by Governor Pardee) and, most controversial of all, the "Citizens Guard," basically a vigilante group that Schmitz deputized.

The National Guardsmen, organized as recently as 1903, had little training in dealing with emergencies or, in the case of San Francisco, major catastrophes. General Greely would later complain that the guards' inexperience "caused them to occasionally ignore municipal authority." Guard officers refused to take orders from police and regular army officers, claiming they took their orders only from Governor Pardee, though some did accept the authority of regular army officers. Jurisdictional confusion was not helped by Pardee's refusal to cooperate with Funston or Schmitz in the efforts to deal with the inferno. Brian Dillon concludes, "This was a recipe not just for confusion, but also, and inevitably, for confrontations between different bodies of armed men working under separate and antagonistic chains of command."

The worst performance, however, came from the Citizens Guard. Whereas the training of the National Guard was minimal, it was nonexistent for the Citizens Guard. Its members seemed more concerned with protecting their own or their employers' businesses, and they refused to acknowledge the authority of anyone other than Mayor Schmitz.

One result from this jurisdictional competition was the shooting not only of suspected looters but also innocent people. Such acts were often blamed

on "soldiers," as bystanders confused National Guardsmen with regular army troops. Later investigations concluded that blame lay entirely on the National Guard.

In order to fight the fires, the city's fire department needed water, and the fire hydrants could not supply water from broken mains; the few hydrants that still functioned were covered in rubble. Tragically, fire chief Dennis Sullivan was killed when the initial shock hit. Two high-ranking subordinates, Patrick Shaughnessy and John Dougherty, reported to Mayor Schmitz for duty. Dougherty was due for retirement; Shaughnessy was a younger man. Schmitz selected Dougherty to replace Sullivan, an unwise decision, as Dougherty was too old and lacked the necessary leadership ability to meet the crisis. Moreover, Schmitz micromanaged any plans for fighting the fires, and even Boss Ruef got involved. Firemen didn't know which contradictory orders to follow, and the firestorms raged on.

Without water, how to battle the fires? Long before 1906, Chief Sullivan had recommended using dynamite to create firebreaks in order to prevent fires from spreading. But Sullivan was dead, and in his absence, there wasn't an experienced leader to deal with the challenge. Brian Dillon found no less than "sixteen demolition squads acting independently of each other at different places and times." Among the explosives used to fight the fires were black powder (which did more harm than good, making small fires instead of extinguishing a large one) and stick dynamite, used widely in fighting the fires. Patrick Shaughnessy later stated that stick dynamite "was used with splendid results as there was no combustion and the buildings were leveled without danger."

Among the many squads using explosives to fight the fires were the U.S. Army, the U.S. Navy, the California National Guard, the San Francisco Fire Department and at least three civilian demolition squads. None of these squads operated in a unified manner. The total number of men in these squads amounted to about one hundred, working in small units of about six men each. Coast Artillery sergeant William T. Dillon, who fought the fires, was Brian Dillon's grandfather.

Procuring dynamite in large quantities posed a problem. For example, a tugboat going to obtain dynamite from the companies manufacturing the explosive had to cross the bay to Pinole Point and return, a round trip that could take up to five hours. At least one supply of dynamite came from Boss Abraham Ruef, who provided it to a squad needing it to create a firebreak. Ruef's apparent altruism likely came from a desire to protect his own property interests in that part of the city. Ruef became a bit too enthusiastic

when he took a hose from a hose cart and said "he would save North Beach." He yielded the hose to the squad leader, Lieutenant Frederick N. Freeman, who took it from him—at gunpoint.

The strategy involved in creating firebreaks called for dynamiting buildings that were near the approaching flames. This could be a tricky business, with at least four major firestorms advancing through the city. Modern buildings that had withstood the earthquake fell victim to the flames. The dynamite squads blew up endangered buildings to create the firebreaks to stop the fires. But which buildings were to be sacrificed became a contentious argument among conflicting lines of authority. A fire department official approving the demolition of a building might have Ruef or Schmitz overrule the decision. Such delays resulted in waiting too long to blow up a building, and the flames raced over and past the rubble.

In one case, Mayor Schmitz ordered John Bermingham, superintendent of the California Powder Works, to assist U.S. Army captain Le Vert Coleman, offering the dynamite made at the factory where he was employed. Coleman rejected Bermingham's assistance because "he was so far under the influence of liquor as to be of no service, and, lest he should in that condition cause serious accident, I sent him away."

Meanwhile, Lieutenant Raymond W. Briggs was ordered to use granulated (not stick) dynamite to blow up a building. Briggs knew that dynamite in that form would not only bring down a building, it would also set the building on fire, thereby doing nothing to stop the approaching flames. Compelled by city bureaucrats to use the dynamite anyway, he had two buildings blown up, but "in the second, which had been a cheap lodging house, bits of bed clothing, etc., which had become ignited by the fire, were thrown across Kearny [Street] to the west side, and soon that block was on fire."

The bedding set the buildings on the opposite side of the street on fire, resulting in the entire destruction of Chinatown. The bureaucrats behind this disaster were likely Schmitz and Ruef. Brian Dillon conjectured that "if Abe Ruef was still with Briggs's dynamite squad, then doubles as the Mayor's temporary mouthpiece and full-time legal counsel and puppeteer, it would have been him." Dillon concedes the possibility that the order might have come from Brigg's superior officer acting under orders from Schmitz or Ruef. In any event, Briggs recalled, "The far side of the street was quickly aflame and Chinatown was doomed. It was a tinderbox wooden city."

If the Chinese were to lose their area of San Francisco, so did some of the city's richest citizens. Their mansions on Nob Hill largely escaped earthquake damage, but as the firestorms roared across the city, orders

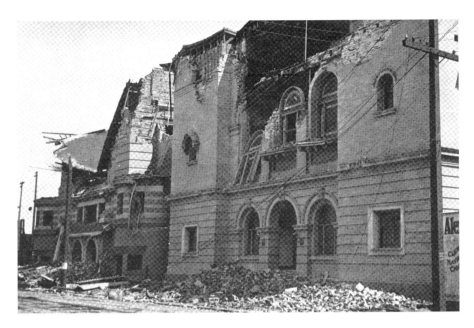

Postcard showing the ruins of the Scottish Rite Temple after the San Francisco earthquake and fire. *Author's collection.*

were given to evacuate the mansions so they could be dynamited as firebreaks. In some cases, the homeowners had little time to take personal belongs with them, even though hours passed before their homes were blown up. Such luminaries as Charles Crocker and Mark Hopkins had built their homes on Nob Hill. Though long since dead, their descendants survived the quake only to see their homes sacrificed to the efforts to stop the flames.

By April 20, the fires had pretty much burned out, with no more fuel to keep the flames going. Now came what likely was Mayor Schmitz's finest hour— or at least moment—in his political career. He organized a Committee of 50, with many subcommittees to supervise relief work, and a Committee of 40 for San Francisco's reconstruction. The subcommittees included Relief of the Hungry, Housing the Homeless, Relief of the Chinese, Restoration of Water, Resumption of Retail Trade and others. The Committee of 50 issued orders prohibiting the use of indoor toilets until sewage lines were restored. Garbage was collected by wagons, placed on scows and towed out into the ocean, where it was deposited. San Franciscans were told to boil all water for drinking purposes. These measures minimized the danger of disease. The Army Medical Corps did much to restore hygienic conditions.

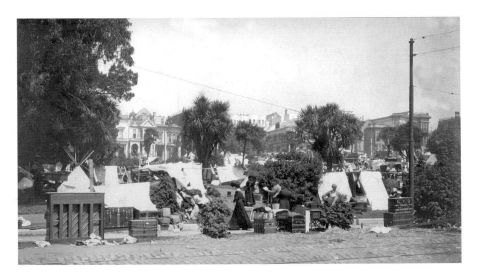

Refugees at Jefferson Square in San Francisco after the earthquake and fire. *Courtesy U.S. Geological Survey.*

Under the Committee of 50, bakers produced bread, stores provided clothing and businesses in general brought a sense of optimism that the city could be restored to its status as the Pacific coast's preeminent city. For the less optimistic, the Southern Pacific gave free transportation to anyone wanting to leave the Bay Area and go out of the state. Some 100,000 people took advantage of the offer.

The belief that San Francisco was under martial law persuaded survivors to obey army and police orders for civilians to aid in cleaning up the streets, a task that usually meant piling up bricks and shoveling dirt. Soldiers conscripted men who might be standing around to join work crews. The work of the Food Committee serves as an example of how quickly the city organized relief aid. Rabbi Jacob Voorsanger, spiritual leader of Congregation Emanu-El, served as chairman of the committee. He recalled:

> *I was the biggest thief in the United States. I commandeered store after store, with a police officer's badge on my clerical coat, and the Mayor's authorization in my pocket. I emptied grocery stores, drug stores, butcher shops, hardware establishments and at four o'clock that great and glorious day [Saturday], I was able to report to the Mayor that the people were fed and that to the best of my knowledge there was not a hungry soul in San Francisco. I vow solemnly state this to be the truth, and it was one of the glories of our calamity.*

Recovery began almost immediately. Isaias W. Hellman, president of Wells Fargo Bank, cautioned fellow bankers to wait until safes cooled down, as spontaneous combustion might destroy valuable documents when the doors were opened. Insurance companies set up offices in tents to handle claims for fire losses. (Earthquakes weren't covered.) Just ten days after the fires died down, streetcar transportation resumed, the rails having been repaired. City planners agreed to repair buildings whose basic structures had survived earthquake and fire, but they missed an opportunity to design a new San Francisco, preferring to rebuild as soon as possible. Within two years, all traces of the earthquake and fire were gone.

Civic leaders were determined to minimize the destruction the earthquake had caused and focused on the fire as the city's major disaster. After all, San Francisco had burned numerous times in the past, only to rebuild and quickly recover. James D. Phelan, former mayor of San Francisco and future U.S. senator from California, summed up the city's

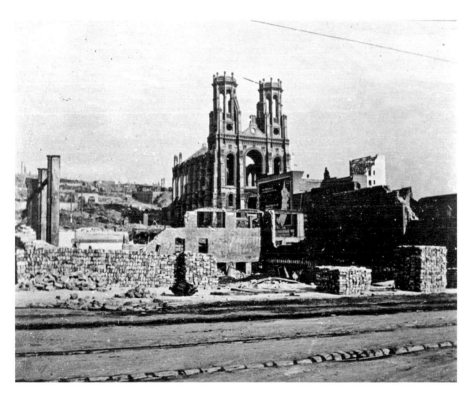

Damage to Congregation Emanu-El as a result of the 1906 San Francisco earthquake and fire. *Courtesy U.S. Geological Survey.*

future with considerable hyperbole: "The burning of San Francisco, caused indirectly by earthquake shock, was merely a tragedy which will subsequently serve to make the history of California interesting." He also said he expected "to see the San Francisco of the future a far greater and more beautiful city than the San Francisco of the last fifty years." Curiously, Phelan happened to own three warehouses built of brick in the city; all three were destroyed by the earthquake, not the fire.

San Francisco businessmen realized that emphasizing the fire would be more beneficial to future investment in the city than reminding people that an earthquake had occurred there—hence the stress on the fire, "caused indirectly by earthquake shock," as Phelan put it. However, when it came to rebuilding the city, businessmen minimized the quake and almost erased it from history, emphasizing the fire. In doing so, they also failed to enact strict building codes, constructing new buildings that essentially replicated the old ones that had been destroyed, ignoring the fact that it was the earthquake that had caused the fire and taking the view, however incorrect, that having had such a major earthquake the Bay Area—like what is said about lightning—

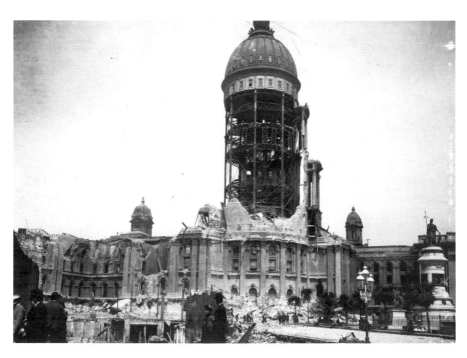

Serious damage to the San Francisco City Hall caused by the 1906 earthquake and fire. *Courtesy U.S. Geological Survey.*

another quake would not strike again in the same place. They believed this in spite of the fact that significant earthquakes had occurred in 1865 and 1868—and would indeed strike again in 1989.

It also turned out that the earthquake and fire, in destroying city hall, inadvertently benefited the city's Chinese community. Chinatown was gone, but the Chinese remained and would rebuild the neighborhood and help make the city a tourist destination. Coping with segregated schools, compelled to live in a segregated environment, denied American citizenship, Chinese lived a marginal existence in the city. However, with records destroyed, many Chinese residents could claim they were American citizens. Since the Chinese Exclusion Act had been passed by Congress in 1882 and periodically renewed, no Chinese could come to the United States. But in San Francisco in 1906, Chinese could say they were born in the United States and were citizens under the Fourteenth Amendment to the Constitution. Under this necessary subterfuge, they had the rights previously denied them.

Although called the San Francisco earthquake, the quake caused damage in a much wider region. More than one hundred people died in Santa Rosa, north of San Francisco, and the quake leveled its central district. Nineteen were killed in San Jose to the south. Stanford University in Palo Alto, its campus buildings only fifteen years old, suffered considerable damage. The quake also caused damage in such communities as Salinas, Hollister, Burlingame and Gilroy, and it was felt as far south as San Luis Obispo.

The year 1914 marked the completion of the Panama Canal, an achievement that took some eight thousand miles off the passage of ships sailing from the Atlantic to the Pacific. On the Pacific coast, two major seaports made plans to celebrate the accomplishment: San Diego and San Francisco. Los Angeles didn't plan a party—construction of the breakwater and port facilities there were still a work in progress.

For San Francisco, the event provided the opportunity to let the world know that the City by the Bay had emerged triumphant from the earthquake and fire that had destroyed much of the city almost a decade earlier. Called the Panama-Pacific International Exposition, it was a world's fair that had been in the planning for four years. On February 20, 1915, the expo opened to tourists with attractions from many states and twenty-three nations. The

city's residents, rich and poor alike, were invited to join in a parade, to announce to the world that San Francisco was back in business.

As the decades passed, San Franciscans estimated the number of dead from the catastrophe as officially 400. This figure was considered absurdly low by Gladys Hansen, director of the Virtual Museum of San Francisco, who spent decades compiling a more accurate count by combing contemporary records that gave the names of those who had actually died. Her research, eventually published in 1989 as *Denial of Disaster: The Untold Story and Photographs of the San Francisco Earthquake and Fire*, counted an indisputable 3,500 dead, a number that Hansen considers still incomplete. The number of Chinese and other minorities was significantly underreported.

Traumatic as it was, some survivors would live long enough to experience another severe San Francisco earthquake, this time in 1989 (see chapter 11). The last survivor of the 1906 earthquake, William Del Monte, died in January 2016 at age 109.

6
THE 1925 SANTA BARBARA EARTHQUAKE

O f the twenty-one California missions, the Santa Barbara Mission church is often considered the most architecturally beautiful one, its two bell towers making it distinct from the other twenty missions.

On Monday, June 29, 1925, that distinction was lost when a 6.8 magnitude earthquake hit offshore, severely damaging the city of Santa Barbara's downtown business district, including toppling one of the church's bell towers. Property damage ran to $8 million (1925 dollars), and thirteen people were killed.

A foreshock at 3:27 a.m. that morning jarred a thermometer at the Southern Counties Gas Company and briefly affected oil pressure gauges at the city's water works. However, this tremor wasn't strong enough to awaken the town's sleeping residents. The major quake at 6:43 a.m. lasted nineteen seconds, with four strong aftershocks coming in the next twenty minutes.

Residents as far north as Paso Robles in San Luis Obispo County felt the quake and as far south as Santa Ana in Orange County and east to the Mojave Desert.

The city's commercial area suffered the most damage, but people's homes fortunately survived the quake. Buildings constructed on landfills collapsed, while those on firm ground held up well. Three factors enabled the city to recover quickly from the earthquake. First, when the shock hit at 6:43 a.m., few people were downtown at work. Had it occurred several hours later, the injury and casualty rate would have been much higher, since office and public buildings sustained the worst damage. Second, unlike the 1906

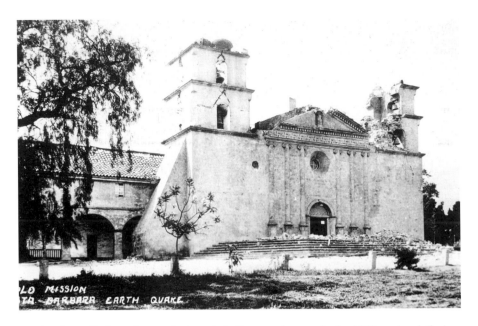

Mission Santa Barbara, known for its twin bell towers, lost one in the 1925 quake. *Author's collection.*

San Francisco earthquake or the more recent 1923 Tokyo quake (in which some 130,000 people died), no fires broke out. This made the Santa Barbara quake a "pure" earthquake in which seismologists and other investigators could examine why some buildings were damaged more than others. Third, public officials quickly organized for the rescue of people trapped, a force that combined local police, American Legion veterans and army and naval personnel to assist people and guard against looting. Electricity and gas would be restored as soon as possible.

Police chief Lester Desgrandchamp had 25 men on the police force, plus 20 reserve officers. The American Legion added another 100 men who helped clear debris and search for victims. Some 80 more men came from the Santa Barbara Naval Reserve, and Desgrandchamp commissioned another 150 volunteers, creating a home guard of almost 400 men.

Santa Barbara officials and city employees merit credit for their quick response to the earthquake. Besides Chief Desgrandchamp establishing an organized force to keep order and help rescue victims, the Red Cross set up a station to distribute water, coffee and doughnuts to the rescue workers. Tents were set up at De La Guerra Plaza to serve as a command center. The Red Cross, Santa Barbara police, chamber of commerce and other businesses

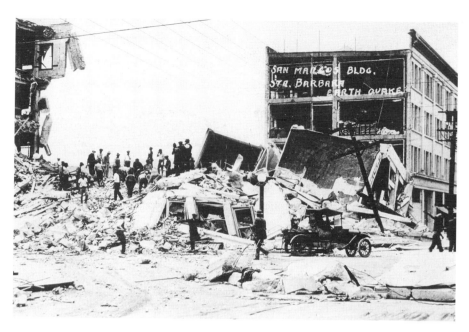

Business buildings destroyed in the 1925 Santa Barbara earthquake. *Author's collection.*

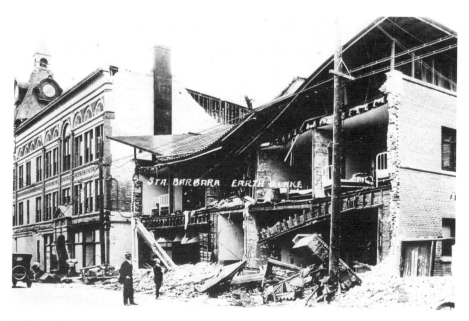

Building in downtown Santa Barbara destroyed by the 1925 quake. *Author's collection.*

and organizations also had tents. Boy Scouts carried messages and brought food and drink to the workers.

When the earthquake struck, Southern California Edison Company's powerhouse night operator, William Engle, risked his life in turning off all the power switches as the building collapsed around him. At the Southern California Gas Company, night engineer Henry Ketz turned off the main emergency valve. William Pfleging, an engineer in the same building, shut off the gas valves to the city. In doing so, these men prevented fires from breaking out.

The earthquake cut off telegraph and telephone communication. Without electricity, radios were inoperative. Two young men "borrowed" a battery-operated radio from a store, created an antenna and listened to radio broadcasts from Los Angeles, where there was no news about the earthquake. They then rigged a broadcast radio and sent an SOS message that a passing ship received, passing the message to the *Peacock*, a salvage tug. By 2:00 p.m., the tug was docked at Stearns Wharf and providing improved radio contact. Mayor Charles M. Andres sent out a radio message: "Santa Barbara suffered from severe earthquake shock that started at 6:40 a.m. and lasted intermittently for about two hours. The principal damage is State Street, the main business street, where almost every business block is damaged. There is probably loss of life, but small."

Office buildings and hotels in the downtown area collapsed. The worst was the San Marcos Building, in which an orthodontist and the building's maintenance engineer were killed. Other guests and hotel staff escaped unharmed. The Arlington Hotel covered an entire city block, with a mission-style tower—and a fifty-thousand-gallon water tank. The tower collapsed, killing two people. Rescuers working through the rubble heard a woman's voice. Macaria Vilamore, who worked as a janitor in the building, was alive, though a beam pinned her leg. It took more than six hours to dig her out, but she survived. Most of the building survived the earthquake, but it was demolished in 1931 to be replaced by a movie theater.

The earthquake destroyed the Unitarian church and seriously damaged the Congregational and Episcopal churches. With the telephone exchange building destroyed, few phone lines were in operation. Santa Barbara's Daily Press building didn't seem damaged, but publisher Thomas M. Storke decided to use a hand press to put out a smaller-sized edition, locating the press in the De La Guerra Plaza. The First National Bank Building, constructed in 1875, was so badly damaged it had to be razed. Meanwhile,

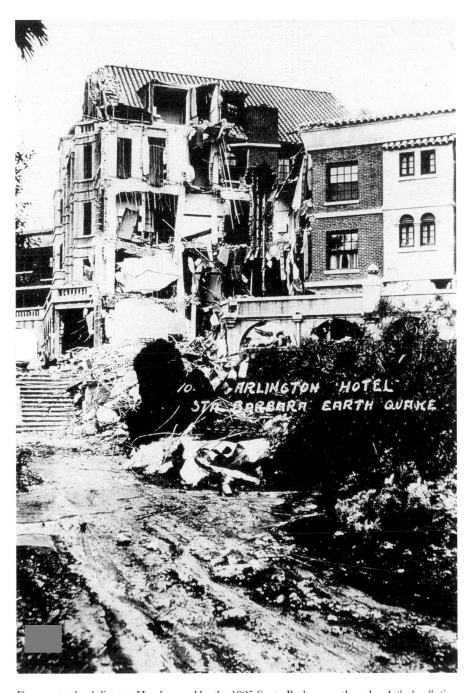

Damage to the Arlington Hotel caused by the 1925 Santa Barbara earthquake. *Author's collection.*

aftershocks continued to rattle nerves; three occurred during the early morning hours on June 30.

Offers of help soon came from other areas. Los Angeles sent 123 police officers to aid in patrolling the streets and dispatched fire trucks in case such equipment was needed. Most significantly, President Calvin Coolidge ordered Secretary of the Navy Curtis D. Wilbur to send the battleship USS *Arkansas*, which arrived at 3:45 a.m. Tuesday morning. From the ship came 180 sailors plus medical men to relieve the exhausted people who had been at work since the quake hit the city. The respite gave workers enough time to rest, and by 9:00 a.m., most of the sailors returned to the ship.

Men clearing rubble found some bodies buried in the debris. Eventually, thirteen bodies were found, with survivors all accounted for. Santa Barbarans continued the routine of business activity through "offices" in the tent city.

The *Arkansas* had provided a radio and receiving set for communications, allowing news rather than rumors to go to the outside world. Still, people wanted to come to Santa Barbara to view the wreckage. More than one thousand people in their cars were blocked at the Ventura County line, but the cleanup on State Street was so successful in clearing away debris that business leader Charley Pressley asked that the road be opened, surmising that visitors could be good for business, even if they had come to see the destruction.

While the clearing of the streets of debris continued, as well as searches for any other victims or trapped survivors, civic and business leaders met to plan for the city's rebuilding. It was noted that certain buildings had survived the quake and the aftershocks with little or no damage. What did these buildings have in common? They were built in the Spanish Colonial Revival style. An architectural advisory committee and an architectural board of review were created. Downtown Santa Barbara was rebuilt with a culturally distinctive style that evoked an image of Spanish California, a task undertaken by the Santa Barbara Community Arts Association. Noted architects would design the new building façades.

The quick action taken by the city's civic and business leaders and police force greatly facilitated Santa Barbara's recovery. Almost no looting occurred. By the third day, telephones were again working and electricity was restored. From Los Angeles came buses to provide public transportation, and electric streetcars were running again two weeks after the quake. Teams of engineers inspected buildings to determine whether they could be repaired or should be demolished.

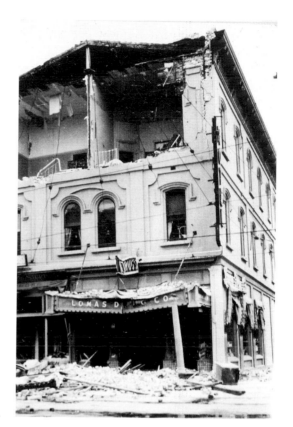

Right: Serious damage to the Lomas Drug Company building, caused by the 1925 Santa Barbara earthquake. *Author's collection*.

Below: Destruction of the Potter Theatre due to the 1925 Santa Barbara earthquake. *Author's collection*.

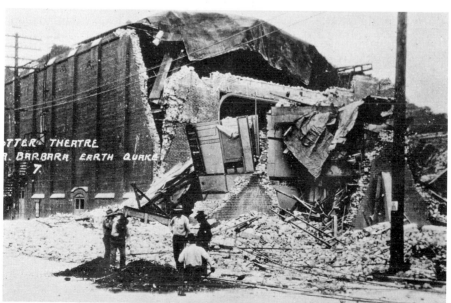

Two reservoirs provided water to the city of Santa Barbara. Located close to the city, the Sheffield Dam, only eight years old, failed during the quake. Thirty million gallons of water poured through part of the city, knocking down trees and destroying some houses and automobiles. Two feet of water covered the western end of the city until it drained away. Luckily, the flood caused no casualties.

Santa Barbara recovered and rebuilt quickly. The fatalities and injuries were small in number, and the more than 264 aftershocks that occurred over the next few months were more annoying than destructive.

Two years later, on November 4, 1927, a massive earthquake estimated at magnitude 7.1 struck offshore near Lompoc, some sixty miles northwest of Santa Barbara. This earthquake caused a tsunami (a seismic sea wave), knocked down chimneys at nearby towns and threw a railroad bridge out of alignment. Fortunately, no one was killed, and injuries were minor. Aftershocks in the area continued for almost a year.

7
THE 1933 LONG BEACH EARTHQUAKE

The Long Beach earthquake of March 10, 1933, was the worst one to hit California since the 1906 San Francisco quake. Although Santa Barbara's 6.8 was a greater magnitude than Long Beach's 6.4, the Long Beach quake caused the death of 120 people and an estimated $40 to $50 million in damages. It was felt not only in Long Beach but also in nearby Compton and Los Angeles. Additionally, communities as far north as Barstow and south to San Diego felt the jolt, and people even experienced it in Owens Valley and in Baja California. The day before the quake there was a foreshock, and in the weeks that followed the quake, many aftershocks strained already frazzled nerves. Minor aftershocks went on for several years.

The quake hit at 5:54 p.m., a time when people were going home from work and families were gathering for their evening meal. When people panicked and ran out of the shaking buildings and houses, falling debris hit and killed or injured many of them. The quake lasted between twenty and forty-three seconds, the difference in time measured by one's closeness to the epicenter.

Jerome Selmer was only two months old when the earthquake struck, but he grew up hearing the stories told by his parents and grandparents:

> *My parents and I lived in Huntington Park at the time. My father told me that the chimney on the house fell down. He took my mother and me over to stay with my grandparents in Boyle Heights (in east Los Angeles, where the quake was also felt). My grandfather came back with my father and*

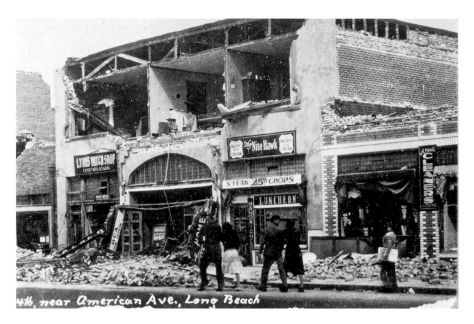

Business buildings damaged on Fourth Street near American Avenue in Long Beach as a result of the 1933 earthquake. *Author's collection.*

the two of them spent the rest of the night sitting on the front lawn. All the neighbors were doing the same thing. He said that he and my grandfather counted upwards of 130 aftershocks that night.

Baby Selmer and his mother didn't return to their home until two days later. Several weeks later, the Selmers had the chimney rebuilt.

Orange County, adjacent to Los Angeles County, also felt the power of the earthquake. George Leichtfuss, a telegraph operator at the Santa Fe Railroad depot in the city of Orange, was at work when he felt the jolt. "I heard a roar and the earth really trembled and so did I," he recalled. He ran outside but returned to the building when the shaking ended. The Western Union offices in Santa Ana and Long Beach were destroyed, leaving Leichtfuss as the sole means of sending telegrams to relatives and friends concerned over the fate of people affected by the quake. "I handled close to 900 telegrams that night," he recalled.

Two months after the earthquake, Marion A. Speer, a petroleum engineer, addressed the Orange County Historical Society about the event. "All of you who went through the nerve racking experience of being bounced around and shoved about, against your will, on the

evening of March 10, 1933, will readily testify," he said. Speer recited the casualties in the region. "A man was shaken from a wind mill and lost his life. He was oiling the mechanism at the time the first shock came. A two-year-old baby was thrown from its high chair and died as a result. Two elderly women died, one from exposure and the other from fright. Two deaths occurred in Santa Ana; both were caused by falling bricks." Three more people in Garden Grove died, also from falling bricks, as did one in Los Alamitos and two in Seal Beach.

"It will be seen from these reports that falling bricks was the principal cause of these deaths," said Speer. "We can and must do away with this known hazard." He urged the state legislature to create a strict building code, but up to that time, no law had been passed. "Necessity and public demand will create such a safety code."

Speer's account demonstrates that the Long Beach earthquake's damage was not limited to its city's limits. Within Long Beach itself, however, the destruction and fatalities were much more severe. Students from St. John's Lutheran School in the city of Orange went to a skating party in Long Beach's Hippodrome Skating Rink. One of the students, Arnold Stuck, said that "it seemed like we were going up and down three or four feet." Confused at first over what was happening, they managed to get out of the rink. The

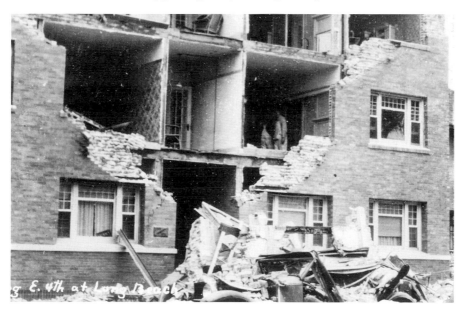

East Fourth Street and Long Beach Boulevard apartment building damaged in the 1933 Long Beach earthquake. *Author's collection.*

challenge then was to get back home. They had arrived in Long Beach by automobile. In returning home, they encountered broken gas lines and had to turn off the car engines lest a spark ignite an explosion. The students pushed their vehicles past the gas lines and made it home safely—but slept outside their homes that night.

Why did so many buildings collapse or suffer serious damage? A major cause was in their construction: unreinforced brick. The shaking literally tore them apart. A thirteen-year-old girl planning a party with some of her friends on the front steps of Garden Grove High School died when the earthquake hit.

Beyond the casualties and the destruction and damage to so many buildings came the shocking realization that the region's schools were especially vulnerable to earthquakes. Some 230 schools suffered damage, including 70 buildings crumbled into rubble. Prior to the earthquake, Theodore Roosevelt High School in the Boyle Heights neighborhood of Los Angeles had an administration building four stories high. After the earthquake only three stories stood, with the damage so severe in the campus's classroom buildings that classes were subsequently held in tents on the school's athletic field for a year. A block away from Roosevelt High, at Hollenbeck Junior High, only the home economics–cafeteria building survived the earthquake.

It was only good fortune that the quake hit at 5:54 p.m. Had it occurred during school hours, hundreds, if not thousands of children might have been injured or killed. In 2008, at age eighty-one, Dorothy Wise recalled the days following the quake. At the time, she was in the first grade at Horace Mann Elementary School in Long Beach. The quake destroyed the school, and Wise and other children went to class in tents. They learned new lyrics to the tune of "Yankee Doodle":

> *We had a quake in '33*
> *That sent the earth a-shaking*
> *They told us not be be afraid*
> *The earth was in its making.*

In the days after the quake, Dorothy's mother drove her around the town to see the damage. "The part that fascinated me was the apartments," she said. "The front was just sheared off, and you could see the bathtubs and the toilets and to me that was just shocking."

The earthquake made hundreds of Long Beach residents homeless. The Red Cross provided tents in which they could stay at public parks.

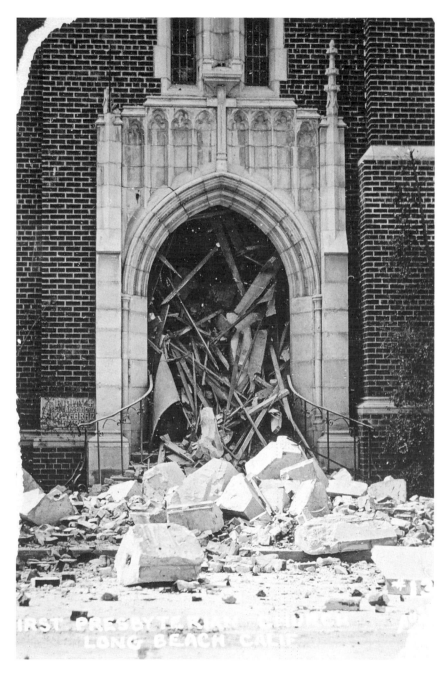

Wreckage clogged the entrance to the First Presbyterian Church in Long Beach as a result of the 1933 quake. *Author's collection*.

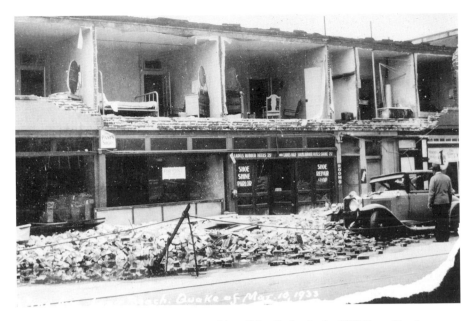

Apartment buildings collapsed above the Shoe Shine Parlor in the 1933 Long Beach earthquake. *Author's collection.*

The crisis made national headlines, and sympathetic people contributed $480,000 to the Red Cross.

The Long Beach earthquake moved the California legislature to take quick action on an issue that had long been discussed. State assembly member Don C. Field introduced legislation to ban further construction of school buildings made from unreinforced masonry. The legislature quickly enacted the bill into law on April 30, only seven weeks after the quake struck Long Beach. The Field Act required that school construction be undertaken at a high standard of earthquake resistance. Professional architects and engineers were to design the buildings. Such designs would be subject to review by the state architect in what is now the Division of the State Architect, an agency created in the Field Act. Designs would also undergo peer review.

The success of the Field Act may be seen in the construction of new buildings on the campus of Hollenbeck Junior High School, where, as noted, only one building survived the Long Beach earthquake. Architect Richard Neutra designed a campus of five basic buildings—administration, East Academic, West Academic, industrial arts/gym and an auditorium—that would withstand the major earthquakes of 1952,

1971, 1987 and 1994. The Los Angeles School District was so impressed by Neutra's design that it was used to construct Emerson Junior High in West Los Angeles.

Although the Field Act was successful in setting standards for new school construction, the law had a few loopholes. The act applied only to *public* schools; private schools were exempt. It covered kindergarten to twelfth grade, but not until much later would construction of new community college buildings be included. University of California and California State College and University campuses were not covered. In the 1960s and beyond, a large number of new campuses were created.

The most serious omission in the Field Act was in not applying its standards to existing school buildings. No provision was made to retrofit these older buildings until 1939 and the passage of the Garrison Act. On May 18, 1940, a massive 6.9 temblor struck the Imperial Valley, in the southeast corner of the state, severely damaging buildings in the towns of El Centro, Brawley, Calexico, Mexicali and Imperial. Cities as far away as Los Angeles and Tucson felt the quake. Because the region was primarily agricultural and sparsely populated, only nine people died. This was the first major earthquake to be recorded on Charles Richter's scale.

The Imperial Valley (also called El Centro) earthquake provided an opportunity to measure the effectiveness of schools built to Field Act standards to resist earthquakes. Sixteen school buildings suffered intense shaking but had little damage, whereas older buildings experienced serious damage. Despite the obvious importance of the Field and Garrison Acts in calling for safe school structures, many school districts in the state held off on retrofitting their buildings to higher standards, usually citing lack of funds.

Decades passed while schools delayed renovating old buildings. Some school districts stalled until after the 1971 San Fernando earthquake. It was not until 1998, when state senator Leroy F. Greene sponsored the passage of the School Facilities Act and its successor act the following year, that inspection deadlines were set for retrofitting school buildings, and the state legislature approved additional funds for renovating pre–Field Act school buildings.

The California Seismic Safety Commission, reviewing the record of the Field Act, stated, "Since 1940, school buildings constructed under the Field Act have performed extremely well in earthquakes. No Field Act building has either partially or completely collapsed, no school children have been killed or injured in Field Act–compliant buildings."

Unfortunately, the same could not be said for commercial buildings and residences, especially apartment buildings. When future earthquakes occurred—and, as will be seen in subsequent chapters, they would occur—such structures would be severely damaged at a cost of millions of dollars and lives lost.

8
THE 1952 KERN COUNTY/ARVIN TEHACHAPI EARTHQUAKE

At magnitude 7.3 (as will be seen, the number varied), the Kern County Earthquake, also called the Arvin Tehachapi earthquake—Arvin being near the epicenter and Tehachapi having the most damage and fatalities—was felt throughout most of California as well as western Arizona, Nevada and as far south as Ensenada in Baja California. In the Los Angeles area, the quake knocked a man out of bed, causing a concussion. At an all-night bowling alley, a man eating in the restaurant suffered a broken arm when the quake jolted him off his stool. Sidney Blumner, twelve years old at the time, recalled that he "woke up with the sensation that the bedroom which I was sleeping in was coming off of the foundations. The brick chimney that we had was cracked."

The major damage, however, was in the southern San Joaquin Valley, one hundred miles to the north, where the towns affected by the quake were Tehachapi, Bakersfield, Arvin and Taft. The area is agricultural, and the towns were relatively small at the time. In Tehachapi, the quake killed nine people in buildings variously described as a two-story hotel, a two-story furniture store with an attached apartment house and an adjacent residence. Whatever the type of buildings, the earthquake turned them into rubble. At least sixteen people were buried in the debris. They included Pete Quintana (or Cantana), whose wife, Blanche, had arrived just the day before with their nine children from Silver City, New Mexico. Louis Martin, owner of the furniture store, was in an apartment with his four children.

Chuck Nerpel, a United Press photographer, flew in from Los Angeles, arriving early enough to witness the efforts of rescue workers in Tehachapi digging in the ruins of downtown buildings, looking for survivors. He recalled:

> *Cars—I counted three—were flattened like pancakes. The two-story Juanita Hotel, which is on the main intersection, was open on all four sides and beds were hanging over the lip of the floors. Some roofs just caved in, leaving only the walls as shells. There are possibly more bodies in those houses under the twisted metal and crumbled brick. It was horrible. Women were blindly leading their crying children, just wandering aimlessly in the streets. They couldn't seem to realize what had happened.*

Almost all of the fatalities incurred lay in the rubble of Martin's building. Martin survived the earthquake, but three of his children, Mary Ann (age twelve), Linda (age eight) and Nancy (age ten), along with a friend, Marilyn Taylor Eisenhower (age thirteen), died. Pete Quintana and his seventeen-year-old daughter Ruth were able to climb out of the debris. Of Pete's nine children, four were dead: Joe (age eleven), Nicholas (age six), Bobby (age five) and Gloria (age thirteen). Quintana's wife, Blanche, was also dead, crushed under a wooden beam.

Other family members lived with Quintana, including one brother-in-law who luckily had left the ill-fated building a few minutes before the quake hit, going to a nearby café—open all night—to get a cup of coffee. Another brother-in-law also wasn't in the building; he was sleeping under a nearby tree when a brick struck him on the head.

Martin's building was unusual in that there were so many fatalities and injuries. Kirby Bezzo, a Tehachapi police officer, happened to be near the hotel when the quake hit. Hearing Martin's cries for help, he rushed to the ruined building, soon to be joined by neighbors and rescue workers. They labored for four hours, digging out survivors and corpses from under the debris with whatever tools they had, including their bare hands. While working at removing the debris, they could hear the cries of the children buried in the rubble.

Ray Cloud, United Press correspondent, reported that "they are digging up more bodies as fast as the rescue crews can break through the debris." Cloud was also the news editor for KVAL in Lancaster, a town some fifty miles south of Tehachapi. "All the dead and injured were in bed at the time of the quake," he said. "The entire business district is flat. There is not a

building standing....It still is all confusion. The people are not sure what hit them—even yet—more than four hours after the quake." People were carefully going over the wreckage in search of friends and relatives who might be injured or dead.

The earthquake and its aftershocks also damaged the California Institute for Women at Tehachapi, the only state prison for women at that time. Sources vary, but most state there were 417 inmates at the prison, plus fifty-eight (or seventy) staff members. Fortunately, no one was injured or killed. The National Guard erected the tents in which guards and inmates lived for several weeks. After the California Department of Corrections pronounced the prison unusable, the inmates were moved to Frontera, a new prison near the town of Chino. No one had attempted to escape. Governor Earl Warren rewarded the inmates for their good conduct by reducing one month from their sentences.

In all, apart from downtown Tehachapi, other areas hit in the southern San Joaquin Valley largely escaped serious injury, though some of the thirty-five people injured in the quake were in critical condition. The quake claimed a total of twelve lives. It destroyed fifteen homes, heavily damaged fifty-three and lightly damaged seventy-five others in Tehachapi, at an estimated cost of $2.6 million.

At Taft, a half-dozen buildings were damaged. In Maricopa, a wall collapsed at the J.C. Penney department store. Also in that town, a wall of the Maricopa Hotel facing the street fell, fortunately not hitting any of the guests who were fleeing the building. Bakersfield, the largest town in the region, had numerous brick buildings and older school buildings that suffered cracks. The quake caused severe damage to the Kern County General Hospital, but no injuries were reported. Windows everywhere were shattered.

The earthquake also resulted in the death of Ramon Tescado of Arvin. Not realizing that the quake had damaged his gas-powered refrigerator, he was killed when he opened its door and the refrigerator exploded.

A month after the quake, on August 22, a major aftershock measuring 5.8 magnitude caused severe damage in Bakersfield. Of 264 buildings, 90 were so badly damaged that they had to be razed. Two people died, and there were some injuries. The cost from this aftershock ran an estimated $10 million.

Seismologists laid the blame for the Kern County earthquakes on the White Wolf Fault, a fault line running roughly parallel to the notorious San Andreas Fault, and the Garlock Fault. The earthquake and its aftershocks were felt throughout a wide area of the Southwest. Tremors could be

capricious; railroad tracks bent and twisted into *S* shapes, walls in reinforced concrete tunnels cracked and some railroad tunnels caved in. At dry Owens Lake, some one hundred miles from the epicenter, salt beds shifted.

On the Ridge Route, where US 99 took travelers over the Tehachapi Mountains into Southern California from the Central Valley, a landslide blocked the highway. California Highway patrolmen and Kern County sheriff's deputies closed the Ridge Route. Anyone wanting to go north would have to take US 101 along the Pacific coast.

In Pasadena, the quake caused church bells to ring, and hundreds of fire alarms in downtown Los Angeles were set off, though the City of Angels experienced relatively minor damage. People reported their bookcases toppling and dishes knocked out of closets and shattering on the floor. Owners of homes with swimming pools reported mini-tsunamis, a common occurrence during an earthquake. Reports of the quake came from San Francisco and other cities in the Bay Area, and it awakened sleepers in Indio, 135 miles southeast of the epicenter. In Long Beach, where memories of the quake of two decades ago were still fresh, some power lines went down.

The news media lost no time in contacting seismologists at the California Institute of Technology. Beno Gutenberg, director of the Caltech Seismological Laboratory, said that the energy generated by the quake was one hundred times more than that of the Long Beach earthquake. "There is no doubt that yesterday's quake is the largest Southern California has had in this century and is the largest to occur in this area since modern instruments were available," he said. "It's possible that the 1857 quake might have been more intense."

Professor Charles Richter, inventor of the scale that bears his name, took a mobile seismograph truck to the San Joaquin Valley to record aftershocks in the fault area. And there were plenty of aftershocks: 8 aftershocks measuring greater than 5.1 magnitude in the month after the initial shock, with 5 of them at 5.5 or greater, including the 1 that damaged Bakersfield on August 22. Those with lesser intensity number 180 at 4.0 or higher. The larger ones inflicted additional damage to Tehachapi and Arvin.

Six months after the July 21 earthquake, seismologists John P. Buwalda and Pierre St. Armand evaluated the damage, the toll and the cost. "As is usually the case in earthquakes in California, the damage to buildings was mainly in business and industrial structures rather than in residences," they wrote. "Brick and concrete-block parapet walls, cornices, store fronts, and side walls collapsed or fell outwards when the buildings swayed. In some cases, roofs dropped when the supporting walls fell away." They attributed

the difference in destruction to Tehachapi having older and more poorly constructed buildings.

After the August 22 quake, the town of Bakersfield had to deal with the ruins of some historic buildings and consider that as a growing community, architectural designs with higher standards would be required in the event of future earthquakes. Meeting the challenge called for funds to demolish unreinforced masonry buildings, but their owners protested that retrofitting was too expensive.

Sixty years after the earthquake, a reporter for the *Bakersfield Californian* interviewed Kate Hutton, a staff seismologist at Caltech. Asked about the differing magnitude numbers for the July 21, 1952 quake—7.3 to 7.7, Hutton stated there were several ways to measure an earthquake's magnitude, the modern method being "moment magnitude," which estimated the total energy released by an earthquake. She said that almost all seismologists agreed on 7.5 as the best estimate for the 1952 quake.

Another question dealt with the dramatic increase in the metropolitan area of Bakersfield's population. From 129,000 people in 1952, in 2012, the city had almost 500,000. Hutton said that if a similar earthquake occurred, deaths, injuries and destruction might be lessened because of the state's current stringent building codes. "On the other side," she cautioned, "population has increased and is now more widely distributed, so there is more exposure to the risk."

The inevitable question was whether seismologists could estimate when or where the next large quake would occur. Hutton replied that while a greater understanding of plate tectonics has been achieved, and that research has made it possible to predict a theoretical earthquake, what was missing "is a way to know when a particular earthquake scenario is going to happen. This is a very bad problem," she added. "Earthquakes apparently occur suddenly, with little or no warning. Even if we could make these types of predictions, they would not be as accurate as society would require, at least in the beginning. People would still have to be prepared all the time."

THE 1971 SAN FERNANDO/SYLMAR EARTHQUAKE

On the night of February 9, 1971, Johnny Carson, host of the *Tonight Show*, was making a comment about the major earthquake that had struck Southern California that morning. Carson had recently moved the show from New York to "beautiful downtown Burbank," a city in the San Fernando Valley. Right after his comment, an aftershock caused his desk to shake ominously. Carson then pledged there would be no earthquake jokes that night. "The God is Dead Rally," he quipped, "has been canceled."

The earthquake was indeed no joking matter. At age eleven, Lori Underwood didn't stay up late to watch the *Tonight Show*. She lived in Mission Hills, in the northern part of the San Fernando Valley, an area that was part of the city of Los Angeles, with her parents, twin sister and two younger brothers. "My Dad would wake us up every morning by shaking our beds," she recalled. "So when the earthquake woke me up I just thought it was Dad shaking my bed, until I heard Mom screaming down the hall, 'Get out of bed—earthquake!' We stood in doorways as instructed by our parents." Standing in doorways was a common practice at the time, based on the belief that the door frame would protect people if the ceiling collapsed. After instances of people losing fingers when doors slammed on them during the shaking, this practice was no longer recommended, though some people still are under the impression this is a safe thing to do.

Lori's family—along with thousands of other Valley residents—were ordered to leave their homes because the Van Norman Dam at the northern end of the Valley had a crack and was in danger of flooding everything

below it. "We went to my parents' business in North Hollywood, joined by some of our neighbors, during the rest of the day and then went to my grandparents' house and spent the night there," said Lori. "The next day we were allowed back into our house." Lori remembered an odd incident: "A big gallon of wine that fell off a high shelf and landed in the laundry basket below, undamaged. My parents opened that bottle that night when we got home."

The earthquake would be named the San Fernando earthquake, also called the Sylmar earthquake for San Fernando's adjacent community. It struck at precisely 6:00 a.m.; had the temblor hit a couple of hours later, it might have killed hundreds of people commuting to their jobs or working in buildings that were seriously damaged.

It was also a close call for Los Angeles–area schools. Sylmar High School was located around three miles from the quake's epicenter. Robert Alm, the school's principal, raced there to find that the chemistry laboratory had caught fire. With the telephones not working, Alm used the amateur radio in his car and was able to contact someone in San Jose, more than three hundred miles to the north, who alerted a fire station near the school about the fire.

"The school looked like it had been bombed," recalled Alm. "The walkways, the arcades, were buckled, staircases collapsed. The floor in the gymnasium was buckled like an accordion." The cafeteria was a mess, and in the choral music room, the tiered seats had crashed forward and backward. Still, the event might have been a major tragedy had the quake occurred a few hours later, when classes would have been in session. Alm at least could put some humor on the destruction—which might have been worse had the campus buildings not been built to Field Act standards. "We put a sign on the front school announcement board that the school was 'Closed for Remodeling.'"

Although not the "Big One" so often discussed and predicted, the San Fernando quake was a "Pretty Big One," measuring 6.5 to 6.7 magnitude. It was the largest earthquake to hit a major metropolitan area—Los Angeles—since the 1933 Long Beach event. As such, the quake served as a measure for testing the results of the Field Act on school construction. With the exception of the cities of Glendale and Burbank, the Los Angeles Unified School District dominated the communities of the San Fernando Valley and, south and east of the Valley, of the Los Angeles Basin area, excluding such cities as Beverly Hills and Culver City. In 1971, there were 619 schools in the district—elementary, junior

Damage to an office at CSUN, where everything hit the floor in the Sierra Tower Building in the 1971 San Fernando/Sylmar earthquake. *Courtesy Special Collections and Archives, Oviatt Library, California State University, Northridge.*

high (later renamed middle schools) and high schools. Buildings on the campuses totaled 9,200, of which 110 structures had been built prior to the Field Act. Not all were reinforced to meet its standards. Also, more than 400 portable classrooms and 53 wood frame buildings were in use

on Los Angeles school campuses. After the quake, about 100 of the older buildings were razed.

Los Angeles High School, the oldest high school in Los Angeles, dating back to the 1870s, is not in the San Fernando Valley but is located in the city's Mid-Wilshire district. Its distinctive façade would have been familiar to a generation of television viewers who watched the television series *Room 222* in the late 1960s and early '70s. Although the school did not experience any damage during the 1933 Long Beach quake, its unreinforced brick masonry made it a target for damage since the main building was constructed in 1917. Other buildings on the campus were built post–Field Act. The San Fernando quake damaged the main building so badly it had to be razed. Its replacement building has been criticized for its lack of architectural style.

In contrast to Los Angeles High's main building, Sylmar High dates only to 1961, and all of its buildings were constructed to Field Act standards. Its proximity to the center of the quake, however, resulted in damage that went beyond Principal Alms's "Closed for Remodeling" sign. Repairs to the site ran up to $485,000.

The San Fernando quake damaged not only Los Angeles High but also caused problems throughout the region. Julie Martin remembered, "There was a round bank building on the corner of Wilshire and Westwood [near UCLA]. It was all glass. I was walking to work when I saw it. The bank was just one huge pile of glass. There was a police car parked at the corner. The cop was standing there with a what-do-I-do-next look on his face." In downtown Los Angeles, a ceiling collapsed at the Midnight Mission. A few blocks away, the Los Angeles Central Library staff faced the challenge of putting 400,000 books back on the shelves—in the correct Dewey Decimal System order. Anna Sklar, public relations director at the library at the time, recalled that the only way to put everything back in order was to call for volunteers. "We were able to overcome librarian's dislike for anyone attempting to re-shelve books when they realized how much it would cost in librarian time to do the job," she said. "So we put out a call for volunteers, include a brigade of fully-garbed nuns. Books were re-shelved in a few hours and volunteers kept coming, so we had them read the shelves. Result, best lining up of books per Dewey in years."

Sadly, much more fell in the earthquake than books from library shelves. The freeway interchange where the I-5 met the I-210 (Foothill Freeway) also collapsed. The destruction was so severe it took three years to rebuild,

during which time a temporary road had to suffice for traffic out of the San Fernando Valley going north over the Tehachapi Mountains. In effect, the I-5, I-405, I-210 and Highway 14, all major traffic arteries, were out of commission, with bridges and overpasses down and roadways cracked and buckled. Anyone wishing to drive from Los Angeles to San Francisco had but one choice: US 101 had escaped damage.

Valley hospitals suffered the most serious damage and the greatest number of fatalities. At the Olive View–UCLA Medical Center—a complex that included buildings constructed both before the Long Beach earthquake and three new buildings, one of which was the Medical Treatment and Care Building—more than six hundred patients and almost one hundred staff were in the building when the quake struck. Two patients on life support died when the quake caused an electric power failure, and a staff member was killed trying to leave the collapsing Medical Treatment facility.

At the Veterans Hospital in Sylmar, which dated to 1926, there were forty-five buildings, twenty-six of which were constructed before 1933. These older buildings suffered the most damage, but even newer ones did not escape unscathed. It took three days to dig out the thirty-five victims. Working all day and through the night, rescuers found two survivors in the wreckage. Edward McHugh, a Roman Catholic chaplain, told the *Los Angeles Times*, "I had just come out of the chapel and was on my way to these five wards when the quake hit. I got thrown to the ground about 20 yards from the building. When I looked up, in that same instance, the building fell. Just like that, it fell. In a single second. Thank God I wasn't in there." It is interesting to note that had he stayed in the chapel, he would have been just as safe as he was lying on the ground outside it. Of all the buildings at the VA hospital, the small building was the only one the earthquake left undamaged.

Two women, Helen Schroop and Grace Fields, were preparing breakfast in the building's kitchen cellar when the building collapsed. Rescuers could hear Schroop calling for help beneath the debris. Schroop's teenage daughter Sharon arrived and kept a vigil as workers used crowbars, jackhammers and cutting tools to get through the wreckage. After three hours, both women were pulled out from the rubble and taken to an emergency field station.

Almost every building in the VA complex had incurred serious damage, and getting an accurate count of injured, dead and missing proved difficult. The numbers changed by the hour. Los Angeles school buses took uninjured patients to other hospitals. This became another

problem, as hospitals—such as the VA hospital in Sepulveda—were already crowded with quake victims. The hospital's gymnasium served as a place for extra beds. Beds were also placed in hallways and at any spot where there might be room.

County firemen digging into the rubble estimated that it might take two days and nights before all patients not accounted for could be found. They set up arc lights to work through the night. By Wednesday evening, they had recovered thirty-four bodies and found twenty survivors. Three patients and five staff members were still missing. Rescuers started at the top of the collapsed buildings and worked their way down to the lower floors. The problem facing them was that the walls had given way, and the concrete slab floors had then pancaked down on the floors below. Some supporting walls had held up, creating pockets in the wreckage where someone might have survived.

Rescuers persisted in their search for victims. On Thursday afternoon, they found Frank Carbonera, a baker in the hospital kitchen. When the quake struck, he ducked under a sink and remained there until he was rescued—fifty-eight hours later. A helicopter airlifted him to Harbor General Hospital for treatment and observation. The sixty-eight-year-old baker later spoke to reporters:

> I thought I was dead…the noise and the darkness…and then the silence. Dead. I closed my eyes and waited, said a prayer for God would forgive my sins. Nobody lives forever. But after a while I noticed I was still breathing.…And then I thought of sky. And trees. And the way the bread smells fresh from the oven. My wife's face in the morning and the way it felt to drive my first car…all those things. And more.

Then he heard noises, and the workers found him. At the hospital, doctors found he had a broken wrist, a broken right hand and chest bruises. The doctor tending him told reporters that "his condition is remarkable. For a man his age, he seems to be doing very well."

As rescuers labored to find survivors in wrecked buildings, a major threat alarmed thousands of San Fernando Valley residents. Two storage reservoirs were located in the northern part of the valley, across I-405 from the Los Angeles Aqueduct Cascades, the picturesque location that was the terminus of the 233-mile aqueduct from Owens Valley. The Upper and Lower Van Norman dams were named for Harvey Van Norman, a former general manager of the Los Angeles Department of Water and Power (LADWP).

The dams held a reservoir of water for the city of Los Angeles and had been built more than fifty years earlier.

When the earthquake hit, it caused a landslide that dislocated a section of the lower dam's embankment. Seven years earlier, the State of California and the LADWP agreed on a lowering of the reservoir level by ten feet below capacity. At the time of the quake, the lower dam held 3.6 billion gallons of water. A year earlier, 6.5 billion gallons were stored behind the dam. If the dam at full capacity had broken, as many as 100,000 people might have been killed. The earthquake caused a crack that likely would have made the dam collapse. Engineers commented that if the quake had lasted just two more seconds, the dam would possibly have given completely away.

The likelihood that the lower dam would collapse caused authorities to issue evacuation orders to everyone south of the dam, all the residents between the I-405 and Balboa Boulevard. This included such communities as Granada Hills, Mission Hills, Van Nuys, Sherman Oaks and Encino. Eighty thousand people fled their homes to move temporarily into hotels and the homes of relatives and friends living outside the possible flood path.

"My cousins were among those who had to evacuate," recalled Nancy Martsch, who at the time lived with her parents in the hills above Encino. "They stayed with us for several days, mother and two daughters crammed onto the fold-out double bed, dad on the couch, dog in the corner. My cousin was a policeman with the LAPD; he was working twelve-hour shifts." Nancy's cousins lived in Granada Hills, not far from the epicenter. Mother Nature had its curiosities: somehow the kitchen clock, sitting on top of the refrigerator, ended up inside it. When her cousin used the toilet and flushed it, broken glass in the toilet stopped up the drain and cracked the bowl, flooding the bathroom.

David and Sheila Epstein lived in Woodland Hills, outside the flood path, but they were concerned anyway, inasmuch as they had moved into their home just eight days prior to the quake. Since they had not unpacked most of their cartons and boxes, they didn't suffer the loss or damage to framed photographs, vases and other objects knocked off walls and shelves. "The only damages we experienced were from a large wooden framed clock that fell off the mantel onto David's guitar," recalled Sheila. "The clock stopped at the very time of the earthquake. The guitar suffered a large hole." Their son Mathew had spent a year building a large model of the USS *Constitution*, also on the mantel; it came flying off "to its demise."

Three anxious days passed while engineers drained water from the Lower Van Norman Dam, getting the level lowered by thirteen feet and

the capacity down to 2.3 billion gallons. At 4:00 p.m. on Friday, February 12, Mayor Sam Yorty announced it was safe for people to return to their homes. However, hundreds of residents hadn't bothered to wait for an official announcement. They went back earlier in the day to survey the damage done by the quake to their homes and businesses. Nancy Martsch's father had a friend who owned a hardware store. "When he set up his store, he was unable to purchase enough standing shelves from Manufacturer A, so he finished off with a few from Manufacturer B. All of A's shelves went down, all of B's shelves stood. He called Manufacturer B, who rushed over a photographer to take pictures of the standing shelves. You can't buy publicity like that." Nancy also noted that at that time hardware stores didn't have small items in little plastic bags. "His shelves had contained open bins of nuts, bolts, screws, nails, etc., which were now all over the floor," she said. "Sorting out all this stuff was going to be a nightmare. One wag suggested that he shovel it all up, bag it, and sell the bags as 'Handyman Grab Bag, $1.' This was not well received."

All over the San Fernando Valley and in many parts of the county, supermarkets and liquor stores faced the daunting project of cleaning up mushy and liquid messes. At the time, many market products came in glass jars that broke when knocked off the shelves, covering the floor with broken glass, cooking oil, honey, jam, wine, whiskey, ketchup and hundreds of other vulnerable products. After the earthquake, many food and liquid products would be put in plastic bottles, jars and containers. Paper products also contributed to the mess. "In a drugstore on Ventura Boulevard, all the greeting cards had been thrown on to the floor," recalled Nancy. "They landed in a pool of some sort of alcoholic product, which dissolved the ink. For the remainder of its life that linoleum floor bore a haphazard pattern of pink and blue rectangles."

Valley residents returned to their homes and the task of cleaning up broken glass, fallen plaster and debris that were once family possessions. Meanwhile, workers still searched through ruins for victims. Some people had been rescued but died in hospitals from their injuries. Aftershocks, numbering in the hundreds and of various intensities, gave everyone the jitters. On the other side of Cahuenga Pass, central and downtown Los Angeles also experienced damage to office buildings, commercial stores and homes. When bricks fell from a downtown building onto a parking lot a day after the initial quake, city building department inspectors ordered everyone out. On East Third Street just south of Main Street, several commercial buildings were in danger of collapsing.

Young people coming of age in the twenty-first century might find it hard to comprehend the difficulty of communicating with relatives and friends outside the area affected by the quake. The present-day ubiquitous cellphones with apps that enable users to contact someone thousands of miles away were the stuff of science fiction in 1971, the "communicators" used by Captain Kirk and Mr. Spock on *Star Trek*. With cellphones far in the future, people in 1971 had telephones—land lines in modern parlance—that were leased, not owned, from Pacific Bell or General Telephone, the two major phone companies in the Los Angeles area. Several days after the quake, General Telephone Company established a message center in Sylmar. If the phone line was restored, the caller could go through a long-distance operator at the message center. The company promised that 25 percent of its customers would have normal service restored within a month, another 25 percent the next month and 25 percent the month after that. Some people went up to three months without telephone service. In some areas, service was normal; in others, intermittent; and in still others, disrupted.

The San Fernando quake left people frightened and isolated, unable to contact relatives in other cities and states to let them know everyone was safe—or injured—or a fatality. Bo Pollard recalled his mother's anxiety and fears in the days following the initial quake:

> We lived in a home in the hills above the San Fernando Valley with a first floor made of brick and a second floor made of wood. It seems the home swayed endlessly with several strong aftershocks within minutes. Eventually the dust settled, but for the next eleven days my mother was afraid to leave the house for fear she might not be able to return up the canyon roadways if another strong aftershock occurred.

During that time, the nearby elementary school remained closed. "Seeing no need to get us back to school, she decided we would all remain indoors throughout that entire period," he said. With electricity soon restored, "An endless stretch of *Gilligan's Island* and *Hazel* ensued."

Joan Mathews remembered her childhood home as a protective place. "However, that thought was shattered that February morning when the ground started shaking," she said. Months of aftershocks had to be endured one way or another. "I remember being at a fraternity party in a small house just east of California State University, Northridge [at the time it was called San Fernando Valley State College]. When the house started shaking, we

would all run outside laughing hysterically—it was frightening, but comical at the same time."

The San Fernando/Sylmar quake buckled freeways, broke sewer lines and shattered windows. Power lines snapped and fell, snaking out high-voltage sparks that made people stay far away from them. There was no telephone service until it could be restored. The official death toll counted sixty-four fatalities, most of them occurring at the Veterans Hospital. More than 2,500 people sustained injuries. The quake caused an estimated $550 million in property damage. Still, Los Angeles was fortunate that the "pretty big one" might have been much worse. Had the Lower Van Norman Dam given way, the number of fatalities could well have exceeded those who died in the 1906 San Francisco earthquake.

In the months following the earthquake, homeowners quickly learned to be very careful regarding contractors who showed up at their doors offering their services in repairing retaining walls and rebuilding damaged homes. Looking back at the quake almost half a century later, Robert Rector said, "If they asked for cash in advance, it was wise to walk away." Unscrupulous shysters posing as building inspectors tried to exact a fee from homeowners. City officials warned homeowners to demand identification from alleged inspectors and stated there was no charge for a city inspection.

This was also a time when individual plastic water bottles lay years in the future. Los Angeles residents obtained water for drinking, washing, flushing toilets, watering lawns and filling swimming pools (if one had a pool) from the Department of Water and Power. Bottled water came in five-gallon bottles set on coolers in the home, Sparkletts being an example of commercial companies that provided that service. The quake made tap water undrinkable in many homes. Silt discolored water from faucets, and in some cases, the water smelled. The Matson Navigation Company sent 3,100-gallon containers to the valley, and the Joseph Schlitz Brewing Company in Van Nuys converted liquid malt tanks into water suppliers.

Early on Monday morning, February 15—5:44 a.m. to be exact—a 3.7 earthquake centered in Granada Hills woke people up. Fortunately, no further damage was reported, and the LADWP engineers said they had reduced the Van Norman Dam level by nineteen feet. The next day, four more aftershocks occurred, three in the early morning hours and one at 8:37 p.m., all greater than 2.1 in magnitude. Some windows were broken, and some walls cracked. The city set up shelters for those families whose homes were considered unsafe, sending them to Pacoima Junior High, Porter Junior

High and Maclay Junior High. Red Cross workers served more than twelve thousand hot meals a day during the crisis.

There were 619 schools in the Los Angeles Unified School District (LAUSD) in 1971. By February 16, all but 4 were opened out of the 148 that had been closed. Teachers and students from the four schools were transported to other campuses.

The San Fernando/Sylmar earthquake was the largest natural disaster since the Long Beach quake of 1933, and local governments had plans ready to meet such a crisis, though the preparations had some glitches. In 1970, the 110 hospitals in the county set up a Hospital Emergency Administration Radio (HEAR) short-wave radio network to coordinate their resources. Unfortunately, the Veterans Administration hospitals were not connected

Fallen tower at Olive View Hospital in the 1971 San Fernando/Sylmar earthquake. *Courtesy U.S. Geological Survey.*

into it. Some three hundred patients needed to be transported from the Sylmar VA hospital to the one in Sepulveda, but the Sepulveda staff didn't know about this until two and a half hours after the initial temblor. Those connected to HEAR, however, were able to send doctors and nurses where they were immediately needed, as happened with the four hundred patients evacuated from the county's Olive View Hospital. Helicopters flew medical supplies and personnel to locations to aid the injured. The short-wave radio system made it possible for hospitals to indicate how many beds were available at their facilities. The sheriff's department and the Rapid Transit District provided buses to move patients to those locations.

Complicating the challenges, medical records at the VA hospital were destroyed in the quake, leaving doctors with no information as to what treatment was needed, as in the case of Sylmar VA tuberculosis patients. Also, the quake knocked out the operating room at the Sepulveda facility, so emergency cases had to be taken to the VA hospital in west Los Angeles.

A week after the earthquake, reports came to the County Board of Supervisors on the delay between the temblor and notifying the county's fire

Two fallen structurally separated stair towers and collapsed basement at Olive View Hospital in the 1971 San Fernando/Sylmar earthquake. *Courtesy U.S. Geological Survey.*

and sheriff's departments. The quake had disrupted telephone lines from the hospitals. County supervisors urged that for such emergencies, their departments and the VA hospitals needed to be connected into the HEAR network. Supervisor Kenneth Hahn recognized the mistake of constructing county facilities such as Olive View Hospital, the San Fernando Juvenile Hall and the Karl Bolton Boys Camp so near an earthquake fault. The property damage to these three facilities alone topped $42 million; total damages to county-owned or operated facilities ran to more than $100 million. Said Hahn, "We should not again permit a dam, a hospital, school, church or major assembly hall to be built on known earthquake fault lines."

On a smaller but no less significant scale, few San Fernando Valley homeowners carried earthquake insurance on their homes. For example, the quake destroyed Earl Dunn's Sylmar ranch house, valued on February 8 at $65,000 (1971 values). He received a second shock when he learned he had no earthquake insurance on his home. A third shock came when he called the savings and loan that held his mortgage. "They told me they would be happy to loan me more to rebuild, at the same 6.75 percent rate as the old loan, but that the house was mine, and so was the mortgage and I was obligated to pay it off." When he went to the Small Business Administration for advice, he was told that even with the federal government's interest rate at 5.125 percent, it would cost some $40,000 to rebuild. "With interest and taxes, my payments would run around $700 a month" (1971 values).

It would cost an estimated $23 million to repair school buildings in six of the county's public school districts. Most of this cost would be in the LAUSD's schools, where thirty-five buildings suffered major structural damage. It was possible that financial aid would come from the federal government. Some buildings, deemed unsafe, needed to be razed, and while new buildings were being constructed, some schools were on double sessions, with students from damaged schools being bused to ones that escaped damage. Almost all of the buildings that had to be demolished, noted LAUSD superintendent William J. Johnston, were built before the 1933 Long Beach quake and therefore were not up to the standards of the Field Act.

Johnston then said, in a comment surely not guaranteed to ease the tensions of parents concerned for their children's safety, "I wish to emphasize to the board and to the community, that the safest place a child can be at the time of an earthquake is in a post-1933 building." Problem was, at that time, about one-sixth of the 5,900 major buildings in the district were constructed before 1933—their children attending school in some 1,000 buildings not constructed to withstand earthquakes.

Almost two years after the San Fernando/Sylmar quake, the California legislature passed the Alquist-Priolo Earthquake Fault Zoning Act, signed into law by Governor Ronald Reagan on December 22, 1972. The law prohibited new construction of houses in a buffer zone around the surface traces of known active faults. Property owners and real estate agents had to disclose to prospective buyers whether the property was within the fault zones.

As is inevitable in politics, some compromises were made to get the law passed. The law applied to new construction; pre-1972 buildings were not affected by the law unless they were renovated to a degree (50 percent or more), in which case they would be considered new construction. Home and apartment owners were not required to inform tenants that their structures were in a fault zone. The law applied to surface fault rupture, not other earthquake hazards, such as liquefaction or landslides caused by earthquakes. Also, the law applied to known faults. When the Northridge earthquake occurred in 1994, its epicenter was on a blind thrust fault that had not been mapped as a fault zone.

The San Fernando/Sylmar earthquake killed 64 people and injured more than 2,500. It caused $550 million in property damage—the high cost due to the fact that it occurred in a highly urbanized area rather than a sparsely populated location. At 6.6, it was considered a moderate quake; the small number of fatalities was due to several factors: many of the Valley's homes and commercial buildings were relatively new and constructed to building code standards, though the quake demonstrated that the codes needed revision.

Valley residents endured inconvenience, injury and some hardships, but they quickly recovered from the experience of a major quake shaking up their lives. Low-cost Small Business Administration loans, most of which would be largely forgiven, helped defray building expenses. Where the Sylmar VA hospital complex once stood—and collapsed—a park now stands with a "Lest We Forget" plaque to remind visitors of the lives lost there. The plaque reads, "In loving memory of the many veterans, nurses and aides of the San Fernando VA Hospital who lost their lives in the Feb. 9, 1971, earthquake."

As time passed, property values rose, and for newcomers, the quake was something from the past, not necessarily dwelt on. The Lower Van Norman Dam became a catch basin for storm water. A new reservoir and dam were completed in 1977. It took three years to rebuild the freeway overpasses, at a cost of $21 million.

On the tenth anniversary of the quake, Los Angeles sponsored a special event to commemorate the anniversary. The state's office of emergency services held a mock disaster drill simulating an 8.3 quake. Staff and juveniles from the new San Fernando Juvenile Hall facility (opened in 1978 at a cost of $15 million), wearing blood and bruise makeup, played the role of injured persons. The *Los Angeles Times* published a lengthy article recalling the experiences of people during the quake and its aftermath.

Twenty-three years after the quake, it would be déjà vu all over again.

10

THE 1987 WHITTIER NARROWS EARTHQUAKE

For many years, California schools have been holding periodic earthquake drills. In the Los Angeles Unified School District, for example, schools have designated areas in their athletic fields or play yards where students are to report following an earthquake. For middle and high schools, the assigned spots are where homerooms are situated, enabling teachers (who must take their roll books with them) to take roll and find out who is absent. Periodic earthquake drills require teachers to interrupt class work by shouting "Earthquake!" (as if students would need to be told that a major tremor is shaking the classroom). Students must then get under their desks to be protected should the ceiling or roof collapse on them.

There are some problems with this earthquake drill, which seems suspiciously like the old "drop drill" of the Cold War era. In the drop drill, the teacher shouts "Drop!" and students must get under their desks. The assumption here is that the teacher would see the flash of light from the nuclear explosion and immediately tell the students to get under their desks, ostensibly to be protected from the atomic blast. This "duck and cover" plan dates to the early 1950s, when the cartoon character Bert the Turtle advised everyone to duck and cover from the atomic explosion. The cartoon was widely shown in American classrooms and can still be seen on YouTube as a relic of an earlier fearful time. Far more realistic is the nuclear apocalyptic scene in the film *Terminator II* (also on YouTube).

With the end of the Cold War in the late 1980s, the drop drill became obsolete, its propaganda message of safety from nuclear attack subjected to

ridicule in a *South Park* episode. But school administrators have done little in preparing for an earthquake other than to change the title "drop drill" to "earthquake drill." As any teacher or student in high school already knows, it's quite amusing to see a 230-pound fullback on the school's football team attempting to insert himself under a school desk. The drill also fails to take in account that during a major earthquake the desks may be bouncing up and down, and a student trying to get under it could injure him/herself by trying to do so. It may not even be necessary, as public schools constructed since the Field Act may be the best buildings to withstand a major earthquake.

In fairness to administrators, the drop drill might have some utility when a natural disaster strikes, such as an explosion from a gas plant (some schools are built near them), though there would really be no warning other than the explosion, followed immediately by classroom windows sending shards across the room.

A better plan for earthquake safety is to make sure that when the shock ends to evacuate the buildings and head out to the athletic fields, there to await further instructions. Many school districts have a direct call to teacher cellphones. (To date, "further instructions" have yet to be given, and no one seems to know what they would be.)

When the Whittier Narrows earthquake struck at 7:42 a.m. on October 1, 1987, most of the teachers and students in Southern California schools were already on campus. This earthquake was the closest one in the state's history to a time when students would be in school. Administrators and teachers escorted students to assigned places on the athletic fields and play yards. The initial shock was 5.9 to 6.1 magnitude, followed by three aftershocks over the next hour, the lightest one (if one can call it that) at 5.5.

As with so many other quakes, naming it the Whittier Narrows earthquake (its epicenter was in the Puente Hills near the City of Whittier) did not do justice to the temblor, as it was felt as far east as Las Vegas, as far north as San Luis Obispo and as far south as San Diego. Eight people died either directly or indirectly because of the quake, at least three of them from heart attack.

Although the epicenter was in the Puente Hills near Whittier, the Burbank Airport reported that the quake broke windows in the airport control tower, necessitating the closure of the airport for an hour. At California State University–Los Angeles, two buildings experienced structural damage. Most of the classrooms at Salazar Hall had severe ceiling problems when ceiling panels fell throughout the classrooms, and interior walls had shear cracks.

A History

"It is important to note that the campus was founded on a slight slope behind which are small hills with one or two-story homes where no damage was observed," reported M.G. Brady and H. Krawinkler in a U.S. Geological Survey preliminary evaluation of structural damage. The authors noted that a campus engineer said "that the campus buildings were founded on cut and fill when the original topography of the area was altered according to a master plan." Evidently, the planners had overlooked the possibility of an earthquake hitting the campus area.

Harvey Lowe worked for the Los Angeles City Transportation Department and served as his floor's civil defense warden. After the first shock, he checked to see if anyone had been injured and then shepherded them to the stairwell. While descending the stairs they experienced more shocks, which caused plaster to fall on them. Lowe recalled, "There wasn't anyone crying or hysterical. But we all wanted out of there fast."

Mikey Moore was sixteen years old and smoking marijuana before school. While waiting for his younger sister to get ready, he recalled, "I heard a loud rumbling noise. I felt the ground rolling beneath my feet. I saw the telephone poles swaying back and forth from the roll of the earth. It came all the way up the hill and into the mountain and they shook and rolled. It was a very cool experience," especially since he was high "on some old-school weed."

Tragedy accompanied the experiences of survivors who escaped injury. Antonio Bernal, a Pasadena utility worker, died when the tunnel he was digging collapsed around him. At California State University–Los Angeles, near the Interstate 10 San Bernardino Freeway, Lupe Esposito, a twenty-one-year-old student attending the university, perished when two tons of concrete from a parking structure fell on her. The quake knocked Juan Herrera out of a second-story window in Maywood, and the fall killed him. In Bell, a seventy-nine-year-old woman, severely upset over the damage to her apartment, died of a heart attack. A heart attack also killed Robert Reilly as he was being taken out of a building on Wilshire Boulevard in Los Angeles. An unidentified young woman in Covina, only twenty years old, died of cardiac arrest, though it wasn't clear that the earthquake had caused the fatal condition.

The quake created power outages, gas and water leaks and a break in telephone, radio and television communication, though these setbacks were relatively brief. Hundreds of workers were trapped in elevators until electricity could be restored. Thousands of employees were told to leave office buildings until the structures could be inspected for damage.

101

And damages there were. *Los Angeles Times* staff writer Eric Malnic reported:

> *Walls crumbled, windows shattered and ceilings collapsed in scattered locations throughout the metropolitan area. The quake forced the closure of the Santa Ana and San Gabriel freeways in the Santa Fe Springs area at the height of the morning rush hour after Caltrans engineers noted major cracks in the San Gabriel River Freeway overpass and chunks of concrete tumbled onto the roadway. A major traffic tie-up resulted as commuters were diverted onto nearby surface streets.*

At Whittier High School, the quake knocked books from the shelves in the school library. (The bookshelves were anchored to the walls.) The auditorium, administration building and library had minor damage. Richard Nixon was the school's most famous graduate. Some bad luck had shadowed the school's history. The 1933 Long Beach earthquake heavily damaged most of the school's buildings, and a fire in 1998 destroyed the school's boys' gym. Years would pass after the 1987 earthquake before the seismic damage to the older buildings would be repaired or replaced.

More than 500 single-family residences and more than 2,000 apartment units sustained major damages. In all, the quake damaged more than 10,000 buildings and cost an estimated $350 million in property losses in the county. The quake destroyed 123 single-family homes and 1,347 apartment units in Los Angeles, Orange and Ventura Counties. The estimated property damage at California State University–Los Angeles alone ran to more than $20 million.

Whittier's commercial district buildings were severely damaged. Whittier Village, a shopping center covering twenty-four square blocks, was so badly hit that a dozen of its commercial buildings were later torn down. Twenty others were pronounced unsafe. Inspectors stated that many of the damaged buildings were of unreinforced brick and masonry—the same old story of older, unreinforced masonry was again repeated, as had been the case in earlier temblors in the state. Municipalities had continued their delay by explaining they lacked funds for retrofitting, as did owners of private buildings. Following the earthquakes of 1933, 1952, 1971 and 1983, the state updated and revised building codes, but enough loopholes existed for cities and towns to delay retrofitting.

By noon on the day of the earthquake, emergency officials concluded that aftershocks, unless there were severe ones, would not wreak any more

destruction. The next steps would be to provide immediate relief for people made homeless by the quake and to seek funding to aid in the demolition of unsafe buildings and reconstruction of buildings to new standards.

Three days after the initial shock, a 5.3 magnitude aftershock struck at 3:59 a.m. on October 4. One person died, and several people were injured. The aftershock also caused additional property damage in Whittier and in nearby municipalities, with more broken chimneys and cracked sidewalks. Orange, Riverside, San Bernardino and San Diego Counties all felt the tremor.

Considering the damage done to property, it was remarkable that so few people were killed or injured. In fact, most of the area's schools, having been checked out by fire marshals and earthquake specialists, were open the next day; some even continued classes later that day. At Disneyland, after all the rides—including the Matterhorn and Space Mountain—were inspected, they were in operation by noon. Attendance was lighter than usual, but park fans apparently were not going to let an earthquake spoil their day's fun at the Happiest Kingdom.

The Whittier earthquake came as a surprise to seismologists. Some four months had passed since a tremor had measured up to magnitude 4.0 in the region, "the longest earthquake lull since measurements began in 1982," reported Judith Cummings in the *Los Angeles Times*. In all, some five hundred measurable aftershocks occurred between October 1 and 4, a number that seismologists considered small for a 6.1 quake.

By the time of the Whittier quake, seismologists had developed more strong motion instruments, enabling the investigators to create a contour map of strong ground motions in the Los Angeles basin and the San Fernando Valley. The records gathered by these instruments made it possible to measure ground acceleration and how they would affect high-rise buildings. Egill Hauksson and Ross S. Stein noted in the *Journal of Geophysical Research*:

> *After discovery of a broad system of active thrust vaults beneath a region populated by 11 million people, we are thus left with a conundrum: Is the message writ by the Whittier earthquake that much of the fault slip is accommodated quietly by aseismic creep* [slippage without temblors], *in which nothing more damaging than a Whittier Narrows earthquake can occur, or are we now overdue for a longer event with much more vigorous shaking? Seeking the answer to the question will undoubtedly drive further study.*

The answer to these questions would come seven years later in Southern California, in the San Fernando Valley. Before then, however, another major earthquake would strike California, this time in front of a national audience.

THE 1989 LOMA PRIETA "WORLD SERIES" EARTHQUAKE

All across America, millions of people awaited the start of the third game of the World Series on October 17, 1989, and the Hoffman family was no exception. Although we lived in Los Angeles, the San Francisco Giants were cross-town rivals of the Oakland Athletics (technically, cross-Bay rivals), so we had a sort of vested interest in watching two California teams meet for the World Series championship.

We set up tray tables by the couch in front of our twenty-five-inch television (large for that time) and had some chips and dips as appetizers. At 5:00 p.m., the pregame show began with a camera on the Goodyear blimp zooming in across the Bay area and into Candlestick Park. Sportscaster Al Michaels presented highlights of the first and second games that had been played in Oakland. The As had taken the first two games in the series, and the Giants needed to catch up. Michaels turned the mike over to his colleague Tim McCarver for a comment.

Precisely four minutes into the program, the screen went blank—or, more exactly, the television set was fine, but the picture was gone. We could hear McCarver say something, but then Michaels excitedly said, "I'll tell you what, we're having an earth—" and for a few seconds there was no audio. All we now saw was a ABC Sports graphic. Then the audio was restored. We could hear Al Michaels say, "Well, folks, that's the greatest open in the history of television, bar none!"

During the next half hour, we heard audio reports, and then at 5:40 p.m., ABC and CBS, but not NBC, had camera crews on site and video restored.

People had been arriving for the big game, but when the temblor hit, fewer than half of the seats were filled. This was probably fortunate, as the weight of the packed stadium might have caused greater stress on the structure than was the case. As it was, initially, the reaction of those already there seemed more excitement than panic. A photographer took a picture of a fan holding up a big sign that would be published in many newspapers: "That was nothing—wait until the Giants are at bat!" When the loudspeaker system announced the game would be postponed, people left in more or less orderly fashion, anxious to reunite with family and friends who had not attended the game.

But the earthquake was anything but nothing. It measured 6.9 on the Richter scale, and its epicenter was not in San Francisco but around sixty miles to the south at Loma Prieta Peak in the Santa Cruz Mountains. The event would be called the Loma Prieta quake. The quake heavily damaged structures in the cities of Los Gatos, Santa Cruz and Watsonville in Santa Cruz County. It also caused damage in San Francisco and, most tragically, in Oakland, where the Nimitz Freeway collapsed.

At the time of the earthquake, San Franciscan Dave Bond was three thousand miles away working on a project in Cambridge, Massachusetts. "When Loma Prieta hit, I was working late Tuesday (8:05 p.m. local time) at the contractors' facility, logged into an Army mainframe when the connection dropped," he recalled. "A call to their phone carrier told us all phone service to Northern California was out due to an earthquake." Dave returned to his hotel, where he watched the news on television. Al Michaels had changed from sportscaster to reporter, and Dave thought he was doing a great job in covering what happened. With video coverage from the Goodyear blimp, Dave saw several fires and the damage to the Oakland Bay Bridge. "That was the last accurate information I received until I returned to San Francisco Saturday and a cab driver from the airport filled me in," he said. "You would not believe the bullshit we were fed by network TV shows and the local paper."

If the news media was to be believed, the marina fire made it seem that half the city was ablaze; it was actually just a few buildings, but the camera angles distorted the coverage. A network news program showed the collapse of a San Francisco overpass on Highway 101. Dave thought the scene looked familiar—it was from the 1971 Sylmar earthquake in Southern California. "There is no structure at Hospital Curve," insists Bond. "The road is at ground level." When his plane landed at San Francisco Airport, the news said the runways were extensively damaged. "The airline said there was no damage and flights were on schedule."

In covering the event, NBC News trailed far behind ABC and CBS. The network experienced a perfect storm of Murphy's Law edicts. Inexperienced technical personnel, failure to communicate with NBC San Francisco affiliate KRON-TV and indecisiveness in the news division resulted in NBC not providing continuous coverage of the disaster until 9:43 p.m. Eastern Time, almost an hour after ABC and CBS were providing it. Francis A. Martin, president of the Chronicle Broadcasting Company (owner of KRON), insisted that, contrary to network claims, the station could have sent pictures from San Francisco to NBC News in New York. The network staff had mistakenly believed that power from KRON was out. In fact, KRON had been telecasting right after the quake hit, but through the CNN satellite, a link making it possible for NBC News in New York to see the coverage—but not the affiliate stations across the country.

Glitches and technical issues aside, Dave Bond's criticism of media coverage of the quake was well founded. Media estimates of fatalities, based on inaccurate and incomplete information, publicized a figure of 273 dead; the total was actually 63. Network news anchors rushing from New York to the Bay Area to describe the scene firsthand (and apparently not noticing that their plane and others were arriving on schedule at the San Francisco Airport) were inadequately informed as to the extent of fires and quake damage. Their reports gave the impression that the quake was as bad as the one in 1906, which it was not. They also neglected or ignored Watsonville and Santa Cruz, where thousands of people had been made homeless, a fact limited to local rather than national coverage. Philip Fradkin, in his 1998 book *Magnitude 8*, took issue with the poor media coverage. "The vast majority of reporting chores are accomplished after the fact," he wrote. "Thus, some distance from the actual event is achieved, and it is easier to don the assumed cloak of objectivity."

Fradkin also cited a report by Professor Everett Rogers, which noted, "The focus of media disaster reporting on events tends to attribute explanations to individual actions, while largely avoiding and underemphasizing environmental explanations and those that consider context and historical background. Thus, news media framed the Loma Prieta earthquake as a singular event, or as a series of unrelated events." As Fradkin points out in his book, the fact of the matter is that California is earthquake country and seismic events do not occur in isolation.

In fact, a 5.1 quake had jolted the Bay Area on August 8, two months prior to the Loma Prieta quake. People from San Luis Obispo to the south and Napa to the north felt this quake, which killed one person.

As earthquakes go, it was a minor one, with no serious injuries or major property damage. Coincidentally, the quake occurred the same day as some five hundred federal and state officials met in Sacramento for a conference on earthquake preparedness.

In the Loma Prieta quake, hundreds of thousands of people in the Bay Area were taking stock of their own situations. Clare Boyles, a student at the University of California–Santa Cruz, was watching a film in one of the university's big classroom buildings "when the screen started swaying back and forth and the ground shaking. We were on the ground floor and it sounded like the building was going to come down on top of us." The students headed for the exits, frightened by a spate of aftershocks. "We rushed out of the building after several minutes and walked down the road toward Crown College where I lived," she recalled. "Aftershocks kept hitting and I remember the street light poles swaying with every shock."

April Beltz lived in the small town of Ben Lomond, about ten miles north of the city of Santa Cruz, in the Santa Cruz Mountains. At the time the earthquake hit, she and her husband were at a doctor's appointment in San Jose, some forty miles south of her home. Attempting to return home, she found that "Highway 17 was closed due to slides and boulders. So, we went around to a small two-lane highway—Highway 9. That took us over two and a half hours to go twenty miles." Fallen trees, downed wires and rocks forced her "to go around, over or through."

Arriving at home, she and her husband found their house severely damaged, cupboard doors open and everything smashed on the floor. "We needed wheelbarrows to clean up the debris," she recalled. "We pulled a mattress out of the house and put it in the detached garage and lived there for over a week." Her husband, a fireman, was called to work and spent the better part of four days away from their home. The mother of three children, April Beltz suffered a miscarriage from the ordeal. "A disaster in so many ways!" she said. "Our two-year-old ended up back in diapers, and the other two felt an earthquake for years at every rumble of a truck or thunder." Their house was yellow-tagged, but the Beltz family obtained a FEMA loan to repair it.

Robert J. Chandler, bank historian and head of the Wells Fargo History Department at 420 Montgomery Street in San Francisco, had just gotten off work and was heading for the Bay Area Rapid Transit station at Sutter, Sansome and Market Streets to go to his home in Concord, on the East Bay. When the earthquake struck,

I felt a jolt, pulled into a little alcove in the building, and put my metal briefcase over my head. Went down to BART. It was closed. Went over to the Transbay Terminal, and news came that the Bay Bridge was down. No one with any authority—national, state, or city, was around to give directions or provide any guidance or leadership. Everyone was just milling around.

Returning to Sansome Street, Bob picked up a rock that had once been a part of the Anglo Cal Bank building. Debris littered the streets. Someone had a cellphone—1989 was a decade before they would begin to be a ubiquitous feature of everyday life—and loaned it to him so he could call his wife to let her know he was safe and to learn his family was also uninjured. "Then news floated around that the ferries were running, so we rushed down there, and got the first ferry out of San Francisco to Jack London Square," he recalled. Once across the bay in Oakland, he took a bus to the BART station, noticing the quake's damage as he went through Oakland's streets. He finally arrived in Concord around midnight, after seven or so hours attempting to get home.

Dave Dillon (Brian Dillon's brother) was at a service station in San Francisco filling up his truck's gas tank when the quake hit. All of the vehicles up and down the street began doing what he described as the "Mexican hat dance." He could also see the quake moving up Nineteenth Avenue "doing the hula." Next to him at the service station was a traveler from Alaska in a camper truck, waiting with a white-knuckled grip on the steering wheel for his wife to get out of the bathroom.

Dave's friends Ed Fenzl and his brother Dave had been at Candlestick Park for the World Series game that was abruptly postponed. Everyone leaving the stadium received a rain check. Dave Fenzl couldn't go, so he gave the ticket to Dave Dillon, who used it to see the Oakland As defeat the Giants in the final game of the World Series.

There would be millions of similar stories that would be told by Bay Area residents, but the most dramatic are the efforts of rescuers who risked their lives to help the injured and recover the dead. They included not only military, fire, highway patrol and police but also civilians who stepped up to the plate during the World Series earthquake to help clear away rubble and dig out injured victims under dangerous conditions.

Eve Iverson from the University of California–Davis compiled an oral history of the Presidio's role in dealing with the earthquake for the Virtual Museum of San Francisco. Sergeant Diane Langdon and her husband, Staff Sergeant David Wayne Langdon, were stationed at the Presidio. They

were to take part in the pregame opening ceremonies at Candlestick Park. Presidio soldiers boarded two buses that took them to the stadium, where they were to carry the flags of the fifty states. They waited at the center field gate to enter along with drill teams, cheerleaders and workers who would release balloons after the flag ceremony ended.

The ceremonies never took place. Diane Langdon recalled:

> *Above us, to the left the light stanchions were swaying, not just shaking, they were swaying back and forth. The concrete on the upper deck moved apart and you could see the sky on the other side. No one fell but you could see the section of concrete moving apart and then back together. There wasn't panic, we stood there and I thought, "Oh my God, man, what a day! Some timing!"*

David Langdon noted the lack of panic in the stands. "Fans reacted really great; they applauded at first thinking that this is San Francisco and it would be apropos to have an earthquake during the World Series. Until we found out the devastation it had done."

The soldiers returned to their units at the Presidio. Military police were assigned to the Marina District at the north end of the city to aid the city's police. Diane went on desk duty. David, an MP, went to the Marina District to bring supplies to the soldiers—radios and food. While there, he saw Vice President Dan Quayle arrive, and the Secret Service assigned him the task of keeping reporters and onlookers at a distance from the vice president. With Quayle having departed after inspecting the destruction, David assisted people in getting out of the damaged area. Some of them were in wheelchairs. "The shock of the people that had lost everything was terrible to witness," he recalled.

For the Presidio Fire Department, the day had been routine, checking on equipment and tools and making sure ladders, chainsaws and water flow alarms worked properly. Then came 5:04 p.m. The station's computer died, and with it went control over alarms and smoke detectors. The telephone emergency line worked, as did portable radios. A request came in for the Presidio Fire Department to assist the city's fire department in fighting a fire at Beach and Divisadero. Vincent Milano and Roy Evans took Engine 2 to the scene, where two buildings were on fire. Two blocks from the scene, they were temporarily blocked by people helping the injured get away. Arriving at the site, they were told a woman was trapped in one of the buildings. "We grabbed axes, there's one on each side where the hoseman usually sits, and I

A section of the San Francisco–Oakland Bay Bridge collapsed in the 1989 Loma Prieta earthquake. *Courtesy U.S. Geological Survey.*

broke the door window for the cop to get access," Milano recalled. "He said he could get her out."

The fire hydrants worked for twenty minutes, until aftershocks knocked them out. Civilians helped Milano by holding hoses connected to the fire engine's tank water. "When we ran out of water, the fire just kept escalating. It caught the building where that woman was trapped on fire [*sic*]. After we ran out of water, it did catch on fire, the radiation or heat was so intense. It just toasted it."

Meanwhile, Sergeant Kurt Mercier was ordered to go to the helipad at the Letterman Army Medical Center to await incoming casualties. The Letterman Center was the only hospital in San Francisco that had a helipad. The quake had knocked out a section of the Oakland Bay Bridge on the lower deck, and a car had gone into the hole, where it was suspended front end down, the bay below it. A Caltrans worker crew succeeded in pulling it to safety, but the two people inside were badly injured. A Coast Guard helicopter, descending carefully to avoid contact between its rotor blades and the bridge cables, landed on the deck to take the casualties to the Letterman Medical Center.

When the helicopter arrived, Mercier was told that the woman, identified as Anamafi Moala Kalushia, was in bad shape and likely dead. The other victim, Lesisita Halangahu, was her brother. "We could see he had bleeding from the chest, compound fractures in both legs, he had his arms crossed over his chest and was in a semi-conscious state," recalled Mercier. He started CPR, performing chest compressions on Anamafi while a doctor began an IV drip. Mercier continued CPR until they got to the emergency room. When he returned to the helipad, he learned that Lesisita had been taken to the hospital.

Anamafi had been married three weeks earlier. She was declared dead on arrival at the hospital. Her brother Lesisita underwent several surgeries and survived. Anamafi was the only person on the bridge to die. Because of the World Series and people leaving work early to see the game on television at home, traffic was light that afternoon. On an ordinary working day, there would have been hundreds of cars on the bridge at 5:04 p.m.

More fatalities and injuries would be found on Interstate 880 on the east side of San Francisco Bay. Known as the Nimitz Freeway, I-880 was a double-deck highway in which southbound traffic ran on the upper deck and northbound traffic below it. When the quake struck, a mile and a quarter of the freeway, known as the Cypress Viaduct (also referred to as the Cypress Freeway), collapsed, the upper deck pancaking onto the lower deck.

Lieutenant William R. Jarrett of the Oakland Fire Department saw dust and smoke rising from the Cypress Viaduct and immediately went into action, his engine and crew speeding to the site. Lieutenant Mark Hoffman and his engine crew also raced to the scene, as did fire chief Reginald Garcia. Within minutes, hundreds of calls were overwhelming the fire dispatch center. The first responders set to work trying to free survivors and aiding the injured. Unfortunately, years of budget reductions had left the fire companies understaffed. But help was already there.

Iverson's account of the tragedy spoke to the bravery of those living nearby:

> *Citizens who lived in a nearby housing project ran to the wrecked freeway moments after the earthquake. Dozens of extraordinarily brave citizens climbed shattered support columns and—holding onto curled steel reinforcement rods that had been bent and exposed by the fearsome collapse—made their way along the top deck.... These brave people covered their faces with handkerchiefs and rags for protection from cement dust and the acrid smoke of many burning automobiles, and went from car to car to search for survivors.*

They did this despite more aftershocks that rocked the freeway. They were prying open car doors to get victims out as the Oakland firefighters arrived. The presence of these civilians can be seen in the photographs taken by Michael Macor of the *Oakland Tribune*, dramatic images that would earn him a Pulitzer Prize.

Firefighters and civilian volunteers worked together to raise ladders to help survivors get away from the wreckage. Lieutenant Hoffman used a telescoping ladder boom known as the Tele-squirt, which had a nozzle at the top of its forty-five-foot extension. Survivors descended the Tele-squirt to be given first aid as needed. Some victims spoke only Spanish; Guillermo P. Guillen, an off-duty marine from the Naval Air Station at Alameda, interpreted for them.

The most difficult—and dangerous—task that fire department firefighters and volunteers undertook was to crawl into the space between the decks looking for trapped survivors. On the upper deck, Oakland firefighter Mike Hill recalled, "The first thing we saw was this recreational vehicle smashed into a semi-truck rig. There was a man trapped under the dashboard. I remember a woman standing outside the truck saying, 'That's my father, help us,' and we spent about 45 minutes cutting him out with the Jaws of Life."

The man was Erik Carlson of Mahopac, New York; the woman was his daughter Diane. They were returning from Reno to Hayward on the 880 when the quake struck and their RV smacked into the rig trailer. "The majority of the man's lower body was crushed, so we put him in our Stokes basket (a special stretcher with high sides) and took him to the ladder," said Hill. Several people appeared seemingly from nowhere to help Hill with the stretcher as he took it down one rung at a time. "I was thinking as we took him down that this guy might not make it. He was looking pretty bad."

An ambulance took Carlson away, and Hill continued his rescue work. "I can't even remember how many people we saved," he said. "There were simple pull-outs we took from cars, people smashed under cement, people with their cars on fire, you name it. It went on all night." Hill thought Carlson was fatally injured, but he was wrong. Despite being paralyzed from the waist down, he lived another four years and died in his sleep of a heart attack. Hill was astonished at the news that Carlson had survived his injuries.

In all, eighteen of Oakland's twenty-one fire department companies took part in the Cypress collapse rescue efforts. Even so, more teams were needed. Neighboring municipalities did what they could to help. In his account of the Cypress disaster, Dave Fowler stated that the rescue operation "would ultimately require resources from the United States Army, Navy, Marine Corps, the Air Force, and fire departments as far away as Los Angeles." The City of Fremont, in Alameda County, sent its two new aerial ladder trucks and crews plus a half-dozen paramedics. Other cities, however, had their own problems. Berkeley had a major fire requiring all of its engines to combat it, and Albany and Emeryville had to deal with their own emergencies. Additional help for Oakland did come from Livermore City, Pleasanton and Daugherty.

After four days, rescue turned to recovery as it was determined that no other survivors could be found between the pancaked Cypress Viaduct decks. However, on October 21, an engineer inspecting the structure saw someone who was still alive. Buck Helm, a fifty-eight-year-old longshoremen's clerk, was saved from death because a large beam falling on his car had prevented it from being flattened. He was trapped for ninety hours. Rescuers found he had a fractured skull and three broken ribs. He suffered from dehydration. The news media called him "Lucky Buck."

Unfortunately, his luck ran out on November 19. Get-well cards and letters came to him from all over the world, but the toll on his body proved beyond the dialysis and respirator to aid his recovery.

With Helm's death, the final count of Cypress Viaduct victims came to 42, and the total number of deaths has been listed as 67 (some sources list 63). More than 3,500 people were injured, and as many as 12,000 people became homeless. Throughout the San Francisco Bay area, communities had to deal with cracks in sidewalks and building walls, yellow- and red-tagged structures, earth displacement, uprooted trees and lots of broken glass, bricks, houses off their foundations and many other issues.

Gary Young looked at his front yard in Santa Cruz. An eight-foot-long, eight-inch-wide chasm had opened there. "It just opened up like an egg," he said. "When the earth literally tears like a sheet of paper, that really sends home the power." Cliff Warren and his wife, Claudette, lived in a two-story house. "It's like a little bomb sitting on top of your house, ticking away," he said. "With each aftershock you wonder if this is the one that will do it." He and his wife chose to sleep downstairs rather than upstairs.

President George H.W. Bush came to Santa Cruz on October 20. "Is it proper for me to come here?" he asked. "If you do, they say you're getting in the way of the lifting of the building or the firefighting or whatever. If you don't, it's neglect." Bush viewed the scene of the Cypress Viaduct, where his presence slowed down the efforts of recovery workers. He promised Governor George Deukmejian, who accompanied him on the tour, aid money without red tape. Bush kept his promise. On October 26, he signed a $1.1 billion earthquake relief package for the state.

People in Watsonville, either having lost homes or afraid to enter them, slept in cars and tents. They gathered wood from a construction project to use in cooking fires. At least one hundred families had to be evacuated from their homes. Down the coast, the historic Cominos Hotel, badly damaged, was razed. Throughout the Bay Area, more than one hundred buildings, many listed in the National Register of Historic Places, stood in danger of being torn down. Kathryn Burns, western regional director of the National Trust for Historic Preservation, urged officials not to make any hasty decisions. "We're trying to tone down the hysteria and make sure there's a little calmer assessment of damage," she said.

In San Francisco, at least 240 buildings received the red tag, identifying them as severely damaged and considered unsafe. Larry Litchfield, the city's superintendent of building inspection, promised there would be no rush to demolish buildings. He said, "It's not our goal to demolish anything. It's our goal to save them, granted that there are some that just can't be saved." City inspectors would work with property owners, engineers and

structural experts to confirm whether a building would have to be torn down or could be repaired.

Santa Cruz lost more than three dozen buildings along Pacific Avenue, Cooper Street and Front Street, a commercial district. Demolished buildings included clothing stores, Ford's Department Store, Blue Moon Café, bookstores, the Colonial Hotel and others. Two young workers died when a wall fell on them in the Santa Cruz Roasting Coffee Company, and a woman was killed in Ford's Department Store. In a positive demonstration of community support, some four hundred volunteers showed up to help move thousands of books from Neal Coonerty's Bookshop Santa Cruz to safety and subsequently helped arrange them on shelves in the tent where Coonerty continued his business. Over a three-year period, forty-seven stores and restaurants would operate in a tent city.

The earthquake caused some $6 billion in property damage. In addition to President Bush's and Congress's aid, the besieged Bay Area received private donations. Demolition and rebuilding followed quickly after the quake in some instances. Caltrans replaced the collapsed section of the Oakland Bay Bridge, and it was opened to traffic on November 18, only a month after Anamafi Moala Kalushia was killed there. However, the eastern span needed to be replaced in a project that took eleven years, from 2002 to 2013.

The Cypress Street Viaduct was demolished and replaced with a single-deck freeway. Initial estimates for the project ran to $650 million. Eventually, the bill came to $1.2 billion, the most expensive project in California's history at that time. Much of the cost came from the state purchasing land owned by the Southern Pacific Railroad, the U.S. Army, the U.S. Postal Service and Amtrak. The re-routed Nimitz Interstate 880 was opened to traffic in 1997. Other freeways and highways had also suffered damage. The Embarcadero Freeway, long a subject of controversy and never completed, was taken down. The Southern Freeway (I-280), also incomplete, was revised and re-routed in a project that was completed in 1997. BART ridership soared from 218,000 during the work week to 330,000 while the Oakland Bay Bridge was being repaired. Ferries, long discontinued since the bridge was complete in the 1930s, were brought back into service to alleviate the overload on BART. Years after the quake, the ferries are still in use, having become a tourist attraction.

The Loma Prieta quake brought hundreds of lawsuits against the state over the failure of the Oakland Bay Bridge section and the collapse of the Cypress Viaduct on the Nimitz Freeway. Attorney David B. Baum represented Anamafi's father, husband and adopted child, plus her brother

Lesisita, who was partially paralyzed. Defendants included Caltrans employees and California Highway Patrol officers. Baum argued that Moala (and hundreds of other drivers) were on the lower deck of the bridge heading for Oakland when the quake struck. They were directed to go to the top deck and return to San Francisco. However, some drivers, including Moala, were not given clear instructions and continued on the lower deck. Some cars avoided the collapsed section; Moala's plunged into the hole.

The lawsuit was settled in April 1991, with the plaintiffs receiving an undisclosed but large lump sum of money and lifetime monthly payments to family members. In announcing the settlement, Joseph R. Radding, deputy executive officer of the state board of control, stated, "It is our goal to make fair settlement offers to all injured parties and survivors of those who were killed in the quake." Out of 411 claims that were made, 201 were settled, 5 rejected and 30 resolved by other means. As of May 1991, 284 claims were still pending.

Seismologists investigating the causes of the earthquake and the destruction that resulted from it placed the blame on the San Andreas Fault. In examining the heavy damage to homes and buildings in the Marina District, the reason once again, as it was in 1906, was that structures had been built on made ground—landfill that liquefied when a temblor struck. The fact that liquefaction occurred on such land was no secret, but it was a fact that real estate developers ignored and of which residents new to San Francisco were ignorant. Earthquake damage in such areas made no distinction between expensive homes and modest housing.

Magnitude 6.9 or even 7.1 put the Loma Prieta quake in the category of "moderate," or even "pretty big one," but not the Big One. Bay area residents were fortunate in that the quake occurred when it did, both at Candlestick Park when the stands were only half filled at 5:04 p.m. and not much traffic on the freeways and bridges; the death toll could have been much higher. To the south, Santa Cruz area residents were not so fortunate; their homes and commercial buildings sustained serious damage, but their fatalities were low in number.

The next major earthquake in California would find residents equally lucky in taking place on a national holiday.

THE 1994 NORTHRIDGE EARTHQUAKE

In 1980, Steve Fasoline opened Westside Automotive, an auto repair shop, in Canoga Park at the western part of the San Fernando Valley. His home was in Moorpark, some twenty miles west of his place of business. On January 17, 1994, he and his wife, Michele, were suddenly awakened at 4:31 a.m. by a 6.7 earthquake, its epicenter in the northwestern area of the valley. He and his wife lost no time in getting themselves and their two sons out of the house. Although the house had little damage, neither he nor his neighbors, who had gathered out on the street, were taking any chances. They found the landline phone dead, cellphone service intermittent and the cable out. "I did have a camping television set that was run on batteries," he recalled. "We fired that up and had a connection with the outside world."

Concerned about his business, Steve contacted his partner, Rudy Detgen, and they drove east on State Route 118, on which they seemed to be alone that morning. They drove carefully under freeway overpasses, mindful of what had happened twenty-three years earlier when overpasses and bridges had collapsed at the northern end of the valley. It could be just as dangerous driving across an overpass. "Every time we went over an overpass we bounced and hit our head on the roof of the jeep," Steve remembered. "The quake dislodged the bonding between the freeway overpasses and the concrete road."

Exiting at Topanga Canyon Boulevard, Steve was amazed at the large number of retaining concrete walls—the usual separation between homes and bordering streets—that were broken down. Going past Lanark Park,

they saw hundreds of people huddled around bonfires trying to keep warm, many sharing food and blankets. Westside Automotive seemed apparently unharmed. "But every light fixture was hanging from one side and every bulb had burst and shattered glass everywhere," he said. "One storage unit fell and like dominos they all came down. $35,000 worth of parts all askew. The cleanup looked like a task that was bigger than the both of us."

The phone remained inoperative, but electricity was working. Steve took the fax machine phone, unplugged it, stripped the wires back on the phone cord and found the telephone pole junction box behind the shop. He hooked up the wires and got a dial tone. Steve called all his employees—some had phone lines working, some did not and a few had cell phones—and asked anyone who could to come help clean up the mess at the shop. "Thirty minutes later I had a shop full of men." Businessmen in the area were told that Steve had a working phone line. "At one point we had about 25 people in line to use the phone," he said. "Most of them called out of town to assure friends and family that we had no power or phone, but all is good."

One neighbor had a generator and brought over hot coffee. The owner of the 7-11 at the corner brought pastries. At the end of the day, Steve, Rudy and their employees had cleaned up the mess and were ready to do business. "I came together with neighbors that day I never would have met otherwise," Steve recalled.

At the northeast end of the valley, Lori Underwood had bought a house in Sylmar despite the concerns of her parents who well remembered the 1971 earthquake. Monday, January 17, 1994, was a holiday marking the observance of the birthday of Martin Luther King Jr., making it a three-day weekend for many people and a four-day one for Lori, who was usually off on Monday, so Tuesday would be a bonus. Lori's five-year-old nephew Alex was visiting with her for the long weekend. "When the earthquake started I jumped out of bed and ran to the guest bedroom, concerned for Alex's safety, and to comfort him," recalled Lori. She was surprised to find he had slept through the initial temblor. Lori carried him out of the house and found all the neighbors were also outside. She went back to get a warm jacket, but all she could find for Alex was a purple sweater, which her nephew reluctantly accepted.

Alex and the other kids on the block soon had a great time playing on the street and were not concerned about earthquakes. While they were playing, the adults watched transformers explode on power poles. With the sunrise, they could see dust clouds coming off the nearby San Gabriel Mountains

every time an aftershock rumbled. Families brought out food from their homes, and everyone had breakfast on the street.

Lori's parents lived a few miles away in Granada Hills; her sister (Alex's mother) lived in Chino Hills, some sixty miles away. Her brother Dan lived in Chatsworth with his wife and daughter at the northwestern end of the valley. Lori's parents insisted that she and Dan come to their house and that Lori's brother-in-law Jeff drive from Chino Hills to pick up Alex. "I didn't want to go because there was a major block party on my street," Lori recalled. "Mom insisted, and being a good kid I finally gave in and Jeff (who had arrived from Chino Hills), Alex, and I drove over to my parents' home in a two-car convoy."

Driving from Sylmar to Granada Hills, ordinarily a fifteen-minute trip on State Route 118, was not easier said than done. Streets closed and/or flooded, freeway overpasses had collapsed once again at the I-5 and Antelope Valley interchange and emergency vehicles making it necessary to pull over made the trip "like driving through a war zone," said Lori. "There was no safe, direct route to get there." It took an hour of navigating through neighborhoods, avoiding earthquake destruction, to get to her parents' house—where there was neither gas nor electricity. The family used the stove in her parents' tent trailer to cook up a spaghetti dinner.

Lori returned to her own home the next day. Other than a few small cracks, the house had escaped damage. Moreover, the utilities were working. Ironically, "After all the pre-earthquake concern for me and my house on the hill in Sylmar, my parents had no utilities for more than a week and had to come up to MY house to shower and wash clothes, and my brother Dan and his wife and daughter had to move in with me for three months while their home was being repaired."

Over in Reseda, Glenn Thornhill lived with his father (his parents had divorced). An experienced camper, Glenn was a member of the Platrix Chapter of the Ancient and Honorable Order of E Clampus Vitus, an all-male organization interested in California history that held campouts at various places of interest, erected historical markers and had lots of fun. So when the earthquake woke him up at 4:31 a.m., he thought he had prepared for such an event, earthquake or power outage or whatever: four flashlights stashed in four different rooms, one on his bedroom dresser, a second one in his office/library, a third in the kitchen and a fourth in his father's bedroom.

Sometimes best-laid plans go astray. The dresser had toppled over, and in the dark, the flashlight was nowhere to be found. The door to his office was blocked by the seven-foot standing bookshelves that had fallen over. In the

kitchen, the earthquake moved the refrigerator to the door and effectively blocked it. That left his father's bedroom. In the dark, Glenn found the six-foot cord attached to the flashlight and pulled it to him through all the stuff the earthquake had tossed to the floor.

After all this, Glenn found his landline phone working, and he was able to call his mother, who lived in the Antelope Valley, and his aunt and uncle in Connecticut, telling them to relay the message to other relatives that everyone was okay. Then the phone lines went on overload, and he had no phone service for several days.

"At dawn, the cleanup began," recalled Glenn. "It took a couple of hours to find my key ring, which allowed me to open the house's side door into the laundry room so I could then work my way into the kitchen to start the cleanup. I didn't get into the library until the next day." No electricity, but the water pipes worked, and friends came over to take cold showers. (The gas was turned off.) A friend had a large number of frozen steaks and pork chops thawing out in his refrigerator. Glenn agreed to grill them, but his camping equipment was in the garage, and its door wouldn't open. Glenn's promise of the "filet mignon hot off the grill was a strong motivator and there was no shortage of help prying open that out-of-whack garage door."

Glenn Thornhill and Lori Underwood met as members of the San Fernando Valley Historical Society, with which Glenn served a term as president. They married in 2003.

The January 17, 1994 earthquake's initial shock had its epicenter in Reseda, east of Canoga Park and south of Northridge in the San Fernando Valley in the city of Los Angeles. Early reports by the media called it the Northridge earthquake, and it has carried that label ever since. After the quake, some prankster (hopefully not a real estate agent) circulated photocopies of a map with boundaries showing the postal zip codes for the valley, purporting to show that it was safer to buy a house in some zip codes than others. Of course, nature's earthquakes don't pay attention to zip codes, but residents paid a great deal of attention to what happened to them, their homes and their friends because of the quake.

Photocopy machines also cranked out satiric cartoons. One, labeled "GREETINGS FROM CALIFORNIA," showed a husband, wife and child (attempting to pick his nose) and the family dog waving "hello" while everything was shaking vigorously. Another map retitled all the neighborhoods: Cracksworth, Granada Spills, Shakin Oaks, Slipmore, Sunk Valley, Tobanga Canyon Boulevard, and Crack-o-ga park. An arrow pointed to "Quakersfield," I-5 was the "Golden Shake Freeway" and

Humor from disaster, a cartoon after the 1994 Northridge earthquake. *Author's collection.*

Map suggesting name changes of streets and neighborhoods in the "San Fragmented" (San Fernando) Valley after the Northridge earthquake in 1994. *Author's collection.*

California State University–Northridge was listed as "Cracked State U." Apparently, if all else fails, try humor.

Unfortunately, the Northridge earthquake provided little opportunity for laughter. When the quake struck, at the interchange in Newhall Pass where Interstate 5 (the Golden State Freeway) connected with State Highway 14 (the Antelope Valley Freeway), the overpasses collapsed, killing Los Angeles police officer Clarence Wayne Dean as he was riding his motorcycle at that very moment. In the darkness, he didn't see the collapsed bridge until it was too late. The rebuilt interchange was named in his honor.

Valley residents gave a collective sigh of relief, for a 6.7 quake could have been much worse. A 6.0 aftershock came just one minute after the initial temblor, and a second one of the same magnitude struck eleven hours later. A total of 72 people died, 16 in one building: the Northridge Meadows Apartments, where the upper floors pancaked onto the ground floor. More than 8,000 people were injured, 1,500 of them taken to hospitals. Estimates of property damage ran between $13 and $40 billion. The quake came from a previously unknown fault, now given the name of the Northridge blind fault (basically a rolling rather than a jolting).

Three places in proximity to the epicenter experienced major damage. At the Northridge Meadows Apartments, the ground-floor residents never had a chance. Time and date proved mitigating factors in the other two locations. The multi-tiered parking lot at the Northridge Fashion Center caved in, and the Oviatt Library and other campus buildings at California State University–Northridge were so badly damaged as to require new construction to replace them. On the positive side, no one was in the university buildings at that hour of the day, a federal holiday with no classes in session. A few hours later on a usual school day, and the casualty lists would have been much greater at the college campus and the mall parking lot.

Eleven Valley hospitals were so damaged as to be unable to offer any aid to injured people. Patients had to be transferred to other hospitals, increasing their burden. Schools in the affected area were closed for a week while their buildings were checked for damage. Determining that classroom buildings at Los Angeles Valley College in Van Nuys did not seem to be damaged, administrators announced that classes would be in session on Tuesday, then recanted and declared the campus closed for the week—students and faculty had objected because they had more immediate issues, such as cleaning up the mess in their homes and dealing with possible injuries. In Valencia, immediately north of the epicenter, a private college, California Institute of

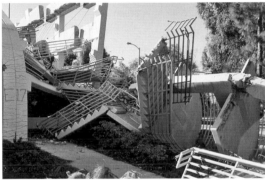

Top: A sawhorse warns people of the damage to the sidewalk at CSUN after the 1994 Northridge earthquake. *Courtesy Special Collections and Archives, Oviatt Library, California State University, Northridge.*

Bottom: Damage to the parking lot at California State University, Northridge, caused by the 1994 Northridge earthquake. *Courtesy Special Collections and Archives, Oviatt Library, California State University, Northridge.*

the Arts, sustained heavy damage, necessitating relocation of students to a Lockheed facility in Burbank for the rest of the year.

As with other California quakes, the Northridge one could be felt far from the epicenter. Phil Binderman and his wife and another couple were spending the weekend at Lake Arrowhead in the San Bernardino Mountains, one hundred miles east of Northridge. The quake awakened them. The television in their room worked, and they learned about the quake striking the valley. The Bindermans lived in Woodland Hills near Pierce College, a community college in the valley. "Drove home expecting the house to be demolished," Phil tersely reported. "Major damage inside, pool deck and driveway damaged. Piano knocked five feet away from the wall. Many cracks in walls. Chimney OK." Electrical power came back around 11:00 p.m., and their water lines worked. "Friends from other areas came over to shower and wash clothes," said Phil.

About a dozen miles south of Woodland Hills, Mark Abbot Stern and his wife lived in Beverly Hills, the two locations separated by the Santa Monica Mountains. He recalled:

We had lived in the same house on Oakhurst Drive for 21 years and there had been occasional jolts from time to time, but this had been a big one. We had no idea how big, but it was big. Flashlights in hand, we surveyed the damage. There were books all over the place as if they had been the target of the quake. Kitchen and dining room cabinet doors had been flung open, and dishes and glassware were strewn about the floors and in the sink in a million pieces.

After sunrise they could make their way through the debris and assess the damage. They found stress cracks above doorways in several rooms. On Wednesday, a team from the Beverly Hills Fire Department inspected the house and informed the Sterns their chimney was about to fall down. Later that day, another team showed up and pulled down the chimney. The estimates for chimney replacement "were eye-popping. It's a good thing there was FEMA."

John Dillon was only three years old at the time, but the event remained memorable for him for another reason. He "had just graduated to the 'big bed' that very night. I awoke to a lot of shaking and the rocking horse on top of the book shelf falling on top of me. Afterward, we evacuated the house and slept the rest of the night in sleeping bags in the backyard." The Dillons lived in Panorama City (now North Hills), not far from the epicenter.

Bo Pollard found that the Northridge quake "threw everything in the house that was on a northern wall to the floor and smashed. Every item on both mantels was thrown to the floor and smashed with the startling exception of a single trophy in the family room upon which hung a St. Christopher's medal and a sculpture of the praying hands on the formal living room fireplace." A week prior to the quake, Pollard had gone into escrow on a vacation home at Lake Tahoe. Within a week after the quake, he closed his law practice and left Los Angeles permanently, other than occasional visits to family and friends.

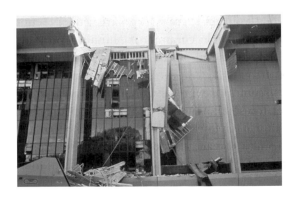

Damage to a campus building at CSUN after the 1994 Northridge earthquake. *Courtesy Special Collections and Archives, Oviatt Library, California State University, Northridge.*

Phil Nathanson lived in a condominium near Santa Monica and Westwood Boulevards near UCLA. His reaction to the quake was to pull the bed covers over his head:

> *Simultaneously, I uttered a profanity as I felt a sharp pain in my right leg. I had been through a number of quakes and this one seemed different....I finally found a light and saw a fair amount of blood on my leg. Looking at my bed, I saw a piece of green glass that looked like a knife blade on top of my comforter. It was from a brass floor lamp across the room that had a green glass globe on top. It had come down on the bed, slicing through the covers into my leg.*

Phil talked to his condominium's owners, who also happened to own a structural engineering firm. They told him that on the side of the building it had risen eighteen inches above the ground. Studs were pulled loose, and nails had scraped marks right up the walls. "It was then that I had a full appreciation of the force of the quake," he said. "It had probably thrown the glass globe up against the ceiling where it shattered. I wasn't even close to ground zero. But I was located right on a thin line the quake followed from Northridge to Santa Monica."

Suzanne and Robert Bermant went outside after the quake and joined their Tarzana neighbors on the street. Damage to their house was minimal, but they had a mess to clean up from a bottle of spaghetti sauce that had broken and spilled all over a wood floor. "We were also very lucky that our son was at home because he was a student at CSUN, and there was a lot of damage there." Their most immediate concern was caring for their dog, Smokie, who had a paw cut by broken glass. They were also surprised to find that the light bridge above their bed had fallen and landed on their pillows.

Joan Mathews lived in an apartment in Burbank. "I had a long gallery kitchen and at one end of it was my dining room. I was dismayed to find a bottle of dried onion flakes that had flown from inside a cupboard on a turntable the entire length of the kitchen, ending up in the dining room—a length of about twelve feet," she recalled. "It was also unsettling to open a self-closing drawer in the kitchen, only to find a broken tea cup or saucer." A friend of hers, Kevin Maher, died when he tried to help a mother and her child who were trapped in a vehicle where a live power line had fallen on the car. In doing so, he was electrocuted. The family held the funeral at the San Fernando Mission, and during the funeral, there were no aftershocks. Another friend lived in Simi Valley and kept a number of steel-reinforced

wine racks in his bedroom. "When the earthquake hit all the bottles shattered," said Joan, "and the only way he could get out of the room was to use his coffee table-sized wine books to use as a footpath."

A surviving trophy and St. Christopher's medal, shattered glass stabbing a man in his bed and injuring a dog, a bottle of onion flakes flying across a kitchen, a Good Samaritan killed by a power line—stories abounded of the earthquake causing often bizarre events. More mundane injuries included patients treated for broken bones, glass cuts, bruises and, apart from physical wounds, stress issues. Several people died from heart attacks.

Sanitation created immediate concerns. Although many areas had no water for more than a week, the region's sewer lines had not broken. This fortunate situation made it possible to flush toilets; all that was needed was a bucket of water to make a toilet do its job. Swimming pool owners could generously provide it to neighbors bringing buckets to "borrow" water. Stories of people digging latrines in their backyards are probably exaggerated. However, a day after the quake, it was noticed that hundreds of people, afraid to go into their homes, were camping out in open areas such as parks and school playgrounds and athletic fields. With nowhere to go—city park facilities still required water to flush toilets—some people were defecating along the perimeters of these open areas.

Authorities wasted no time in providing portable outhouses to solve the problem. It also helped that despite aftershocks, people wanted to inspect their houses. With little structural damage evident, residents decided it was safe to go inside and clean up the mess the quake had made. Hospitals placed portable toilets in the parking lots. The lots also served as the location for makeshift emergency rooms, where doctors and nurses worked overtime in diagnosing patients' problems. This was a daunting task, as some injuries required CAT scans and imaging equipment, but the machines needed electricity to work. It was imperative that electric power be restored as quickly as possible, a task DWP workers accomplished within a few days.

Until clean water could be restored, the California National Guard provided water trucks at locations like local high schools. People holding everything from five-gallon bottles to large buckets and even canteens lined up to get some potable water. A National Guardsman (with unloaded rifle) standing at the water truck persuaded anyone from cutting in line.

The greatest tragedy of the quake occurred at the Northridge Meadows Apartment building. Its ground-floor residents never had a chance, as the building collapsed on them. Sixteen people died there. One survivor, a veteran of Operation Desert Storm, spent more than three hours trapped in

the rubble until rescuers got him out. Three of his roommates died. Dr. Steve Salenger, chief of staff at the Patton State Hospital, said of the survivor, "He couldn't move, and he could hear one of his roommates slowly choking to death each time there was a slight settling of the rubble."

Interstate 10, generally known in metropolitan Los Angeles as the Santa Monica Freeway, lost two bridges when the quake hit, even though the location was at least twenty miles from the epicenter. The Santa Monica Freeway carried an average of more than 340,000 vehicles a day. Without it, commuters had to seek alternate routes to get to and from work. They had to endure lost time and traffic jams, and businesses suffered from the disruption of a major transportation network.

Fortunately, no one was killed or injured as a result of the collapse of the bridge. It was imperative that the bridges be replaced as soon as possible. Caltrans set a deadline of June 24, 1995, for a construction company to complete the repair work, sweetening the challenge with a bonus of $200,000 for every day the work was completed ahead of schedule. There was a catch to the offer: a penalty for every day after the deadline.

The firm of C.C. Myers Inc. accepted the challenge of building two new freeway bridges. The company had experience in meeting such a task: it rebuilt two bridges that had collapsed in the Loma Prieta earthquake, completing the work forty-five days ahead of schedule. Money proved a prime incentive, as the firm collected $30,000 for each day the project was completed ahead of schedule. The pot for the Santa Monica Freeway bridges was considerably larger.

Clinton Myers, president of the construction company, knew how to meet the challenge. He hired extra workers, rented additional equipment and paid his crews overtime. Rebuilding the bridges—or, more accurately, building new ones—called for a race against time, as the closure of the freeway cost the region $1 million a day. Crews worked on the project twenty-four hours a day, seven days a week. Caltrans facilitated the effort by eliminating bureaucratic red tape.

Myers's company completed the project seventy-four days ahead of schedule and collected a $14.5 million bonus. The freeway officially opened on April 12. After paying for the rented equipment, extra workers and overtime pay, Myers netted a profit of around $8 million. When asked what he would do with his money, he answered, "I gonna buy me a bigger airplane." Myers never doubted he would beat the deadline. "I wouldn't say it was a piece of cake, but we knew we could do it within 100 days," he said. Meanwhile, companies working on other damaged or demolished

bridges, using similar incentives, also expected to finish their projects ahead of schedule.

Los Angeles mayor Richard Riordan cheered the accomplishments. "This Santa Monica project demonstrates what can happen when private sector innovation and market incentive replace business as usual. This is the way government should be carried out all the time, not just emergencies." Governor Pete Wilson declared at a news conference by the new bridges, "This freeway, with its broken bridges, broken connectors, became one of the most visible signs of the devastation brought upon Los Angeles by the Northridge earthquake." Evidently, he overlooked the destruction and loss of life in Northridge itself. He said that the reopening of the freeway symbolized "the energy of this great community." The price paid for the "energy" came to almost $30 million for the bridges.

The Northridge quake indirectly created opportunities to examine some of the region's oldest buildings that long antedated building codes. For example, the Pio Pico mansion in Whittier, built in the 1850s, survived (with some damage) no less than four quakes—1857, 1971, 1987 and 1994. After the Northridge quake, researchers could see where the building's cracked walls had revealed the original adobe bricks used in constructing the home of the last Mexican governor of California. Remodeling over the decades had covered up wallpaper, doors and windows that were now exposed. Now Pio Pico State Historic Park, Pico's home, El Ranchito, has been renovated at a cost of $2.1 million, its walls reinforced by the latest building codes.

In the San Fernando Valley, Los Encinos State Historic Park includes the two-story Garnier building and the De la Osa adobe. The Northridge quake badly damaged both structures. It took $1.2 million for restoration of the buildings, completed in 2002. The structural engineer in charge, Nels Roselund, said, "The northern wall was close to collapse. It was kind of scary even getting close to it to start working on it. The way it was built, it was just a stack of stones mortared together." Today, tour guides point out evidence of the 1994 quake, and an exhibit traces the history of what began as a cattle and sheep ranch and is now a venue for weddings and other events.

The San Fernando Mission, founded in 1797, has sustained damage from quakes in 1857, 1971 and 1994. It was allowed to fall into ruin in the latter part of the nineteenth century, but organizations raised funds to restore the mission and make it a landmark place in the Valley. The San Fernando and Northridge quakes injured but didn't destroy the historic buildings. Visitors today should note that what they see may not date to 1797 but includes parts only as old as the renovations made after 1994.

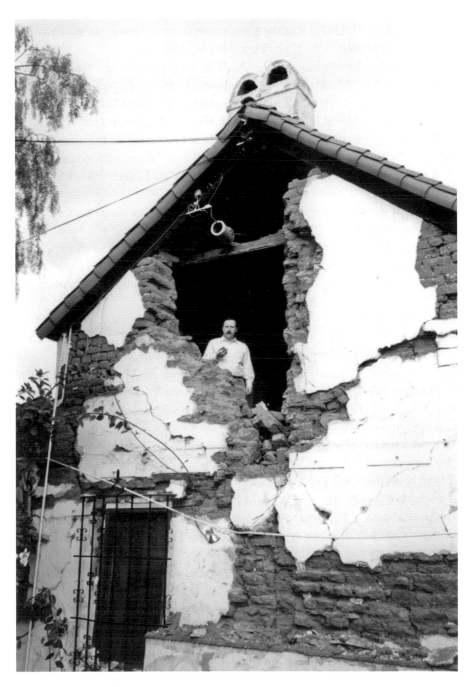

Glenn Thornhill examines damage to the historic Andres Pico Adobe in Mission Hills after the 1994 Northridge earthquake. *Courtesy of Glenn Thornhill.*

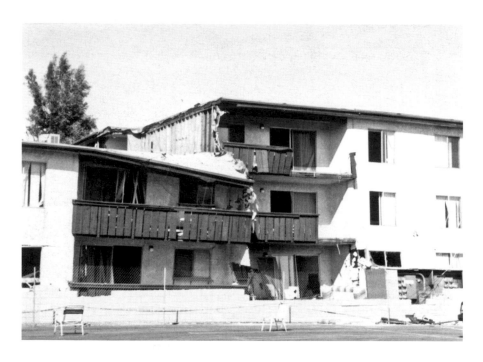

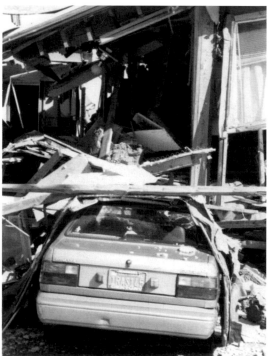

Above: Earthquake damage to an apartment building caused by the 1994 Northridge earthquake. *Courtesy of Glenn Thornhill.*

Left: Wood from a severely damaged home covers an automobile in the aftermath of the 1994 Northridge earthquake. *Courtesy of Glenn Thornhill.*

Opposite, top: This home shifted enough to crush an automobile parked in the driveway during the 1994 Northridge earthquake. *Courtesy of Glenn Thornhill.*

Opposite, bottom: Wooden pallets support a weakened carport after the 1994 Northridge earthquake. *Courtesy of Glenn Thornhill.*

A History

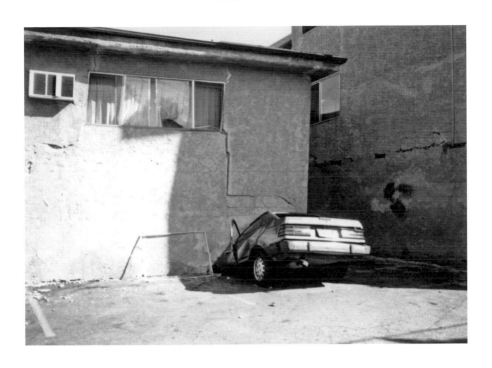

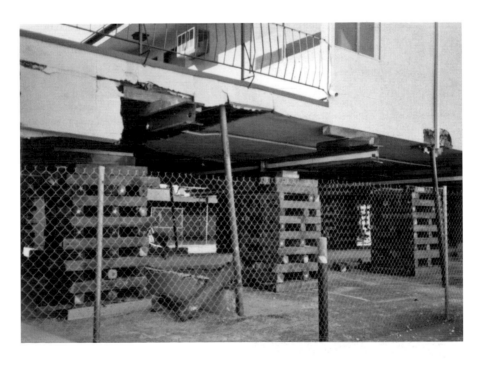

Across the street from the mission are the grounds of the Andres Pico Adobe, the second oldest building in the San Fernando Valley, dating to 1834. Andres was the brother of Pio Pico. Although Andres never lived in the building named for him, he operated a cattle ranch in the Valley. The Adobe is located six miles from the Northridge quake's epicenter. In December 1992, city authorities approved an earthquake stabilization project for the Adobe, but the earthquake hit before the work began. It caused extensive damage in some walls that collapsed, and others had large cracks. The Getty Conservation Institute's report stated that previous water damage had weakened the structure. After the quake, the City of Los Angeles began a restoration project that took three years and cost $450,000. The San Fernando Valley Historical Society, which utilizes the city-owned Adobe, has its headquarters there, and offers tours, a research library and exhibits of Valley history.

Other buildings did not enjoy similar restoration efforts. Certain apartment buildings came in for considerable criticism as to their design. These were usually two- or three-story buildings with a carport underneath and held up by pillars that proved to be structurally unsound. Such buildings, known as "soft structures," collapsed onto the carports, flattening vehicles parked there and, in some instances, starting fires. Government and assistance programs paid $25 billion for rebuilding, but homeowners had to shell out $15 billion. Nearly 1,900 buildings were red-tagged and either brought up to earthquake code or demolished. The city issued close to seventy thousand permits for repairing houses, apartments and offices. And that was just for the city of Los Angeles.

All over the Valley, homeowners faced the task of getting cinderblock retaining walls rebuilt. These ubiquitous walls served as boundaries for backyards and houses fronting on streets. Contractors rang doorbells offering to repair the walls, as well as cracked driveways. Walls could be strengthened by inserting rebar into the blocks. Some of the contractors turned out to be unscrupulous, demanding up-front payments and then disappearing before work was completed or even begun. City authorities cautioned homeowners to get written estimates and not to pay more than 10 percent before repair work was done.

The official death toll was counted initially as fifty-seven, with 9,000 injuries. By the end of the year, the count was up to seventy-two, with 11,846 injuries that were quake-related. The discrepancy between the numbers of the dead may have been due to people who died of heart attacks rather than fatal injuries, including one person who committed suicide, disheartened at the destruction of his uninsured business.

The quake disrupted large sections of the region's economy. Movie studios and office buildings were closed for repairs, some briefly, others until repairs were completed. Universal Studios Hollywood felt obligated to close down its Earthquake attraction based on the 1974 film of that name. Disneyland, Knott's Berry Farm and Six Flags Magic Mountain were closed briefly for inspection. A week after the quake, almost all public schools were back in session, as were local universities and community colleges. California State University–Northridge proved the exception. Many of its buildings were badly damaged, and classes had to be relocated to alternate places for the rest of the year.

It was obvious that changes would have to be made in upgrading building codes. The freeway bridges that had collapsed in 1971 and again in 1994 needed greater retrofitting standards. The state legislature created the California Earthquake Authority to offer some earthquake insurance coverage for homeowners, though the co-payment would be too steep for many homeowners to make it worthwhile. A law was passed in 1995 requiring water heaters to be securely strapped to walls.

Seismologists took a baleful look at the "soft-structure" apartment and office buildings with carports and the failure of pipe columns to hold up the buildings. They also utilized data to develop patterns of earthquake faults, the frequency of disruptions and locations.

The raising of earthquake standards and retrofitting, however, tended to overlook loopholes in state laws and regulations. Owners of older buildings—ordinary apartments and office buildings, as well as homes constructed as far back as the 1920s—were reluctant to undertake the great expense of retrofitting them. Thousands of buildings throughout California remained vulnerable to earthquake jolts. The 1994 Northridge earthquake was the biggest such event in the 1990s, but it wasn't the only one, and while memory may have faded, the possibilities of a Big One, a pretty big one and lots of not-so-big ones would reawaken concern about living in earthquake country.

RECENT EARTHQUAKE ACTIVITY

This chapter deals with earthquakes that have occurred in California over the past forty years, with the exception of the Whittier and Northridge quakes, discussed in the previous chapters. It by no means covers *all* the earthquakes, just those that were mainly 5.0 and above and did little more than rattle the dishes in the cabinet and, regrettably, killed some people and injured others. A few tremors that were under 5.0 have been included because they received media coverage. The U.S. Geological Survey (USGS) cautions that a small quake may be followed by a larger one within five days, providing a mathematical probability that may be as little as 5 percent or up to 95 percent.

Coalinga, a small town in California's southern San Joaquin Valley, suffered a 6.2 to 6.5 earthquake at 4:42 p.m. on May 2, 1983, surprising both residents and seismologists, as a previously unknown fault was its cause. Nearby Avenal, another small town, experienced some damage. Fortunately, no one was killed. Ninety-four people were injured. "It could have been an enormous disaster, with millions of dollars in damage," observed Ken Maley of the governor's earthquake preparedness task force.

On June 17, 1985, three quakes jolted San Diego within a four-hour period. Tom Heaton, the scientist on duty at the USGS, estimated a 5 percent chance of an aftershock greater than 5.0. Although Heaton made this statement as a *probability*, the media and general public might well have interpreted the statement as a *prediction*, which it wasn't. USGS officials stressed that the important thing to do before an earthquake is to plan for

when it comes. Fire, police and hospital agencies need information; but it can be tricky if a prediction causes mass hysteria.

In any case, the San Diego quakes were small, and no larger ones occurred afterward. USGS staff seismologist Lucile Jones, who in recent years became the go-to person for the media when an earthquake occurred, did considerable research on small quakes (3.0 or lower) since 1931, and found that 6 percent were indeed followed "by an event larger than the first and—while a small number—it is a higher percentage than we expected," she said. For seismologists, knowledge was an ongoing effort.

The Sierra Madre earthquake struck on June 28, 1991, and lasted fifteen seconds. It killed two people and caused moderate damage in Pasadena, Sierra Madre, Monrovia, Arcadia and other nearby communities. Its magnitude was estimated at between 5.6 and 6.0. Located in the San Gabriel Mountains just north of metropolitan Los Angeles, the epicenter was close to Charles Richter's office at the California Institute of Technology. More than one hundred people sustained injuries, most of them minor, such as cuts and bruises. Tragically, a steel beam at the Santa Anita Race Track grandstand in Arcadia was shaken loose, killing thirty-four-year-old Julie Nickoley, a horse handler at the track. The same beam also struck Arthur Lerille, whose shoulder was dislocated. Stress from the quake caused Barbara Sutherland, age sixty-eight, to die from a heart attack.

Janet Whaley was getting ready for work at the Pasadena Chamber of Commerce when the quake struck. At the time, she lived in a three-story apartment building near the I-210 Freeway. "As I braced a cabinet from falling in my bedroom, I could hear the glass breaking as things poured out of my kitchen cabinets," she recalled. "My refrigerator had 'walked' several inches across the kitchen." The "things" exiting the cabinets included honey, jam and syrup, "making a lovely concoction of glass and sticky elements." Janet tried to call her office, but the phone was dead. She spent the next several hours cleaning up the mess. Her fiancé arrived to tell her that her boss had asked him to check to see if she was all right, as she had not been able to contact her by phone. It turned out that the quake had knocked an extension phone off its cradle and buried it under books that had fallen off shelves. Hence, no dial tone.

The earthquake damaged historic buildings in Pasadena, including the famous Pasadena Playhouse (which would be rebuilt), and knocked chunks of concrete off the 112-foot bell tower of the Westminster Presbyterian Church. Many people told newspaper reporters that the quake reminded them of the recent Whittier Narrows earthquake in 1987. Jeff Langen,

owner of a paint and wallpaper store in Whittier, felt the quake. "We have such horror stories from the last one that all I could think of was I can't go through it again," he said.

Apart from the tragedy of two deaths, a few serious injuries, and the inevitable property damage, not to mention jittery nerves, the Sierra Madre earthquake did not occur on the dreaded San Andreas Fault. Seismologists laid the blame on the Clamshell-Sawpit Fault deep in the mountains; blame was also placed on the Sierra Madre Fault. USGS seismologist Lucy Jones summed it up: "On a worldwide scale, this is a real puny earthquake."

On April 22, 1992, an earthquake struck the area of Joshua Tree in the Mojave Desert. Preceded by a 4.6 foreshock, the quake was of 6.1 magnitude in a sparsely populated area. The communities of Joshua Tree, Yucca Valley, Desert Hot Springs, Palm Springs and Twenty-Nine Palms experienced some damage and minor injuries. Seismologists expressed concern that there might be a 5 to 25 percent chance of a larger quake on the San Andreas Fault. Cities as far away as San Diego, Las Vegas and Phoenix also felt the quake. Just three days later, on April 25, a major quake hit Northern California, weighing in at 7.2 near Cape Mendocino in Humboldt County. Although no one died, ninety-five people were injured. Two strong aftershocks followed the initial temblor, and a tsunami splashed up at Crescent City.

Seismologists believed that the Joshua Tree and Humboldt quakes were not related. They could not be tied to one single major fault line. Subsequent aftershocks, though, were felt as far south as Salinas, east to Reno and north to Oregon. Numerous aftershocks hit in the 4.0 to 4.8 range but caused little damage.

Two months later, and a year to the day after the Sierra Madre quake, two major earthquakes occurred just a few hours apart on June 28, 1992. The first one, the Landers quake, struck at 4:57 a.m. James J. Jackson and his wife, Teri, both U.S. Post Office supervisors, were vacationing at the Mountain Lakes RV Park at Lytle Creek in the eastern San Gabriel Mountains. They were awakened by their trailer "shaking like a small boat in rough seas." James first thought some pranksters were outside rocking their RV. Then they realized they were experiencing a major earthquake. "We got up and immediately drove to our house in Highland to survey the damage this earthquake must have caused," he recalled. "To our surprise we saw no immediate damage." Later, cracks in the stucco walls appeared that James thought were likely caused by the Landers quake. "We were not covered with earthquake insurance anyway," he recalled.

The initial Landers quake registered at magnitude 7.3. Meanwhile, at 8:05 a.m., just three hours after the Landers quake, another quake hit Southern California, this one near the community of Big Bear in the San Bernardino Mountains. At magnitude 6.5, the epicenter was some twenty miles west of Landers and around six miles from Big Bear Lake. The quake caused landslides and toppled chimneys in the vacation homes surrounding the lake and in the town, famous as a winter ski resort. Seismologists did not consider the second quake an aftershock of the Landers quake, but that the San Andreas Fault might have been the cause of both quakes.

Only one person died in the Landers quake, and none at Big Bear. The casualty was three-year-old Joseph Bishop, whose parents, Cindy and John Bishop, had been raised in Yucca Valley. They lived in Massachusetts and had returned for their twenty-year high school reunion, bringing their five children with them. While the reunion affair was taking place, Joseph and several other children whose parents were friends of the Bishops attended a slumber party. When the quake hit, the boy was asleep in a sleeping bag by the fireplace. A wall of bricks and rocks came down, hitting Joseph on the head and killing him. With deep roots in the town, the Bishops were consoled in their grief by the community. "A lot of people in this town knew them," said Kindred Petersen, mayor of Yucca Valley. "People are standing by ready to provide any assistance when they need it. I know how important it is to have that support."

Soon after the second quake, eight seismologists and geophysicists from Caltech and the Pasadena USGS office met to discuss the apparent coincidence of two large but seemingly unrelated quakes occurring within the same general area just hours apart. The *Los Angeles Times* summarized the main points of the meeting in question-and-answer format. The occurrence of two quakes was uncommon but not unheard of. The Humboldt County and Joshua Tree quakes the previous April had occurred just three days apart, but hundreds of miles had separated the two events. All eight scientists agreed that the Johnson Valley Fault had caused the Landers quake, but the temblor at Big Bear came from an as yet unnamed fault.

Seismologists had placed 220 seismographic stations throughout Southern California that measured quake waves and intensities, and they expected reports to come from all over the world. Caltech seismologists, among them Kerry Sieh, a prominent scientist, found a surface rupture that was thirteen miles long near Landers. Lucy Jones of the USGS expressed concern that since 1986, Southern California had experienced six 6.0 or greater quakes—

and a possibility (not a prediction) that a Big One could occur. However, other than Landers aftershocks, the swarm of quakes seemed to subside for the next several years.

On October 16, 1999, at 2:46 a.m., a huge quake with a magnitude of 7.1 struck a remote area of the Mojave Desert near a quarry called Hector Mine, giving its name to the quake. It was preceded by twelve foreshocks of much less magnitude. This event lay near the same location as the Landers quake. Coming in the middle of the night, it awakened people in Las Vegas and even farther north, in Carson City, Nevada. Late-night (or early morning) gamblers momentarily stopped putting coins in slot machines and shooting dice, then resumed their gaming. Its remoteness meant little property damage and only a few minor injuries. An Amtrak train had the bad luck to be going through the area when the quake hit. The train was derailed, but no one was seriously injured.

By this time, Caltech, the USGS and the State Division of Mines and Geology had developed a map that measured intensity rather than magnitude. The map was based on reports from thousands of people who had experienced firsthand the effect of the Hector Mine quake. The *Los Angeles Times* published a map of Southern California using the Mercalli intensity scale of I to X, X being the worst possible damage. Interestingly enough, the map showed areas by zip code, with yellow and orange areas denoting measurements of VI to VIII—strong to severe.

With the beginning of the twenty-first century, earthquakes came one after another, none of them the Big One but some doing serious damage. These quakes followed no clear pattern in that they occurred all over California, in remote as well as highly urbanized areas, and pretty much put a final end to the naïve view that lightning would not strike twice in the same place.

On Saturday, January 14, 2001, two moderate quakes measuring 4.2 and 4.1, respectively, hit near the San Fernando Valley at 6:26 and 6:51 p.m. Seismologist Lucy Jones at the USGS said, "We are not calling them aftershocks. We haven't had a magnitude 4 aftershock from Northridge in two years." Jones seemed less concerned about the quakes than did newcomers to the area. Elizabeth and Michael Marcheschi had left Chicago in 1995 "where the snow and the cold shows that God is trying to get you," Michael told the *Los Angeles Times*. "Here, it comes out of nowhere."

In the main, residents in the San Fernando Valley apparently thought the quakes weren't worth getting excited about. Officer Leonard Yniguez of the San Fernando Police Department said, "The only people calling in, quite honestly, are newspaper people."

On the same day, a 5.4 struck off the state's northern coast, some sixty miles out in the Pacific. No damages or injuries were reported.

Nine months later, a 4.2 quake struck the Los Angeles area at 4:49 p.m. on September 9, 2001, an event eclipsed by the tragedy of the terrorist attack on New York City and the Pentagon two days later. Jim Wells of the Los Angeles County Fire Department dismissed the twenty-second temblor as a minor quake. "It will shake the nerves and the dishes, but not do any damages," he said.

Six weeks later, another jolt shook nerves and dishes, but it was only 3.7, on October 29, occurring at 8:27 a.m. in the southeast corner of Los Angeles County. Lasting a brief second, its intensity was high. It was followed by more than thirty aftershocks. The *Los Angeles Times* reported that it was but the latest in a series of light tremors, most of them not worth reporting (2.9, for example) and causing no damage.

Almost immediately, another quake struck Southern California, a 5.1 jolt near Palm Springs on October 30. Fortunately, it occurred in a sparsely populated area and caused no damage. However, seismologists expressed the view that the quake marked the end of the "stress relief shadow" in which light or low-level moderate earthquakes had occurred over the previous dozen years in Southern California, a period of reduced seismic activity. Did the end of the so-called "seismic lull" mean a pretty big one or the Big One was in the offing? No seismologist would make such a prediction, but public officials issued a statement that the end of stress shadows in the state should not be a cause for alarm.

Moderate quakes nevertheless continued to shake California. Once again, the northern San Fernando Valley and adjacent areas, including Valencia and Simi Valley, felt a 4.1 quake at 9:53 p.m. on January 29, 2002, followed by more than a dozen aftershocks. Two and a half months later, a 5.2 quake jolted the San Francisco Bay Area at 10 p.m. on May 13, 2002. Although no reports of serious damages or injury occurred, the temblor temporarily knocked out phone service. Seismologists blamed the San Andreas Fault for this one, and the news media reported it as the strongest quake to hit the region since Loma Prieta in 1989. Gilroy, famous as the Garlic Capital of the World, was close to the quake's epicenter. Alarmed guests at the Motel 6 in Gilroy called the front desk. "It was scary," admitted night clerk Rose Martinez. "Guests started calling immediately and I told them, 'This is California. Everything is going to be OK.'"

Later that year, a 4.2 quake rattled the dishes in the very small hamlet of Parkfield, halfway between Los Angeles and San Francisco. Parkfield's

residents labeled their town the "Earthquake Capital of the World," a place where earthquakes occurred so frequently that a historical marker had been placed there in the form of two jagged segments as if a quake had split the marker apart. The USGS had set up a monitoring station there. The quake hit on November 12 at 8:48 am. USGS seismologist John Langbein, stationed there, said a low possibility existed for a larger quake within a few days.

Smaller quakes continued into 2003. Imperial County, in the southeastern corner of the state, experienced more than 140 small quakes near the town of Brawley beginning on Friday morning, May 23, with a barely perceptible 1.9. The fiftieth one struck at 7:00 p.m., a 4.2. Brawley city clerk Janet Smith commented, "You never get used to them. They put you on edge, but you have to learn to live with them, like the heat here." *Los Angeles Times* reporter Kenneth Reich, who covered numerous earthquake events, reported scientists as saying that quake swarms such as the swarm in Imperial County "allow pressure to be released through many small quakes that occur frequently, thus averting some of the large quakes that can cause widespread destruction and loss of life." However, the county lies in a region of major historic quakes, such as the 7.1 in 1940. Mainly an agricultural area, the county has a small population and few skyscrapers.

The month of February brought more than two dozen minor quakes to the San Francisco Bay area. A "swarm" began on Sunday, February 2, 2003, at 8:15 a.m., and by the end of the day, at least two 2.8 quakes had struck. USGS seismologist David Schwartz asserted that the quakes were likely caused by a section of the Calaveras Fault, the epicenter near the suburban cities of San Ramon and Dublin. There were no injuries, no damage.

On July 16, a 4.2 aftershock from the Landers quake—the latest of some seventy thousand of varying magnitude after the 1992 event—rumbled through the Mojave Desert at 11:15 a.m. No damage, no injuries. "Until Saturday," Kenneth Reich reported, "California went for nearly eight days without a quake of magnitude 3.0 or larger, an unusually long time in this seismically active state." The record ended when a 4.0 quake shook up Sonoma County on July 31. No injuries were reported.

In 1998, the USGS had inaugurated a comment opportunity, "Did You Feel It?" on its http://quake.wr.usgs.gov website, allowing people to report on whether they felt an earthquake (or not). For the Sonoma County quake, 835 people from as far south as San Jose said they had. On September 11, another quake, at 4.3 magnitude, occurred offshore near the coastal town of Eureka. This temblor followed with events on August 15 and 25.

Five months later, California's central coast received an early and unwelcome Christmas present. On December 22, a 6.5 quake struck near Paso Robles at 11:57 a.m., killing two women when a building collapsed in that town. Jennifer Myrick and Marilyn Frost-Zafuto had the misfortune of being in the Acorn Building, an unreinforced masonry structure that was built in 1892. Since the epicenter was closer to San Simeon, where the famous Hearst Castle is located, the quake has been given two names: Paso Robles/San Simeon. Paso Robles's downtown area, with many such older buildings, experienced severe damage. Retrofitted buildings held up well. Families of the deceased women sued the building's owners and were awarded almost $2 million, a likely warning that owners of such buildings needed to retrofit them to building code standards. After this quake, the state legislature passed an amendment to the California Business and Professional Code, Jenny's Bill, named after Jennifer Myrick. The amendment required that warnings be posted on unreinforced masonry buildings declaring their vulnerability to potential earthquake hazards.

Paso Robles residents were certainly aware they lived in an active seismic region; some 2,500 measurable earthquakes had occurred there since 1931. San Luis Obispo, forty miles from Paso Robles and the home of one of California's twenty-one missions, had a number of unreinforced masonry buildings that experienced minor to moderate damage. After Jenny's Bill, these buildings posted signs at their doors warning people—such as tourists—to enter at their own risk, not the best invitation from stores wanting their business.

Occasional jolts during the next few years kept reminding Californians they lived in earthquake country. Kern County felt one on Saturday, April 16, 2005, shortly after noon, with no reports of injuries or damage. Larry Hickerson was eating lunch at Tina's Diner in Maricopa when the quake hit. "We were sitting here in the restaurant, and she shook us pretty good here," he said. "It wasn't a large one; it was just two or three jolts. The water shook a bit."

Some 150 years after the Fort Tejon earthquake, scientists took stock of the changes in the state and how prepared people were for a massive quake similar to the 1857 event. Whereas few people had lived in Southern California at the time, the region had become highly urbanized, with a population of close to twenty million. Older buildings were still very much in existence, however, and remained unretrofitted. Property damage in the early twenty-first century could run to $150 billion in a catastrophic quake. The University of Southern California, home of the Southern California Earthquake Center, held a meeting where seismologists, engineers

and experts in emergency preparedness called for much greater public awareness and preparation for the day another Big One, such as the 1857 quake, would come. Participants stopped well short of making predictions but tried to develop an estimate as to when a Big One might come.

Eighteen months later, on July 29, 2008, a 5.4 quake in the Chino Hills, about thirty miles east of downtown Los Angeles, struck the region, the strongest jolt since the 1994 earthquake. Whatever went through the minds of people feeling the shaking, this one wasn't the Big One or even a pretty big one. There was some minor damage and a few injuries but nothing especially serious. What was noteworthy was the performance of retrofitted hospitals, such as the new Glendale Adventist Medical Center, where no damages were reported, and hospitals still struggling financially to meet state retrofitting mandates. They reported minor problems such as loss of power and phone service briefly not working. Students in area schools followed the earthquake drills and left the buildings. Bridges, subway lines and water systems all remained intact.

The media—by now enhanced by security cameras, cellphones, personal digital cameras, social media, radio, television and the press—in addition to reporting the quake, included suggestions on how to be prepared "before a disaster strikes." The broadened definition of *disaster* now included not only earthquakes but also power outages, brushfires that required evacuation from suburban homes in the hills and floods. It also meant for people to forget the mistaken adage that lightning doesn't strike twice in the same place. "All of us who live in Southern California live with the possibility of an earthquake each and every day," announced Los Angeles city council member Wendy Gruel. "Today, we were lucky. Now is the time for every family to have a plan of action in case of an emergency."

Although by 2008 just about everyone seemed to have a cellphone, the fact was that the handy communication devices were becoming victims of their own success. Almost as soon as a quake hit, millions of people were calling family, friends, hotlines and fellow employees, overloading both cell and landline phone systems that couldn't handle the deluge of calls. But they also could use e-mail, Facebook, instant messaging and, above all, texting to let seemingly everyone else in the world know that all was safe. But few Californians were paying for earthquake insurance—only 12 percent of California homeowners as of 2008—the rest not doing so either from apathy or its high cost.

Sporting goods stores reported a major increase in purchases of survival gear, including flashlights, lanterns, bottled water, dehydrated food and the kind of equipment needed for camping under the stars. A drill called the Great Southern California Shakeout simulation attracted people who registered for the event. Families were advised as to where individual members, scattered between home, school and workplace, should agree to meet. It also helped for everyone with cellphones to keep the numbers of out-of-state relatives and friends to act as a clearing house for notifying the situation of callers.

After the Chino Hills quake, concern and preparations among the general public seemed to be put on back burners, though scientists continued to probe the mysteries of thrust faults, slip slides and the historical record geologists literally dug out of the ground in search of fault lines and precedents of prehistorical (that is, quakes in geological, not recorded, history) quakes. Occasionally, a cluster of quakes attracted attention. Brawley again experienced increased seismic activity. A series of small tremors hit the Brawley area on Sunday, August 26, 2012, one registering 3.8 at 10:02 a.m., followed by numerous shocks all morning long. A 5.2 hit at 12:30 p.m. and another at 4.4 at 2:00 p.m. The USGS reported more than three hundred jolts by 5:00 p.m., most under the 3.0 magnitude. The temblors brought canned goods tumbling off market shelves, and there was some damage to older buildings but no injuries. The series of quakes reached as far as San Diego.

Two years later, the biggest quake to hit the San Francisco Bay Area since Loma Prieta struck nearby Napa Valley, famous for its boutique wineries, luxury hotels and spas. The temblor measured 6.0 magnitude at 3:20 a.m. on Sunday, August 24, 2014, and lasted up to twenty seconds. Some seventy thousand people were left literally in the dark as Pacific Gas and Electric's power was lost, as was natural gas and water. On the positive side, PG&E restored power the next day, and company workers went door to door to check on possible gas leaks. On the negative side, the quake injured almost two hundred people, mainly in Napa County, and fires destroyed half a dozen homes. The quake also buckled local roads, broke dozens of water mains and damaged many buildings.

Governor Jerry Brown lost no time in declaring a state of emergency for the affected area. Downtown Napa suffered the most damage, impairing efforts that were under way to restore historic buildings that dated to the late nineteenth century. These included the old county courthouse. Structural damage also occurred in neighboring cities. Dawn Weeks, a Napa resident,

considered herself lucky. "We're on bedrock and I only lost a few glasses," she said. "My dog woke me up and I got out of bed. It was like a haunted house—the whole pace moving from side to side."

Injuries included people who got out of bed and, apparently unlike Dawn Weeks, did so barefooted and immediately stepped on broken glass from windows, picture frames and mirrors. A fourteen-year-old boy was critically injured, along with an adult with multiple fractures. Fortunately, no one died.

Some four dozen aftershocks hit the Napa Valley following the initial quake. Over in the town of Petaluma, Sergeant Andrew Urton of the Petaluma Police Department said that his department had received hundreds of 911 calls. "We chased 15 to 20 audible alarms, motion detectors going off, broken glass," said Urton. "None of the alarms were valid." Most of the calls came from people who just wanted to know what had happened, seemingly oblivious that "what happened" was an earthquake. "You wake up from a dead sleep, wonder 'Hey, did an earthquake actually happen' and think 'I'll call 911, they're not busy,'" said Urton. Petaluma police officers knew what happened. "It was rumbling. I haven't felt something like that in a while. That one went for a long time. It was scary," said Urton.

Initial reports estimated property damage at close to $1 billion, a figure reduced to $362 million, still a significant figure. A church, six homes, some small buildings and a bridge were red-tagged, and fourteen houses received yellow tags, numbers that would increase with further inspections. Inspectors checked out homes and office buildings for damage. In the Napa Valley, 6 wineries received red tags, and 122 out of 238 wineries reported some damage. Four hotels were temporarily closed. With San Francisco only an hour's drive from Napa, and the hotels and wineries favorite weekend excursions, hotel and winery businesses suffered, as people cancelled reservations.

Other businesses in Napa Valley suffered considerably as a result of the quake. The Target store was red-tagged, as inspectors concluded that the building's tower could collapse. At Whole Foods, thousands of dollars' worth of wine hit the floor. The CVS drugstore smelled of alcohol from broken liquor and wine bottles. Losing 85 percent of its inventory, Napastak gourmet food shop lost products ranging from balsamic vinegar kits to truffle jars. Proprietor Lusine Hartunian lamented, "Today we are having an earthquake sale, cash only." The Home Depot did a brisk business in garbage bags, shovels and water heater parts.

How much the quake hurt the Napa Valley economy was difficult to estimate. Wineries, a major tourist attraction in the valley, lost wine when

oak barrels cracked open, buildings were damaged and some were red-tagged. Winery owners didn't want a lot of publicity about their misfortunes. Instead of discussing damage, Napa Valley vintners created the Napa Valley Community Disaster Relief Fund to donate $10 million to aid people in repairing their homes and finding temporary housing.

Two weeks after the quake, Napa homeowners and businesses were still assessing damage. USGS research geophysicist Annemarie Baltay commented on Napa's location in a basin under a layer of topsoil that resembled a bowl of gelatin, that "once you start shaking it, it continues to shake for a long time." Although new buildings had performed well in the quake, older buildings constructed of brick or stone suffered severe damage, by now an old story for advocates of retrofitting. By September 5, some 150 buildings had been red-tagged, and another 1,000 were yellow-tagged. Carports under apartment buildings, as in the Northridge earthquake, had also collapsed, crushing vehicles parked there.

A year later, scientists evaluated what was now called the South Napa earthquake. Aftershocks had continued for months along the eight-mile-long surface rupture, shaking building foundations. Numerous seismic recordings had been made of the quake, giving seismologists lots of data to evaluate. On the USGS "Did You Feel It?" website, more than forty-one thousand people sent in reports telling what they had felt. One person had died, the only fatality in the Napa quake. The property and economic damage had risen to $500 million. New technology enabled scientists to assess the likelihood of quakes and the mapping of fault zones, though no one was about to make exact predictions.

A reminder of the 2014 quake came on Thursday, May 14, 2015, when a magnitude 4.1 earthquake hit the Napa Valley at 7:52 p.m. No one seemed too perturbed by the quake. At Hurley's Restaurant in Yountville, bartender Cassie Gesickowski commented, "Nothing broke, just some rumbling and people holding onto their chairs." Local residents then told out-of-town visitors about the 2014 quake, calling it a "big one," which it no doubt was when compared to the one they just experienced.

Retrofitting takes time and money, and a cheap interim solution is to post warning signs on buildings, as was done in San Luis Obispo and Paso Robles. In Napa, for years the Napa Valley Unified School District had a sign on the front of its administrative offices: "ENTER AT YOUR OWN RISK. THIS WING DOES NOT MEET STRUCTURAL STANDARDS OF EARTHQUAKE SAFETY FOR SCHOOL BUILDINGS." Teachers had to enter the building to get their paychecks.

Media reports on earthquakes in recent years drew increased attention to tremors regardless of how light they might be. On December 29, 2015, a 4.4 magnitude rattled the dishes in San Bernardino County, followed by fifty aftershocks, including a 2.7 one. The San Jacinto Fault was the center once again on June 10, 2016, when a 5.2 quake shook Southern California at 1:06 a.m. from the Anza-Borrego Valley area, followed in the next two hours by seven more aftershocks and dozens more afterward. However, though it was minor league compared to the 1992 Landers quake, it attracted international attention as well as e-mails from both my sons living in Europe and The History Press editor Megan Laddusaw inquiring if everything was all right.

Security cameras provided instant visual coverage of this quake on television and on YouTube, and Facebook and Twitter entries went viral. Numerous people tweeted seismologist Lucy Jones asking if the quake meant a bigger one was imminent. Jones tweeted back, "Probably a little bit bigger."

14

PREPARING FOR THE BIG ONE

Three years after the 1971 San Fernando/Sylmar earthquake struck, John R. Gribbin and Stephen H. Plagemann published *The Jupiter Effect: The Planets as Triggers of Devastating Earthquakes*, a book that appeared in several editions and versions. The authors argued that when planetary alignment occurs, in which the planets in the solar system have their orbits aligned, a gravitational force can trigger earthquakes. "We are convinced that this will trigger off regions of earthquake activity on Earth, and by that time the Californian San Andreas Fault system will be under considerable accumulated strain."

The authors also claimed, "In particular the Los Angeles region will, we believe, be subjected to the most massive earthquake experienced by a major center of population during this century." They cited evidence that a major alignment of the planets occurs once every 179 years, and that the next year would be 1982. Citing a lyric from the musical *Hair*, the authors predicted, "'When the Moon is in Seventh House, and Jupiter aligns with Mars,' and with other seven planets in the Solar System, Los Angeles will be destroyed."

The year 1982 came and went, and Los Angeles wasn't destroyed by an earthquake. In January 2016, Mercury, Venus, Mars, Jupiter and Saturn were in planetary alignment, but California didn't experience any major earthquakes, though some severe ones occurred elsewhere on the planet.

Gribbin went on to a distinguished career, writing numerous books on scientific topics intended for general readers. Interviewed in 1999 about

his prediction of an earthquake destroying Los Angeles, he commented, "I didn't like it, and I'm sorry I ever had anything to do with it."

In fairness to Gribbin, he was not the only one who theorized about the alignment of planets causing a future earthquake. Immediately after the San Fernando earthquake in 1971, William Kaufmann, director of the Griffith Park Observatory in Los Angeles, laid the cause of the quake on the pull of the sun and moon setting off the quake, as there was a total eclipse of the moon some seventeen hours after the temblor. "I don't say the lineup caused the earthquake, but merely that it could have been the trigger for it," he said. Although most seismologists dismissed this idea, it was at least considered as a possible factor by Dr. C. Hewlitt Dix, a geophysics professor at Caltech:

> There may be something to it, but there's always more to it than that. If the alignment of the sun and moon had anything basic to do with setting off quakes along faults, there would be a lot more earthquakes when they are lined up. If you go back over Richter's catalog of earthquakes since 1900 you will find very few that fit the bill. Earthquakes are due to many things, including many that are not understood.

Seismologists and geologists have had headaches regarding earthquake prediction. While they monitor buildups of stress, calculating a possible earthquake at a certain time, place or magnitude (or all three) remains outside the realm of accurate pinpointing. Meanwhile, this leaves the field open for others such as "amateur scientists and publicity seekers, who often resorted to astrology or psychic means for prophesying fault rupture," as Carl-Henry Geschwind caustically noted in his book *California Earthquakes: Science, Risk, & the Politics of Hazard Mitigation.*

Charles Richter did not hesitate to condemn predictions, perhaps because he was annoyed by various astrologers, psychics and assorted cranks hoping to pump him for information. In July 1965, psychic Jeane Dixon, the darling of tabloid newspapers for her often bizarre predictions, claimed that there would be an imminent earthquake in Santa Barbara County, and local authorities believed her and alerted police and fire departments to be ready for it. Richter notified county officials that astrologers had made predictions of catastrophic earthquakes for January 17, February 4, February 28, March 17, April 1, April 17, May 30 and June 17, and nothing happened on those dates. In a television interview in 1968, Richter exclaimed, "Bah, no one but fools and charlatans try to predict earthquakes!"

Perhaps the zaniest earthquake prediction came from the American rock quartet Shango with their song "Day After Day," in which they sang in a faux Jamaican style the demise of California by violent earthquake:

> *Day after day, more people come to L.A.*
> *Ssh! Don't you tell anybody the whole place's shaking away*
> *Where can you go, when there's no San Francisco?*
> *Ssh! Better get ready to tie up the boat in Idaho.*

Despite the best efforts of seismologists, earthquake prediction has yet to be developed to the point where ample warning is given to people in a region where an earthquake may (or may not) strike. Seeing your dog or cat act strangely might give you a few seconds' warning that a calamitous event is about to occur, but all you get is a few seconds, barely enough time to get under a table or brace yourself for the shaking of the earth under your feet. Tornados and hurricanes can be tracked, as with other major storms, but technology giving an hour's notice on earthquakes remains elusive. There's also an economic issue involved. A meteorologist on the local television can predict rain, sun, snow, hurricanes or tornadoes, and viewers will know what to do: take out umbrellas, sunscreen and heavy coats or head for shelters until the hurricane or tornado has passed. A prediction of an imminent earthquake with some degree of accuracy—such as within two days or twenty-four hours—would likely induce mass panic as people storm grocery stores and jam freeways trying to escape from the coming catastrophe. One has only to see an earthquake disaster movie and watch as hundreds or thousands of people run around like headless chickens while buildings fall on top of them to suspect that film hysteria could translate into unacceptable reality.

Type "earthquake" into the Internet Movie Data Base, and in addition to movies, you also get numerous television programs in which some sort of earthquake takes place. IMDb doesn't usually give plot summaries for television programs, so it's hard to tell what these shows were about. It should also be noted that Japan and China have made earthquake disaster films, which is understandable in a way, as those nations have experienced catastrophic earthquakes.

Moving from fictional film to reality leads to areas of speculation that seismologists wish very much to avoid. Alchemists tried for centuries to turn lead into gold, but their formulas never worked. Chinese seismologists, based on lengthy written records and modern research, successfully predicted

an earthquake at Haicheng to occur on February 4, 1975. When a 7.3 quake struck on that date, most of the city's population of more than 1 million people escaped death and injury by getting out of their homes, and only 1,000 people were killed in homes that collapsed. Unfortunately, an earthquake of magnitude 7.6 destroyed the city of Tangshen on July 28, 1976, with 650,000 estimated dead—no one expected or predicted a quake in that region.

Robert S. Yeats, in his book *Living with Earthquakes in California*, wrote that "Los Angeles [ought to] be prepared for a local earthquake somewhere in the metropolitan area, even though we can't say which fault will break." Yeats notes that forecasts, unlike predictions, avoid the risks of stating a precise time, date and location of an earthquake event. This cautious view is comparable to meteorologists on the news saying that the next day or two will have a 70 percent chance of rain—or, put another way, a 30 percent chance of no rain. People don't panic at weather forecasts; they prepare for what is expected. With earthquakes, that's another story.

As with Icarus flying too close to the sun, a few scientists have lost credibility by making predictions about when, where and even what time a quake will occur. In the 1920s, Stanford University professor Bailey Willis, a founder of the Seismological Society of America, ran into trouble when he predicted a massive earthquake in California within ten years— actually, newspapers misconstrued a more cautious statement, but the irate opposition of business and real estate developers effectively curtailed his career. The same thing happened to Jim Whitcomb in the 1970s when he issued a "test of hypothesis" that the news media called a "forecast" of another quake in Sylmar of between 5.5 and 6.5 magnitude within the coming year. When the predicted time elapsed, he lost credibility. Geophysicist Brian Brady hurt his standing in the profession by predicting a magnitude 9.0 quake off the coast of Peru for June 28, 1981. The date came and went, with no such earthquake.

Charles Richter had little but contempt for anyone making earthquake predictions. "Since my first attachment to seismology, I have had a horror of predictions and of predictors, journalists and the general public rush to any suggestion of earthquake prediction like hogs toward a full trough," he said. In 1946, seismologist James Macelwayne said, "The problem of earthquake forecasting [prediction] has been under investigation in California and elsewhere for some years, and we seem to be no nearer a solution of the problem than we were in the beginning." He wrote in the *Bulletin of the Seismological Society of America*, "In fact, the outlook is

HANNA-BARBERA'S
YOGI, the BE-PREPARED BEAR

EARTHQUAKE

PREPAREDNESS

"Hey, Hey, Hey! This is Yogi, smarter than the average bear, with some words to the wise!

An earthquake is no picnic, so be ready and...

EMERGENCY EARTHQUAKE KIT

...DON'T PANIC!"

The widely distributed Yogi Bear booklet helped children—and adults—learn how to prepare for an earthquake. *Author's collection.*

much less hopeful." And in 1977, writing in *Astronomy and Geophysics*, Robert Geller stated, "The idea that the Earth telegraphs its punches, i.e., that large earthquakes are preceded by observable and identifiable precursors—isn't backed up by the facts."

Since few seismologists would dare to make such predictions, their research into theories and causes of earthquakes are largely confined to technical journals, such as the *Journal of Geophysical Research, Bulletin of the Seismological Society of America* and *California Geology*. This leaves lay people, the ordinary citizens, with few options regarding understanding earthquakes. They can ignore the problem (a bad idea, as they will be completely unprepared when—not if—one strikes). They can obtain guides and pamphlets issued by federal, state and local agencies such as the Federal Emergency Management Agency (FEMA), which publishes an "Earthquake Safety Checklist." At the state level, there is the California Governor's Office of Emergency Services' "Earthquake." The Southern California Earthquake Center publishes "Putting Down Roots in Earthquake Country," and there are also the Los Angeles Department of Water and Power's survival guide "Earthquake," the American Red Cross's "Earthquake Safe—27 Things to Help You Survive an Earthquake" (in English and Spanish) and many more.

These survival guides range in size and detail from brochures to forty-page booklets. In 1983, Safeway Stores sponsored the publication of a comic book for children featuring Yogi Bear. The cover has Yogi saying, "Hey, Hey, Hey! This is Yogi, smarter than the average bear, with some words to the wise! An earthquake is no picnic, so be ready and...Don't Panic!" These are words adults as well as children can take to heart. Yogi carries a picnic basket with the words "Emergency Earthquake Kit" on it.

Ralphs Markets provided a brochure suggesting a sturdy thirty-two-gallon trash barrel and how to pack it with three days' survival necessities. Vons

Markets, Coca Cola and Domino's Pizza co-sponsored a "Quake Ready in Southern California" booklet. Sparkletts Water Company issued a thirty-two-page booklet, "Earthquake Preparedness." One company even put out a can labeled "California Canned Earthquake." Battery operated, when the can is touched, it shakes as if in an earthquake—useless, but funny.

Many of these guides come out after the fact, subsequent to major quakes such as Sylmar, Loma Prieta and Northridge. Instead of taking the attitude of "I told you so" about a lack of preparedness for the previous quake, they offer good advice as to getting ready for the Big One, the pretty big one or the one that will cost you power, gas and telephone connections for a day or two while you clean up the broken dishes and glassware because you didn't put magnetic locks on the kitchen cabinet doors. Unfortunately, many of these guides are ephemeral. Generously distributed at markets, stores and "Shakeout" events, they are still available, but as time passes, people might not make the effort to contact agencies for the information.

That being the case, for readers of this book, here's some advice to get you ready for the next big earthquake. And it doesn't have to be an earthquake. It could be a power shortage that lasts for thirty-six hours because a cat climbed a power pole and electrocuted itself when it encountered a transformer. (This actually happened in my neighborhood.) A Santa Ana wind in Southern California, a hurricane on the East Coast, cyclones and tornadoes in the Midwest or blizzards in the North and Northeast—pick your problem wherever you live.

First and foremost, make the effort to contact local, state and federal government agencies to get those survival guides. They all have websites. The guides are also used by police and fire departments, the local chamber of commerce and the Red Cross. Read these guides! No two have exactly the same information in providing tips on earthquake preparedness.

You don't need more than common sense to make sure your family is ready when an earthquake strikes, and you can't start trying to deal with the problems you will have when one actually does occur. The local hardware store has magnetic locks that are easy to install on kitchen cabinets and pantry doors to ensure that breakable items won't fall out. Inexpensive children's hooks do the same job and will also keep small children from poking around in kitchen cabinets. Standing bookshelves will likely fall over; use anchor bolts to keep them attached to the wall. Place adhesive patches under items that might slide off tables and dressers, such as lamps, vases, portable televisions, CD players and those cute little ceramic houses.

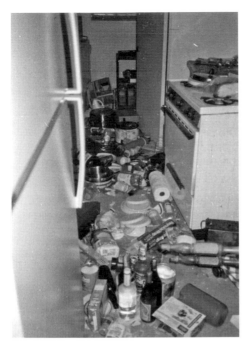

Glenn Thornhill's kitchen after the 1994 Northridge earthquake. *Courtesy of Glenn Thornhill.*

Take an old pair of shoes and place them under the bed within your reach. When the shaking stops, reach down and put them on and don't worry about stepping on broken glass and cutting your feet, a common problem among earthquake victims and usually lumped under the general category of "injuries." Put a flashlight in one of the shoes. These two suggestions put you way ahead of someone who jumps right out of bed in the middle of the night and immediately is hurt by stumbling around in the dark and walking on broken mirrors, window fragments and shattered picture frames. Don't stand in a doorway. This method of riding out a quake has been obsolete since it was realized that doing so could result in the door slamming shut and amputating some fingers.

The best long-term plan in preparing for an earthquake is to do pretty much the same things you would do if you're going on a camping trip. Every member of the family should have a sleeping bag and a backpack filled with three days' supply of socks, underwear, pants and a couple of shirts. Everyone should have a flashlight in the backpack. Battery or propane lanterns are essential; flashlights will show you where you are going, but a lantern provides light for when you get there. Cookware, cutlery, cups and plates (plastic or paper, not breakable ceramic or china), a portable cookstove and matches (propane lighters run out of fuel; have both) should be apportioned to family members.

Sporting goods stores always seem to have tents on sale in varying sizes. Pick one or two that are neither too small nor too big. (The bigger the tent, the more complicated it is to set up). Create a usable first-aid kit—not just bandages but a thermometer, needles, thread, scissors, aspirin or non-aspirin pain reliever, gauze, alcohol and other items. If buying a commercial first-

aid kit, make sure it comes with all of the above or more and add your own items as needed.

Where to stow all this stuff? All of the nonperishable items should be carefully packed and stored in either the trunk of the car(s) or the garage. Many families have two vehicles; divide the items between them. Quite a few families have so much stuff in the garage that cars are routinely parked outside. Consider this problem that happened to Glenn Thornhill, as told in the Sylmar earthquake chapter. When the quake hit, it displaced the garage door so that he couldn't pull it up. And with power out, the garage door opener would not work, so it took several friends to pull up the door until it yielded and he could get inside the garage.

If it's preferred to keep preparedness items in the garage, keep them near the front. Use wall shelves to store them. If they tumble off, no problem; these are the unbreakable camping items. If the garage isn't an option, store the items in a closet near an exterior door.

Water may be cut off. Prepare for that possibility by purchasing bottled water. The two-and-a-half-gallon size is best because it has a handle and is easy to carry. Have at least three of these per person. Storage could be a challenge. Plastic containers deteriorate in hot weather, and during much of the year, California has some very hot days. Best to keep them in a closet near an exterior door.

Regarding food: keep it simple. Canned goods (pack a can opener with the camping stuff), cereal boxes and dehydrated food products are best. Keep a list of food items and their "sell by" dates. Also, check the batteries four times a year. The easiest way to do this is to do it the first day of each season. "Hey, it's the first day of spring. Gotta check the batteries in the flashlights, lanterns, radio, CD player, whatever else needs batteries."

Then there's the issue of sanitation. Keep a full roll of toilet paper in the trunk of the car. One guidebook suggested digging a latrine in the backyard. This is impractical for several reasons. It's not an option for people living in apartment buildings. Digging a trench deep enough to accommodate a family is hard work and not particularly sanitary. Some sort of seat would also have to be devised. There are better alternatives. If local authorities are on the job, there might be outhouses set up in shelter areas, likely at schools, playgrounds or recreation centers. Sporting goods stores sell a small portable toilet that doesn't take up much room and does what needs to be done with them.

If your house isn't tagged red or yellow, you might not need any of the camping gear. (You can always go camping!) In the Northridge earthquake,

water was cut off, but the sewer lines held. You can flush the toilet by pouring water into it—a neighbor generously allowed people to take buckets of water from his swimming pool. You should also be prepared for the possibility that the sewer line is broken. Keep a box of powdered (not liquid) bleach and a box of tall kitchen bags handy. Put a bag on the useless toilet, do your stuff and sprinkle the powder to cut down on odor and germs. This method is good for three or four uses. Tie up the bag and put it in the black trash barrel; replace it with another bag. It's probably not all that different than picking up after the family dog.

Taking care of family pets—usually a dog or cat—requires some preparation. Always have an extra bag of pet food and, in the case of dogs, keep an extra leash with it.

Finally, in this marvelous age of cellphones, every family member should keep the numbers of out-of-state relatives or friends in the phone's address book. Should a major quake occur when the family is scattered—one child in middle school, another in high school, one parent shopping, the other at work—making contact with one another or with people not in the quake area who could let you know everyone is safe will ease tensions and concerns. If the phone service is knocked out, wait awhile; keep trying.

The above suggestions are not a definitive list. The survival guides will have more ideas on what to do in preparing for and surviving a natural disaster, not just earthquakes. And remember, California leads the nation in high standards in building codes. San Francisco's 1906 quake was exceptional in the number of fatalities. That was more than a century ago, and we now know more about earthquakes and how to deal with them. The better prepared you are, the greater the opportunity you'll have to tell your "earthquake story" to the next generation, which might not be as aware as you are that California is truly earthquake country.

AUTHOR'S NOTE

This book is not a technical work and makes no effort to compete with the studies of seismologists, geologists, geophysicists and other scientists who often literally work in the trenches examining rock formations and fault zones or measuring the earth in geological spans of millions of years. Their work tends to be very specific in assessing damage done by earthquakes and reporting on deaths, injuries and property damage. These are important issues, but this book tries to tell the stories of people who experienced the temblors. They are not the stories told by scientists or public officials but instead are the words of ordinary people who went through extraordinary experiences.

For those readers interested in examining the scientific aspects of earthquakes, the bibliography includes a number of books and articles from which I learned quite a bit, though they didn't make me a specialist. Historians tell stories, and in this book, I relate the stories of a number of people who were willing to share them with me, along with the testimonies of people who told them to newspaper, radio and television news reporters or who wrote about the earthquakes in their diaries and memoirs.

Special thanks go to the following people: Robert Alm, April Beltz, Suzanne and Robert Berment, Sid Blumner, Dave Bond, Clare Boyles, Phil Brigandi, Brian Dillon, Dave Dillon, John Dillon, Sheila and David Epstein, Steve Fasoline, Teri and James Jackson, Claudia Jalaty, Julie Martin, Nancy Martsch, Joan Mathews, Mikey Moore, Phil Nathanson, Kenneth Pauley, Bo Pollard, Jerry Selmer, Anna Sklar, Mark Abbot Stern, Lori Underwood Thornhill, Glenn Thornhill and Janet Whaley.

Special thanks also go to Roberta Harlan, curator at the Eastern California Museum, for providing photographs; Glenn Thornhill, for his photographs; Phil Brigandi; Holli Teltoe at the California State University–Northridge's Oviatt Library; and Megan Laddusaw and Candice Lawrence, The History Press editors who made this book possible.

BIBLIOGRAPHY

Books

Barker, Malcolm E. *Three Fearful Days: San Francisco's Memoirs of the 1906 Earthquake and Fire.* San Francisco, CA: Londonborn Publishers, 1998.

Bolton, Herbert E., ed. *Fray Juan Crespi, Missionary Explorer on the Pacific Coast, 1769–1774.* New York: MA Press, 1978.

Brigandi, Philip. *Old Orange County Courthouse: A Centennial History.* San Antonio, TX: Historical Publishers Network, 2001.

Bronson, William. *The Earth Shook, the Sky Burned: A Moving Record of America's Great Earthquake and Fire: San Francisco, April 18, 1906.* San Francisco, CA: Chronicle Books, 1959.

California '71 Earthquake. Hollywood, CA: Lee Publications, 1971.

Fradkin, Philip L. *The Great Earthquake and Firestorm of 1906: How San Francisco Nearly Destroyed Itself.* Berkeley: University of California Press, 2005.

———. *Magnitude 8: Earthquakes, and Life Along the San Andreas Fault.* New York: Henry Holt and Company, 1998.

Geschwind, Carl-Henry. *California Earthquakes: Science, Risk and the Policies of Hazard Mitigation.* Baltimore, MD: Johns Hopkins University Press, 2001.

Getty Conservation Institute. *Survey of Damage to Historic Adobe Buildings After the January 1994 Northridge Earthquake.* Los Angeles, CA: Getty Publications, 1996.

Hansen, Gladys, and Emmet Condon. *Denial of Disaster: The Untold Story and Photographs of the San Francisco Earthquake and Fire of 1906.* San Francisco, CA: Cameron Publishers, 1989.

Heppenheimer, T.A. *The Coming Quake: Science and Trembling on the California Earthquake Frontier.* New York: Times Books, 1988.

Hough, Susan Elizabeth. *Finding Fault in California: An Earthquake Guide.* Missoula, MT: Mountain Press Publishing Company, 2004.

Hyland, Lynn M., et al. "Intensity Studies." In *The Coalinga, California, Earthquake of May 2, 1983*, edited by Michael J. Rymer and William L. Ellsworth, 349–58. Washington, D.C.: U.S. Government Printing Office.

Klett, Mark, and Michael Lundgren. *After the Ruins, 1906 and 2006: Rephotographing the San Francisco Earthquake and Fire.* Berkeley: University of California Press, 2006.

Kramer, William, ed. *California: Earthquakes and Jews.* Los Angeles, CA: Isaac Nathan Publishing, 1995.

Kurzman, Dan. *Disaster! The Great San Francisco Earthquake and Fire of 1906.* New York: William Morrow/HarperCollins Publishers, 2001.

Morris, Charles. *The San Francisco Calamity by Earthquake and Fire.* Champaign: University of Illinois Press, 2002.

Muir, John. *The Yosemite.* New York: Century, 1912.

Page, Jake, and Charles Officer. *The Big One: The Earthquake that Rocked Early America and Helped Create a Science.* Boston: Houghton Mifflin, 2004.

Reed, Chester A. *Earthquakes.* New York: American Museum of Natural History, 1934.

Ritchie, David. *The Ring of Fire: Volcanoes, Earthquakes, and the Violent Shore.* New York: Atheneum, 1981.

Rymer, Michael J., and William L. Ellsworth, eds. *The Coalinga, California, Earthquake of May 2, 1983.* U.S. Geological Survey Professional Paper 1487. Washington, D.C.: U.S. Government Printing Office, 1990.

Secrest, William B., Jr., and William B. Secrest Sr. *California Disasters, 1800–1900: First-hand Accounts of Fires, Shipwrecks, Floods, Epidemics, Earthquakes, and Other California Tragedies.* Sanger, CA: Quill Driver Books/Word Dancer Press, 2006.

Smith, Dennis. *San Francisco Is Burning: The Untold Story of the 1906 Earthquake and Fires.* New York: Viking, 2005.

Winchester, Simon. *A Crack in the Edge of the World: America and the Great California Earthquake of 1906.* New York: HarperCollins, 2006.

Yeats, Robert S. *Living with Earthquakes in California: A Survivor's Guide.* Corvallis: Oregon State University Press, 2001.

Journal Articles

Bewalda, John P., and Pierre St. Armand. "The Recent Arvin-Tehachapi, Southern California, Earthquake." *Science* 116 (December 12, 1952): 645–50.

Brady, Caleb G., and H. Krawinkler. "Preliminary Evaluation of Structures: Whittier Narrows Earthquake of October 1, 1987." Accessed May 8, 2016. U.S. Department of the Interior, Geological Survey. http://pubs.usgs.gov/of/1987/0621/report.pdf.

Bryant, William A. "History of the Alquist-Priolo Earthquake Fault Zoning Act, California, USA." *Environmental and Engineering Geoscience* 16 (February 2010): 7–18.

"Coalinga Earthquake—California—May 2, 1983." Accessed May 7, 2016. http://devastatingdisasters.com/coalinga-earthquake-california-may-2-1983/.

Cooper, Linda Stahle. "32 Seconds in Coalinga." Accessed May 7, 2016. https://www.lds.rg/new-era/1983/11/32-seconds-in-coalinga?lang=eng.

Dillon, Brian Dervin, et al. "Sergeant Dillon with the Dynamite Squads: 1906." Part One. *California Territorial Quarterly* no. 91 (Fall 2012): 4-40.

———. "Sergeant Dillon with the Dynamite Squads: 1906." Part Two. *California Territorial Quarterly* no. 92 (Winter 2012): 4–30.

Easton, Robert. "The Santa Barbara Earthquake: Three Episodes and an Epilogue." *Noticias* 36 (Spring 1990): 1–15.

Feldman, Bernard J. "The Nimitz Freeway Collapse." *Physics Teacher* 42 (October 2004): 400–4.

Fowler, Dave. "The Initial Response to the Cypress Freeway Disaster." Virtual Museum of the City of San Francisco. Accessed May 17, 2016. http://www.sfmuseumnet/cypress/response.html.

Graffy, Neal. "1925 Earthquake." http://edhat.com/site/tidbit.cfm?nid=34217.

Greensfelder, Roger. "Seismology and Crustal Movement Investigation of the San Fernando Earthquake." *California Geology* 24 (April–May 1971): 62–68.

Harte, Bret. "The Ruins of San Francisco." In *Mrs. Skaggs's Husbands, and Other Sketches.* Boston: James R. Osgood and Company, 1872.

Hauksson, Egill, and Ross S. Stein. "Whittier Narrow, California, Earthquake: A Metropolitan Shock." *Journal of Geophysical Research* 94 (July 10, 1989): 9,545–47.

"Historic Earthquakes: Whittier Narrows, California, 1987 October 01 UTC 14.42 Magnitude 5.9." Accessed May 7, 2016. http://earthquake.usgs.gov/earthquakes/states/events/1987_10_01.php.

Howard, Helen Addison. "Unique History of Fort Tejon." *Journal of the West* 18 (January 1979): 41–51.

Iversen, Eve. "An Oral History of the Presidio of San Francisco during the Loma Prieta Earthquake." Accessed May 17, 2016. Virtual Museum of the City of San Francisco. http://www.sfumseum.org/hist2/presidio.html.

Kennedy, Barrett. "'Yes We Got It Safe': A 1906 Earthquake Letter." *California History* 71 (Winter 1992–93): 510–15.

LaMacchia, Diane. "Yucca Valley Earthquake Surprised Experts." Accessed May 30, 2016. www2.lbl.gov/Science-Articles/Archive/yucca-valley-earthquake.html.

Levitt, Abraham H. "Impressions of the San Francisco Earthquake-Fire of 1906." *Western States Jewish Historical Quarterly* 5 (April 1973): 191–97.

London, Jack. "The Story of an Eyewitness." *Collier's* 37 (May 5, 1906).

McAfee, Ward M. "A Social History of Southern California's Great Quake of 1857." *Southern California Quarterly* 74 (Summer 1992): 125–40.

Meyer, Larry L. "California's Fault, Part One." *Westways* (May 1977): 60–65

———. "California's Fault, Part Two." *Westways* (June 1977): 32–35.

———. "Giants in the Earth: Two Hundred Years of California Earthquakes." *American West* 14 (January–February 1977): 4–9, 63.

Moran, Kelly. "1906, April 18, 5:14 a.m.: Jack London Tells His Wife, 'I'll Never Write a Word about It. What Use Trying?'" In *A New Literary History of America* edited by Greil Marcus and Werner Sollors. Cambridge, MA: Harvard University Press, 2012.

Palmer, Christine. "The 1925 Santa Barbara Earthquake, a 75th Anniversary Commemoration." *Noticias* 46 (Summer 2000): 21–43.

Ridgeway, Rick. "In Harm's Way." *Westways* 69 (May 1977): 56–59.

Santa Cruz. "City Quake Report." City of Santa Cruz, December 1989.

Southern California Earthquake Data Center. "Significant Earthquakes and Faults." Accessed June 3, 2016. http://caltech.edu/significant/jashuatree1992.html.

Speer, Marion A. "The Earthquake of March 10th 1933." Unpublished paper, Orange County Historical Society Collection.

Steinbrugge, Karl V., et al. "Dwelling Monetary Losses." In *The Coalinga, California, Earthquake*, edited by Rymer and Ellsworth. 359–80.

Voorsanger, Jacob. "Relief Work in San Francisco after the 1906 Earthquake-Fire—An Overview." *Out West* (June 1906). Reprinted in *California: Earthquakes and Jews*, Kramer, ed.

Wagner, David L. "Geologic and Tectonic Setting of the Epicentral Area of the Loma Prieta Earthquake." *California Geology* 43 (November 1990): 243–51.

White, Trumbull. "Complete Story of the San Francisco Horror Scenes of Death and Destruction." *California Territorial Quarterly* no. 65 (Spring 2006): 4-46.

Wollenberg, Charles. "Life on the Seismic Frontier: The Great San Francisco Earthquake [of 1868]." *California History* 71 (Winter 1992–93), 495–509.

"Wrightwood Earthquake." Chronological Earthquake Index. http://scedc.caltech.edu/significant/wrightwood1812.html.

Newspaper Articles

Abram, Susan. "Retrofitted Hospitals Perform Well; Others Face Deadline." *Daily News* (Los Angeles), July 30, 2008.

Adelstein, Jake. "Japanese Premier Assures Public after Deadly Earthquake in South." *Los Angeles Times*, April 15, 2016.

Anderson, Troy. "Technology Changing How We React to Crisis." *Daily News* (Los Angeles), July 31, 2008.

Atagi, Colin, and Sherry Barkas. "5.2 Earthquake Shakes Valley Awake Friday." *Desert Sun*, June 10, 2016.

Bakersfield Californian. "Earthquakes of 1952: A Conversation with a Caltech Seismologist." July 21, 2012.

Barrett, Beth. "Whole Lotta Shakin', Little Damage." *Daily News* (Los Angeles), July 30, 2008.

Bartholomew, Dana. "Sylmar-San Fernando Earthquake: 45 Years Ago Tuesday, 64 Killed." *Daily News* (Los Angeles), February 8, 2016.

Becerra, Hector, and Dough Smith. "Some Northridge Quake Wounds Are yet to Heal." *Los Angeles Times*, January 17, 2004.

Beitler, Stu. "Tehachapi, CA (Other Areas) Earthquake, July 1952." *San Mateo Times*, July 21, 1952.

Berrios, Jerry. "Shake, Rattle, Roll Out a Plan." *Daily News* (Los Angeles), August 3, 2008.

Biederman, Patricia Ward. "Quake Damage Is History at State Park." *Los Angeles Times*, April 29, 2002.

Blake, Gene. "Little Quake Insurance in Effect, Broker Says." *Los Angeles Times*, February 10, 1971.

Brigandi, Philip. "Residents Remember Long Beach Quake." *Orange City News*, March 16, 1983.

Carter, Lori. "Napa Quake Damage Rises to $362 Million." *Press Democrat* (Santa Rosa), April 28, 2014.

Chavez, Stephanie. "Science, Sentiment Mark Day of Quake." *Los Angeles Times*, January 18, 2004.

Cheevers, Jack. "Bay Area Quake: Landmarks Totter: Preservationists Fear Quake-Damaged Historic Buildings Will Be Torn Down." *Los Angeles Times*, October 25, 1989.

Cheevers, Jack, and Alan Abramson. "Earthquake: The Long Road Back." *Los Angeles Times*, January 19, 1994.

City News Service. "Unmoved, Fewer Californians Have Earthquake Insurance." *Daily News* (Los Angeles), July 31, 2008.

Cummings, Judith. "6 Die as Severe Earthquake Hits Los Angeles Area." *New York Times*, October 2, 1987.

Drummond, William. "Disaster Planning Brings Quick Aid." *Los Angeles Times*, February 16, 1971.

Dye, Lee. "Chapel at Veterans Hospital Untouched by Fury of Quake." *Los Angeles Times*, February 12, 1971.

———. "Search Continues for 8 Still Buried at Sylmar Hospital." *Los Angeles Times*, February 11, 1971.

Endicott, William. "Phone, Water, Electric, Gas Services Disrupted." *Los Angeles Times*, February 10, 1971.

Fagan, Kevin. "On the Cypress Freeway, Strangers Joined Together for a Snap in Time/Famous Photo Shows One of Many Heroic Rescues." *San Francisco Chronicle*, October 12, 1999.

Garrison, Jessica, and John Glionna. "Bay Area Rocked by 5.2 Earthquake." *Los Angeles Times*, May 14, 2002.

Gathright, Alan. "Loma Prieta Earthquake: 15 Years Later." *San Francisco Chronicle*, October 16, 2004.

Gerard, Jeremy. "The California Quake: NBC News Tells of Errors and Obstacles to Early Coverage of Quake." *New York Times*, October 24, 1989.

Getze, George. "Shock Stronger Than One That Hit Long Beach." *Los Angeles Times*, February 10, 1971.

———. "Uninhabited Area Was Hit Hardest, Scientists Believe." *Los Angeles Times*, February 17, 1971.

Hager, Philip. "Claim Settled in the Only Quake Death, Injury on Bay Bridge." *Los Angeles Times*, May 1, 1991.

Harris, Ron. "San Francisco Marks Earthquake of 1906." *Daily News* (Los Angeles), April 19, 2008.

Haynes, Karima A. "Amid Devastation, There Was Joy." *Los Angeles Times*, January 16, 2004.

Hebert, Ray. "New Skyscrapers Ride It Out, Damage Slight." *Los Angeles Times*, February 10, 1971.

———. "Quake Serves as Source of Data." *Los Angeles Times*, February 15, 1971.

Hennessy-Fiske, Molly. "1933 Long Beach Temblor Defined Southern California as 'Earthquake Country.'" *Los Angeles Times*, March 10, 2008.

Hinshaw, Horace. "Remembering World Series Earthquake." *Mercury News* (San Jose), June 17, 2009.

Houston, Paul. "4 Aftershocks Hit Basin; New Damage Found." *Los Angeles Times*, February 16, 1971.

———. "Olive View Facility Called Total Loss." *Los Angeles Times*, February 10, 1971.

Hudson, Berkley, et al. "6.0 Earthquake Rocks Southland." *Los Angeles Times*, June 29, 1991.

Huffman, Jennifer. "Damaged Businesses Struggle to Reopen." *Napa Valley Register*, August 25, 2014.

Hume, Ellen. "Unsafe Buildings Endanger 200,000." *Los Angeles Times*, April 7, 1975.

Jordan, Thomas H. "Shift Happens, So Get Ready." *Los Angeles Times*, January 9, 2007.

Larsen, David. "80,000 Returning to Homes in Valley." *Los Angeles Times*, February 13, 1971.

Lin, Rong-Gong II, et al. "Little Known but Highly Dangerous." *Los Angeles Times*, April 11, 2016.

Lindsey, Robert. "Lessons of 'Moderate' Coast Earthquake." *New York Times*, May 4, 1983.

Los Angeles Times. "Death Toll 33 in Massive Earthquake." February 10, 1971.

———. "4.2 Quake Rattles Parkfield." November 13, 2002.

———. "Last Survivor of 1906 San Francisco Earthquake." January 12, 2016.

———. "1 Dead as 5.1 Quake Jolts Bay Area." August 8, 1989.

———. "Quake Hits Northern Areas of the Region." January 29, 2002.

———. "Quakes Rattle Bay Area on '06 Disaster's Anniversary." April 19, 1996.

————. "Twin Temblors: The Landers and Big Bear Quakes: Questions and Answers." June 29, 1992.

Malnic, Eric. "6.0 Quake Rocks L.A.: At Least 3 Dead, Scores Hurt, Buildings Damaged." *Los Angeles Times*, October 1, 1987.

Marosi, Richard. "3.7 Quake Produces Brief but Heavy Jolt." *Los Angeles Times*, October 29, 2001.

Martinez, Gabe. "The Landers and Big Bear Quakes: Death of Toddler Touches Many in Close-Knit Town." *Los Angeles Times*, June 30, 1992.

Mather, Kate, et al. "Quake 'Storm' Strikes." *Los Angeles Times*, August 27, 2012.

McCarthy, Dennis. "Relax—It Wasn't the Big One." *Daily News* (Los Angeles), July 30, 2008.

Meagher, Ed. "Evacuees Return—Subdued and Weary." *Los Angeles Times*, February 13, 1971.

Mohan, Geoffrey. "4.2 Temblor Jolts Nerves in Southland." *Los Angeles Times*, September 10, 2001.

Molina, Sandra T. "Whittier's Big One: 2 Decades Later." *Whittier Daily News*, September 28, 2007.

Moore, Dick, and Randi Rosman. "Napa's People, Buildings Hit Hard by 6.0 Earthquake." *Press Democrat* (Santa Rosa), August 24, 2014.

Nesfield, Emma M. "Bret Harte, Prophet." *San Francisco Call*, June 23, 1907.

New York Times. "Man Who Lived 90 Hours in Quake Rubble Is Dead." November 20, 1989.

————. "People Move Gingerly as They Pick Up Pieces." October 21, 1989.

Pool, Bob. "Quakes Shake Loose History of Pico Adobe." *Los Angeles Times*, January 22, 2004.

Rasmussen, Cecilia. "Mighty '52 Quake Took Toll in Tehachapi." *Los Angeles Times*, June 2, 2002.

Rector, Robert. "Remembering Lessons of Southern California's History of Earthquakes." *Pasadena Star-News*, February 14, 2016.

Reich, Kenneth. "Don't Tell Brawley, but Those Smaller Earthquakes Are Good." *Los Angeles Times*, May 30, 2003.

————. "Dozens of Aftershocks to 1994 Quake Shake Region." *Los Angeles Times*, January 30, 2002.

————. "End of Seismic Lull is Possible." *Los Angeles Times*, November 1, 2001.

————. "4.2 Quake Shakes Desert." *Los Angeles Times*, July 16, 2003.

————. "Quake in Northern California Ripples Through U.S. Website." *Los Angeles Times*, July 31, 2003.

———. "Study Raises Northridge Quake Death Toll to 72." *Los Angeles Times*, December 20, 1995.

Reich, Kenneth, and John L. Mitchell. "Gilroy Quake Is Vivid Reminder of '89 Shaker." *Los Angeles Times*, May 15, 2002.

Reich, Kenneth, and Peter Hong. "2 Moderate Earthquakes Rattle Valley." *Los Angeles Times*, January 14, 2001.

Roderick, Kevin. "Search for Bodies to Take Days: State Puts Toll at 273, Then Says It Is Uncertain." *Los Angeles Times*, November 20, 1989.

Shaw, David. "Antelope Valley Cut Off as Bridges Collapse." *Los Angeles Times*, February 10, 1971.

———. "Sightseers Jam Earthquake Area to View Rubble." *Los Angeles Times*, February 15, 1971.

Stein, Mark A. "Day the Earth Shook: 10 Seconds That Few Will Forget." *Los Angeles Times*, February 8, 1981.

Stevens, Matt. "Napa Calif., Earthquake: Economic Hit Could Reach 1 Billion." *Los Angeles Times*, August 25, 2014.

Stevenson, Richard W. "Quake Kills 2 Near Los Angeles; Damage Is Moderate." *New York Times*, January 29, 1991.

Stingley, Jim, and Lee Dye. "Veterans Hospital Scene of Terror and Heartbreak." *Los Angeles Times*, February 10, 1971.

Thackerey, Ted, Jr. "Survivor Learns Difference Between Living and Existing." *Los Angeles Times*, February 12, 1971.

Time. "Earthquake Jitters." March 8, 1971.

Torgerson, Dial. "Aftershock Shakes Van Norman Dam." *Los Angeles Times*, February 15, 1971.

———. Two More Die; Four New Shocks Jolt Southland." *Los Angeles Times*, February 17, 1971.

Yardley, William. "Oklahoma Is Moved to Action." *Los Angeles Times*, March 2, 2016.

Young, Robert B. "School Repairs to Cost $23 Million." *Los Angeles Times*, February 17, 1971.

Zamichow, Nora, and Virginia Ellis. "Santa Monica Freeway to Reopen on Tuesday." *Los Angeles Times*, April 6, 1994.

Zeman, Ray. "Delay in Receiving Emergency Calls in Disaster Deplored." *Los Angeles Times*, February 17, 1991.

ABOUT THE AUTHOR

Abraham Hoffman was born in Los Angeles and attended Los Angeles City College and received BA and MA degrees from Los Angeles State College (now California State University–Los Angeles). He earned his doctorate in history at UCLA. Dr. Hoffman taught in Los Angeles schools for more than thirty years and has also been an adjunct professor at Los Angeles Valley College since 1974. He serves on the board of editors for *Southern California Quarterly*, reviews books and contributes articles to history publications. His books include *Unwanted Mexican Americans in the Great Depression: Repatriation Pressures, 1929–1939*; *Vision or Villainy: Origins of the Owens Valley–Los Angeles Water Controversy*; and *Mono Lake: From Dead Sea to Environmental Treasure.* In addition to being a member of the Los Angeles City Historical Society, he is also a member of the Historical Society of Southern California, Organization of American Historians, Western History Association, Western Writers of America and the Los Angeles Corral of Westerners.